Practically Posh

* *

by

Robyn Moreno

Practically Posh

The Smart Girls' Guide to a Glam Life

by

Robyn Moreno

Collins

An Imprint of HarperCollinsPublishers

Practically Posh. Copyright © 2008 by Robyn Moreno. All rights reserved. Printed in
Hong Kong, China. No part of this book may be used or reproduced in
any manner whatsoever without written permission except in the case of brief
quotations embodied in critical articles and reviews. For information, address
HarperCollins Publishers, 10 East 53rd Street, New York, NY 10022.

HarperCollins books may be purchased for educational, business, or sales
promotional use. For information, please write:
Special Markets Department, HarperCollins Publishers,
10 East 53rd Street, New York, NY 10022.
first edition

Designed by Michael Worthington and Yasmin Khan at counterspace, Los Angeles,
with Tasheka Arceneaux and Cassandra Chae.
Photographs by Morgan & Owens

Library of Congress Cataloging-in-Publication Data has been applied for.

ISBN-13: 978-0-06-134946-1

08 09 10 11 12 ID2/PEL 10 9 8 7 6 5 4 3 2 1

Dedicated to
my mother,

Yvonne Guzman,

and my sisters,

Nevia, Yvette, and Bianca:

YOU ARE MY DREAM TEAM AND MY POSHEST INSPIRATION.

Contents

Introduction

It's hard out here for a modern chick. We aspire to keep fashionable flats, entertain with Epicurean flair, travel like rock stars, raise awareness like Angelina Jolie, and all the while, look effortlessly chic.Unfortunately, our salaries and schedules haven't kept up with our burgeoning sense of style and service. So, what's a girl to do?

Become Practically Posh. By practical, I certainly don't mean boring or joyless. Rather, it's about looking at a situation thoughtfully and resourcefully. And while I do applaud Victoria Beckham's smarts and style—Bravo, Love!—when I think of posh, I think of its acronym as a sailing term: port out(ward), starboard home, which is where the first-class accommodations were located on English cruise ships.

A Practically Posh girl is one who steers her own first-class ship. Someone who gets that life is about working with what you have, then *working* what you have.

I have always been a Practically Posh kind of gal. As an enterprising teen in San Antonio, Texas, I volunteered as an usher at the local playhouse so I could see shows for free, and scored trendy haircuts from a fledgling hair stylist by being his practice model.

My industrious attitude reached new heights when I moved to New York City. It had always been my dream to live and work in the Big Apple, and within months of moving to Manhattan I landed a plum position at a women's lifestyle magazine. I stocked my closet with great one-of-a kind pieces that my office mates coveted.

I couldn't afford to buy from the cool designers, but I didn't want to look like everyone else either, so I mostly turned to vintage and secondhand stores, where things are usually well made and well priced. On one inspired occasion, I even enlisted my trusty mom to raid my grandma's wardrobe—luckily Granny had great taste and a small waist—for Victorian-inspired blouses that were in that season.

My practically posh attitude didn't end at fashion. When I wanted to entertain friends in the fifth-floor walkup studio I shared with *two* roommates, what kind of fête could I throw in my tiny pad but a "Divine Dessert and Champagne party." The slaved-over sweets were really Jewish pastries from the bakery downstairs, and the Champagne certainly wasn't from France, but trifling details on a memorable evening. Truly, a night à la mode!

You see, being practically posh is much more than just about finding deals, it's about finding pleasure in your present life. Whether your dream includes fame and riches—or maybe just a smartly decorated apartment and a bank account not in the red—the road to success doesn't have to be shabby. *Practically Posh* is your bible for living as a bon vivant on a budget.

Recall Scarlett O'Hara in *Gone With the Wind*. When she wanted to go to the big society party but couldn't afford a dress, *she* didn't cry, "But I don't have a thing to wear!" Instead, she whipped up a gorgeous gown out of her velvet house curtains, *Project Runway*–style, and proved herself again to be the belle of the ball.

With *Practically Posh* in hand, you'll exude determination, audacity, a bit of wiliness, and above all, *possibility*.

Packed with brilliantly simple expert advice, I'll show you how to whip up a luscious meal with leftovers for two days. I'll also offer easy cheats for staying organized. (Save space in your closet by placing curtain rings on a hanger, then looping your scarves and belts through.) I'll show you how to throw an unforgettable fiesta on your unmentionable salary. (Find a local band or trio and try bartering their rate—it helps if you promise booze and hot chicks.) And I'll reveal to you how you can book your dream vacation *now*.

So for daring dames who refuse to be slowed down by life's practicalities, let ingenuity and attitude be your currency and *Practically Posh* be your guide.

Nesting

"We should learn from the snail:
It has devised a home that is both
exquisite and functional."

Frank Lloyd Wright

For most of my early twenties, my apartment was a poorly outfitted crash pad, decorated with some donations from my mom, a day trip to Ikea, and a few kitsch items found at Goodwill and on the street. But as I started moving into the faster-paced grown-up world—complete with a full-time job and financial responsibilities—my house increasingly became a haven: a place to seek solace from grouchy bosses and immature boyfriends; a lounge where I could entertain my lady friends. In short: a place to call my own.

So as I evolved (read: got older) and actually started making a little dough (emphasis on little), I started craving a bit more from my *casa*, mainly in terms of cleanliness, order, and design. It's hard to pretend you're Ms. Organization at work when you start your day spending 15 frustrating minutes trying to find your left stiletto.

And while I didn't really know the difference between Bauhaus-style furniture and pieces bought at Bed, Bath & Beyond, what I did know was that I wanted my home to reflect my personality. So in the practically posh spirit, I gave myself a crash course in home improvement. I read design magazines, scoured flea markets, clicked through apartmenttherapy.com and rearranged my furniture— a lot.

Robyn's Tip

The easiest way to cozy up your home is to get a pet. Whether a parakeet or a puppy, pets are proven to reduce stress and encourage laughter. If you feel your life is too busy, opt for a low-maintenance pet like a cat or fish. The companionship they provide and the nurturing qualities you develop help make for a happy home.

The Golden Rules of Organizing

You don't have to have OCD to keep your place neat, just use a little strategy. To help simplify my space, I employed the "Truth, Love, Meaning, Purpose" method from organizing expert June Saruwatari. The basic principles are:

TRUTH: Be honest with yourself about the space you're living in. For instance, if you have a tiny apartment, is it really practical to own a monster sleigh bed? You may like the *idea* of an antique birdcage or a floor-to-ceiling bookshelf, but if you don't have a huge space your place may end up looking like a storage unit instead of a chic pad.

LOVE: Do you truly love the item? With limited space, a simple crush won't do. Not only is this a good way to help filter out unnecessary items, but it will also hopefully prevent you from acquiring more of those "seemed like a good idea at the time" pieces. Adopt a recycling rule: For everything you buy and bring into your house, you'll have to toss something to make space. I guarantee this will make you think twice about that "fixable" on-sale item at Crate & Barrel.

MEANING: Does this awful space-stealing eyesore at least have some sentimental value to you? It can be hard to separate the rubbish from, well, *meaningful* rubbish, like the scary-as-hell mask Mom brought you back from her trip to Peru. The thing to remember here is that the item should have meaning for *you*, and not other people.

PURPOSE: Does the item serve a purpose? Look around your room right now. I bet there are five things that are totally useless (besides your fat cat) hanging out in plain sight. The magazine rack that holds everything but magazines? Chuck it! Shadeless lamp you were going to brilliantly redesign? Toss it! Torn menus from the diners you ate at on your cross-country trip wallpapering the kitchen? Get rid of 'em! It might be hard, because these are pieces of your life, but it's best to save the memories and lose the miscellany. Take a picture or write about it in a journal. Commit it to memory, and then say *adiós*.

Robyn's Tip

Start small. Often the very idea of cleaning or organizing is so overwhelming, we either do nothing or do everything all at once, only to find ourselves wading through piles of mess an hour before we're supposed to be somewhere on a Saturday night. Instead, pick a room or an area to clean, like under your sink, and a set a time limit so you don't get carried away.

THE PLEASURES OF PURGING

Apartment after apartment, along with my clothing, furniture, and other necessary objects, I insisted on lugging around an inherited oversize disco ball. Although I put this groovy guy to use many nights, I still dragged it around long after he wore out his welcome. It wasn't until I moved into my smallest apartment to date (technically a living room) that I finally rolled him out the door.

Some things may be easy for you to discard, like torn Frida Kahlo prints, a finicky hair dryer, or drunken photos of you and your pals on spring break (it's best to destroy the evidence now). Other things, like your Tae Bo tapes (it's a great workout!) or your pink feather boa, may be more difficult to part with. But with a little practice, poshie, you'll soon be a discerning decorator.

Robyn's Tips

My friend rides a cool vintage bike, and since she lives in a small space, rather than lean it in her hallway, she mounted a rack right behind her couch, where she hangs it when she comes home. Not only is it out of the way, it actually looks like a decorative piece.

Make your bed every day. It's the easiest way to feign neatness. Even if the rest of your house is a bit disheveled, coming home to a made bed makes you appear more posh and pulled together than you really are.

Space odyssey

Now that you've tossed what you don't need, you've got to hide what you don't want to see. No matter where you live, a teeny flat or a massive mansion, you'll always be on the lookout for room. So get creative. Your place actually yields much more storage than you think. You just have to look up, under, sideways, and out.

Look at the cabinets in your kitchen—can you utilize the space on top? Check under your bed—it's a great place for foldable exercise equipment, hand weights, or yoga mats. Don't forget the holy trinity of organizing accessories: baskets, over-the-door shoe holders, and a pegged coatrack.

Baskets can hold mail in the foyer, keep makeup together on your dresser, and even hold remotes in the living room. In your closet, a hanging shoe organizer can hold socks, scarves, tights, and bathing suits. You can also use one in your bathroom to hold everything from brushes to a blow dryer.

Besides holding purses, coats, and scarves in an entryway, a small pegged coatrack can display necklaces in your bedroom attractively.

HERE'S HOW TO MAKE A DIY VERSION

1. Buy a piece of wood measuring 18 in. x 3 in.

2. Hammer in a nail 2 inches from the end.

3. Continue adding nails every 2 inches; you should get about 6 or 7.

4. Spray paint the entire piece your favorite color.

5. Let dry and hang jewelry!

INVEST IN DOUBLE-DUTY FURNITURE

When selecting furniture, think function as well as aesthetics. Consoles and buffets are retro-looking and cool, and can stash dishes inside while the top serves as a bar. An armoire can be placed in the hallway to hold winter clothes and sports equipment. Opt for a coffee table with built-in storage—perfect for corralling candles, magazines, and photo albums. An antique trunk placed at the foot of your bed can be both charming and practical when used to hold extra bedding.

Robyn's Tip

To save some floor space next to your bed, install a bracketed shelf. Place it at the height of your bed so it can serve as a nightstand.

Bless your home

While you're tossing out the old and creating order in your home,
it is also a good idea to "clean" the energy of your casa.

A couple of years ago, I went through a particularly rough patch in my life where I lost a boyfriend and a job within two months. After lying around my home in sweats for weeks, buried under a mountain of self-help books, a good friend suggested I give my house a "cleansing." I responded with an indignant, "Hey, lady, all I've *been* doing is cleaning my house." She explained what she meant was a spiritual cleansing of my house: Kick out bad energy and invite happiness in. Happiness, eh? That was enough incentive to tear me away from the pages of *Stand Up for Your Life!* for a couple of hours. I looked up home cleansing rituals on the Internet and found most of them involved sage, cedar, or frankincense. I walked to a local *botanica* (a Latino herbal store) and picked up some sage tablets, cedar incense sticks, and a candle for Santa Clara, the patron saint of clarity.

I then opened all my windows, dropped the sage tablets in glasses of water and placed one in the corner of each room. Then, beginning at the front door, I lit a cedar stick and began walking room to room waving the stick like a sparkler and shouting, "Out, damned bad energy, out!" I finished by saying a prayer in front of old Santa Clara.

This was my interpretation of a cleansing ritual, but you could choose to ask a pastor, priest, rabbi, or even your friends to bless your house. Your spiritual tidying may be as simple as throwing away negative items from your past (like photos of evil ex-boyfriends or betraying best friends), trashing old work files, or cutting up your work ID and dancing around in your underwear to "I Will Survive." Sometimes you need a busload of hope to get by, as Lou Reed once sang, so ladies, whatever it takes for you to feel good, go for it.

Robyn's Tip

If you don't like the smell of sage or cedar, you can sweep out bad energy—literally. Starting in the corner of every room, brush out the negativity towards and out the door.

Decorating Magic

PAINTING 101

Now that you've cleaned up this joint, let's pretty up the place. Splashing some color on your walls is hands down the easiest and quickest way to give your crib instant character. Plus, it can help change the dimensions—and mood—of your home. Want to make a claustrophobic living room seem larger? Paint the room in a soft landscape hue like ocean blue.

A natural panoramic color like blue, green, or violet will seem to make the room stretch: think of an infinity pool or a far-reaching landscape. If you're lucky enough to have a loft or a big room, you can warm it up by painting it in colors that envelop you, like red, brown, and gold. You can also make a ceiling appear higher by painting it a lighter color, like sky blue. (A ceiling painted bright white also reflects natural light better, making the room seem brighter.) Likewise, you could make a ceiling appear lower with a darker shade, like chestnut.

Regardless of the color you choose, be sure to spend some time poring over swatches and testing paints to make sure you choose the exact hue that works for you. For my first on-my-own (no roommates or boyfriends, thank you very much) apartment, I decided to cover the walls in a sun-kissed Mediterranean yellow. I had golden visions of sunning *sur la plage*, fields of lavender, and bottles of rosé dancing in my head. Instead, what I ended up with was more of a Velveeta cheese yellow tint. Not *quite* the look I was going for. To avoid this fiasco, try testing different colors on your wall before committing to gallons of paint. Glidden offers dry paint samples that stick to your walls like Post-its, so they don't leave any mess or residue like wet paint. Their Peel & Stick paint samples retail for less than $5 for a palette of 10 colors, so you can experiment with shades. Plus, you get a rebate if you buy a can of paint, so it's practically a free way to get your ideal color.

DID YOU KNOW?

The color red stimulates your appetite, while the color blue suppresses it.

(*Source: Pantone Institute*)

OVERWHELMED BY YOUR PAINT OPTIONS?

TAKE MY QUIZ AND FIND A COLOR SCHEME THAT WORKS FOR YOU.

What was your favorite childhood color?
a. Candy apple red
b. Easter yellow
c. Princess pink
d. Sailor blue
e. Orange crush

Your wardrobe is filled with:
a. Fashion-forward, trendy pieces
b. Jeans and cashmere sweaters
c. Sweet dresses and feminine tops
d. Blazers and tailored pants
e. Funky, retro ensembles

Which celebrity would you most like to have at your cocktail party?
a. Kate Moss
b. Kate Hudson
c. Beyoncé
d. Katie Holmes
e. The Olsen Twins

What's your favorite gemstone?
a. Ruby
b. Pearl
c. Amethyst
d. Diamond
e. Tiger's eye

If you could buy from your dream designer, who would it be?
a. Roberto Cavalli
b. Donna Karan
c. Marc Jacobs
d. YSL
e. Anna Sui

What shade would you secretly love to dye your hair?
a. Platinum blonde
b. I wouldn't dye my hair
c. I'd go with highlights
d. Dark brown or black
e. Any shade of red

IF YOU PICKED MOSTLY As: You're a trendsetter, in fashion and in life. Sexy and self-assured, you can handle painting a room red or purple.

IF YOU PICKED MOSTLY Bs: You're a chill chick who likes to kick back, bliss out, and enjoy nature. Your home is your haven, and friends and family enjoy your inviting pad as much as your great company. Welcome guests with clean whites and warm browns.

IF YOU PICKED MOSTLY Cs: A true romantic at heart, your home exudes your whimsy and playfulness. You could pull off a pink boudoir or a lilac living room brilliantly. Channel Marilyn Monroe and lounge around in a vintage dressing gown.

IF YOU PICKED MOSTLY Ds: You're a confident gal who enjoys the good life. Self-possessed yet easygoing, you know what you want and you know you deserve it. Opt for ocean blue or charcoal.

IF YOU PICKED MOSTLY Es: You're a vibrant thing who loves to bring on the fun, make a splash, and live for today. Go for bright and bold colors, like orange and green.

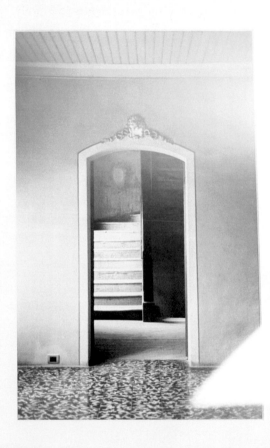

Robyn's Tip

If you're a little color-phobic, why not paint something small, like your front door or flower boxes? Even just a pop of color can make a bold statement. Think of the fanciful bright blue front door of Hugh Grant's home in the movie *Notting Hill.*

Buying the basics

When decorating your pad, it's important to spend money on key, quality pieces, such as a couch. It's also wise to choose items that are as neutral as possible. When your taste changes, you can easily update with accessories and a new coat of paint without having to reoutfit your home.

FURNITURE

TIMES TO BE PRACTICAL, TIMES TO BE POSH

Be practical with the coffee table.
Almost anything can serve as a table, like two end tables pushed together. Get inventive and save your money. Plus, you can effortlessly dress one up with fresh flowers and pretty coffee-table books.

Be practical with the bed frame.
As long as it's sturdy, most frames are fine—and it's almost too simple to create a clever headboard yourself. Hit flea markets and vintage shops for unique finds. My sister bought an ornate iron headboard for next to nothing and covered it in one coat of white spray paint. The patina still shows through and it looks very shabby chic. You could also utilize what you already have and place a pretty room divider, bookshelf, or nice piece of fabric behind your bed. And if you're really tight on space, DIY guru Barbara K. suggests creating the look of a headboard by stenciling patterns on the wall behind your bed and filling them in with metallic paint. The color and texture of the paint creates a 3-D effect: a virtual headboard.

Be practical with the dining table.
Who doesn't want a French farmhouse table? But until you can afford one, bring a picnic table inside for a fanciful look, or serve dinner on a drafting table to exude urban chic. Besides, this is an especially forgiving setting. Ply your friends with good food, wine, and conversation, and they won't even notice the stack of books holding up one leg.

Be practically posh with your rug.
A high-quality rug will be the room's centerpiece, but you don't have to break the bank. Check out Anthropologie, Pier 1, West Elm, or even eBay for good finds. I had a friend who coveted a $1,500 rug from ABC Carpet and Home. After she came back to earth and realized it was out of her price range, she scoured the Internet until she found a replica on eBay for $250.

Go posh on your mattress and linens.
A good night's rest is too valuable for you to toss and turn on a flimsy, unsupportive mattress. Because so many deals abound—you can easily get a good mattress at up to 50 percent off—it makes sense to invest a couple of hundred dollars in one that should last you up to ten years. Department stores like Macy's have good selections and frequent sales.

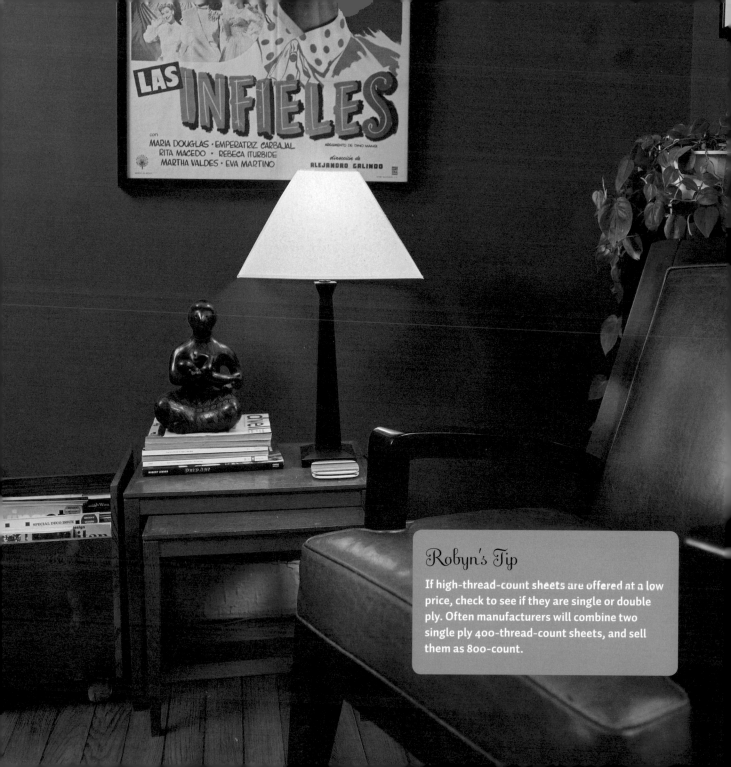

Robyn's Tip

If high-thread-count sheets are offered at a low price, check to see if they are single or double ply. Often manufacturers will combine two single ply 400-thread-count sheets, and sell them as 800-count.

Encasing your bed in quality sheets is another smart buy. The first thing most people consider when buying sheets is the thread count—the number of horizontal and vertical threads in one square inch of fabric.

But you don't have to splurge on 800-count Frette sheets to get a sound slumber. Many experts say anything over a 320-count isn't noticeably softer, and according to *Consumer Reports*, cotton and cotton-blend sheets with a thread count of 180 to 200 were found to provide both great comfort and durability. A smart time to invest in high-thread-count sheets is in January, when most department and home stores have annual "white sales," where you can find big discounts on bedding. Last year I bought 400-thread-count sheets from Bed, Bath & Beyond for $40. Check out www.overstock.com for great deals year-round.

Go posh on your couch.
It's the most used piece of furniture in your pad, so make it comfy. Remember, when you shop for a couch, forgo polka dots and crazy patterns for a classic, clean style you can always update. Also, be realistic about color and fabric choice. A white couch conveys class and elegance, but when I bought my own, the sucker was already dirty after being carried up the stairs. And trust me: If you want to have a romp on the couch or enjoy a glass of red wine after a long day at work, a white couch is hazardous. Like my friend Grace Bonney—blogger at designsponge.blogspot.com—says, you have to buy furniture for the way you live now, not the adult you think you'll be in twenty years.

Robyn's Tip

Do your fitted sheets always pop off the corners, driving you crazy? It's because most people buy sheets for the length of the bed (Full, Queen, King), but ignore the pocket depth: the highest point on the mattress to the bottom edge. Once you have the pocket measurement, add a few inches for safety, as most fitted sheets run small.

WHEN BUYING A SOFA YOU'RE LOOKING FOR THREE THINGS:

1. **A sturdy frame**—a sure sign it's well made. Look for a frame made of "kiln-dried" hardwoods such as maple, birch, and poplar. Wood that is dried in a kiln or oven has less moisture than wood that is dried by air, so it lasts longer.

2. **Strong springs**—for intense makeouts and portly visiting relatives.

3. **Comfy cushions**—probably the most important factor in being happy with your couch. Foam cushions are the least expensive, while goose feather cushions are the most expensive. Try to find something in between, like a foam core surrounded by a down cover.

ROBYN'S SUPER-EASY DIY PROJECT

Are you coveting an Asian-inspired armoire but you can barely afford Chinese takeout? Pick up an unfinished dresser from Ikea and give it your own mod Mandarin look.

Supplies you'll need:

Old newspapers
Cotton rag or towel
One package of 120-grit sandpaper
One spray can of primer
Two cans of spray lacquer paint in black gloss
Tack cloth
Wool rag for buffing

Application time: 60–90 minutes **Total time:** 7 hours

Supply cost: $30 (minus dresser)

Directions:

1. Remove the drawers from the dresser and set the dreser and drawers on newspapers in a well-ventilated and well-protected area.

2. Sand the dresser and drawers using the 120-grit sandpaper. You just want to give the primer a good surface to stick to.

3. Wipe with a tack cloth to remove dust.

4. Spray on a thin coat of primer to the surfaces being painted.

5. Let dry for 15 to 30 minutes, and then remove any excess primer with a clean, dry cloth.

6. Spray several thin coats of the black lacquer, letting each coat dry in between, moving smoothly and steadily across the surface.

7. Repeat coats until dresser is desired color.

8. Let dry for about 6 hours, and then rub down with a wool rag.

* An easy way to glam up any piece of furniture is to change the knobs. Stores like Anthropologie and Restoration Hardware have great collections, from vintage-inspired to a mod style, but can be pricey. Instead, scour vintage stores and flea markets for practically posh knobs and pulls.

Robyn's Tip

Get yourself some tools! I love the kit from Barbara K (barbarak.com). It has everything you need for home repair: hammer, adjustable screwdriver, level, wrench, and more. And it all comes in a slim blue case for easy storage—genius. Having these tools in your home—and knowing how to use them—will not only save you money and time, it'll also give you roaring confidence.

Resurrection boulevard

Furniture has a chameleon-like quality: A lived-in velvet chair with a Victorian vibe can find new life in your flat, while an inherited dining room hutch can be smartly transformed into a bar. Depending on the condition of the piece, a little sanding, polishing, or even reupholstering may be in order.

You're probably thinking, "Sanding, my ass!" but keep in mind that home improvement projects can be fun and easy if you know what you're doing. Learning these skills is easier than ever with help from the plethora of DIY shows on television, step-by-step guides on the Internet, and clinics offered around the country where you can learn these skills for free. Home Depot offers "Do-It-Herself Workshops" designed especially for women, where you can learn practical skills, like how to make bookshelves, and even tackle tough tasks like installing a ceiling fan. Remember, when it comes to DIY projects, it's all about what your time is worth.

Check out home improvement stores in your area to see what classes they offer.

Robyn's Tip

Slipcovers are an easy way to give your tired couch or loveseat a quick makeover; check out www.surefit.com or www.overstock.com for a variety of choices.

FROM TRASH TO TREASURE

Some people might balk at the idea of picking up someone's unwanted furniture and bringing it into their homes, but I can tell you from firsthand experience, the streets of America's cities are lined with discarded gems. For whatever reason—job transfers, messy breakups, or sheer laziness—people often throw away quality usable items.

The best times to look for cool castaways is in January, when people start anew, and May and September, when the school year ends and begins. If your city has specified certain days for bulk-trash collection, these are a surefire furniture bonanza. Great finds include: lamps, end tables, intact mirrors, and kitschy decorative pieces. Leave behind bedding and mattresses—it's not just a nursery rhyme, bedbugs do exist, and anything broken or you deem a "fixer-upper" is so not worth your time.

If you're a little skeeved out by sidewalk shopping, check out www.craigslist.com for inexpensive used furniture.

What's your style?

Don't know the difference between midcentury and Shaker? Angela Matusik of www.Shelterrific.com recommends going to museums or libraries, visiting hotels, and even reading design magazines to get a better understanding of how design fits into your everyday life. Check out the Web site 1stdibs. com, which offers designer pieces at discount prices. It's an affordable way to start experimenting with different styles. And even if you've gone mad for one particular period or store, never buy everything from the same place or the same era—it'll scream straight-out-of-the-catalog. It's like buying an entire outfit off a mannequin: too obvious. The key to well-executed home decor is to mix things up. And add a dash of the personal for a truly unique look: showcase your grandma's teacups or hang an antique plate collection on the wall.

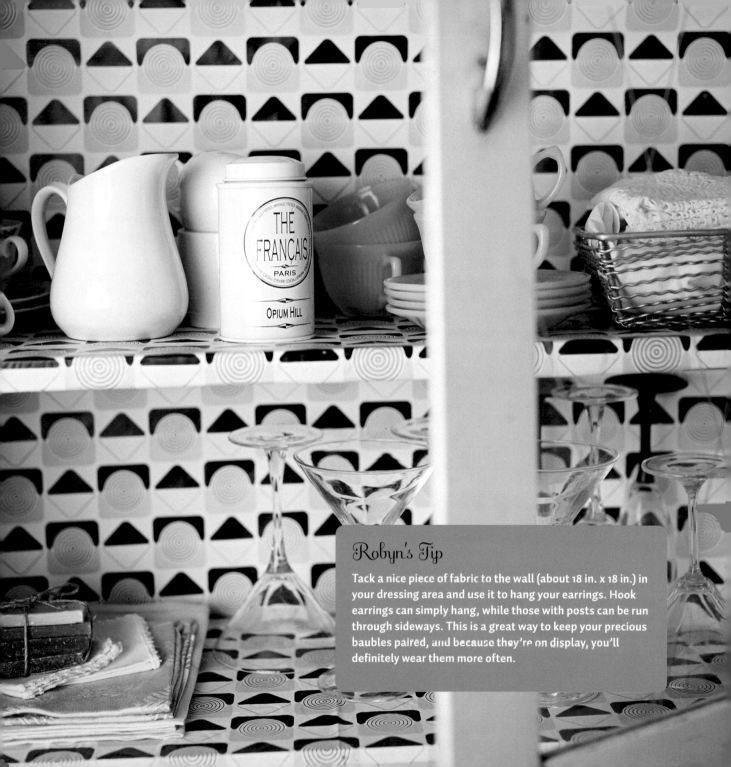

THE
FRANCAIS
PARIS

OPIUM HILL

Robyn's Tip

Tack a nice piece of fabric to the wall (about 18 in. x 18 in.) in your dressing area and use it to hang your earrings. Hook earrings can simply hang, while those with posts can be run through sideways. This is a great way to keep your precious baubles paired, and because they're on display, you'll definitely wear them more often.

I love your accents!

Wallpaper is very trendy right now and is also a great way to bring pattern and texture to your home. But you'll want to use it sparingly, because not only is it expensive, but it requires more effort than just slapping on a coat of paint when you tire of the color.

Try papering one wall, or maybe something small, like the inside of a closet, a room divider, or the back of a bookshelf. You can also mount a catchy paper print onto a foam core and hang it above your mantel for a piece of art on the cheap. How did you get so clever?

A cheaper version of wallpaper is fancy gift-wrapping paper. My friend Pepa lined her '50s-style metal china cabinet with black-and-white pop-art-printed gift-wrapping paper. All she did was measure the inside of the cabinet and then apply the paper with double-sided tape. She's a practically posh inspiration!

You can also "wallpaper" a wall with nice gift-wrapping paper by mixing carpenter's glue and water, and brushing a layer on the back of your measured paper. Apply to the wall, and you're all done. Visit www.katespaperie.com or www.papyrusonline.com for pretty options. If you rent, make sure to clear wallpapering projects with your landlord.

Fabulous fabrics

Highlight your home with textiles—you can dress up your place with chic patterned wall tapestries, or even upscale shower curtains. Visit Web sites like www.reprodepotfabrics.com and browse through their huge selection of wonderful and inexpensive fabrics.

If you're hankering to make your own curtains, avoid window treatment specialists that "specialize" in costing you more money; instead pick out some fabulous fabric and pay a visit to your neighborhood tailor and have him whip them together for you.

Robyn's Tip

If your space is really small—forgo billowy curtains and hang blinds instead. Natural wooden-slatted or bamboo blinds give your space a streamlined look and are inexpensive. Check out surprisesurprise. com for cool options.

DEAR JOHN

People often forget bathrooms, but they can be transformed with some TLC. Not only do you spend more time in there than you think, but this is one room everyone will see. My friend is a travel buff, and she has a map of the world printed with world capitals as her shower curtain—an easy way to get a geography lesson. The bathroom is also the perfect place to experiment with bright colors or to hang fun finds. My bathroom is decorated with a collection of butterflies I inherited from my grandma, which adds a sweet touch of whimsy. My friend Steph has a pink boudoir-inspired bathroom where she framed beauty ads—like the Breck girl—from vintage magazines. So glam and girlie!

POP PHOTO

If you're like me, then you probably have hundreds of photos scattered in a drawer or forgotten in files on your computer.

Now you can show off your love for travel and your photography skills by turning those pictures into wall art. Web sites like www.canvasondemand.com and www.snapfish.com can create cool canvas prints in color, black-and-white, or even moodier sepia. Available in poster size or smaller, these pretty panoramas can adorn your apartment at a fraction of the cost of a print or painting. I lined my hallway with blown-up canvas panoramas from some of my travels, so when guests use my bathroom, they have a nice gallery to look at along the way. You can also make a book out of your travel pics at www.shutterfly.com and put it on your coffee table.

THE MAGIC OF MIRRORS

While my friends tease me mercilessly about having so many mirrors in my small apartment, we all know that every girl's flat should have at *least* one full-length mirror. How are you going to know what your bum really looks like in those skin-tight jeans? In addition to primping purposes, strategically placed mirrors can enlarge your space. Try hanging a large mirror over a mantel. Not only will it broaden the area, but it will also reflect light, an ideal fix for dark spaces. If you're looking to cover an entire wall, don't overlook getting custom-made mirrors, especially if you have a hard-to-cover space. A glass shop can cut a mirror to the size you need for about $50.

When you have a wee apartment, every inch counts. Enhance an odd-shaped wall or nook by hanging a cluster of mirrors for an antique effect. Scour flea markets and garage sales for mix-and-match mirrors, and position them any which way for an effortlessly chic look. Don't fret too much about scratches or discoloration of the mirrors. The softened patina of age will lend your room a romantic feel.

Robyn's Tip

Don't forget to arrange mirrors in your bathroom so you can see the back of your head when styling your hair.

PRETTIFY WITH PLANTS

All through college I had a cactus named Lucy. Well, actually I had many cacti called Lucy, because, guess what? You can kill a cactus. Hmmm. Apparently, the reason plants add such life to residences is well, because they're actually alive, and accordingly need proper care. Blasted! Instead of buying a plant willy-nilly, like because it's on sale or you like its hot pink color, try buying a plant that works with your style and your schedule.

According to Nina Willdorf, author of *City Chic*, if you have a low-light apartment, buy a bamboo plant, fern, or succulent, which can do well in the dark.

If you travel often or spend weekends at your boyfriend's house, opt for an aloe or jade plant—they don't need much H_2O.

And don't worry; if all else fails, just hang dried flowers for a poetic look.

I am now the proud owner of a spider plant, which I'm happy to report is doing splendidly. Because I'm traumatized from killing Lucy—again and again—I now tend to overwater. Luckily, spider plants can handle the downpour, so Spidey and I are getting on quite well.

. .

DID YOU KNOW?

Flowers are proven to boost creativity. So buy a bunch for your desk to serve as inspiration as your write your business plan or screenplay.

. .

Robyn's Tip

Spruce up inexpensive store-bought flowers by arranging them with fresh herbs. Sprigs of rosemary or tarragon add a pretty dimension to a bouquet of roses and infuse your casa with a warm, earthy scent. To make your flowers last, change out the water every day. Instead of laboriously changing containers, just hold the vase under the tap of running water for a minute—the vase will recycle itself. When your arrangement is on its last leg, extend the shelf life of the flowers by plucking out the liveliest flowers and placing them in individual vases around your house. When those start to droop, cut off the buds and float them in water.

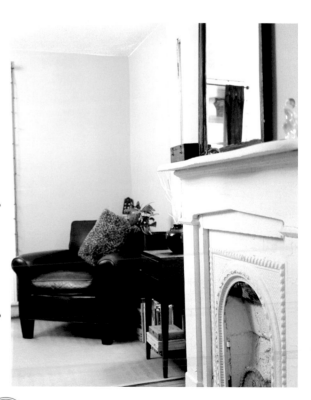

In the Kitchen

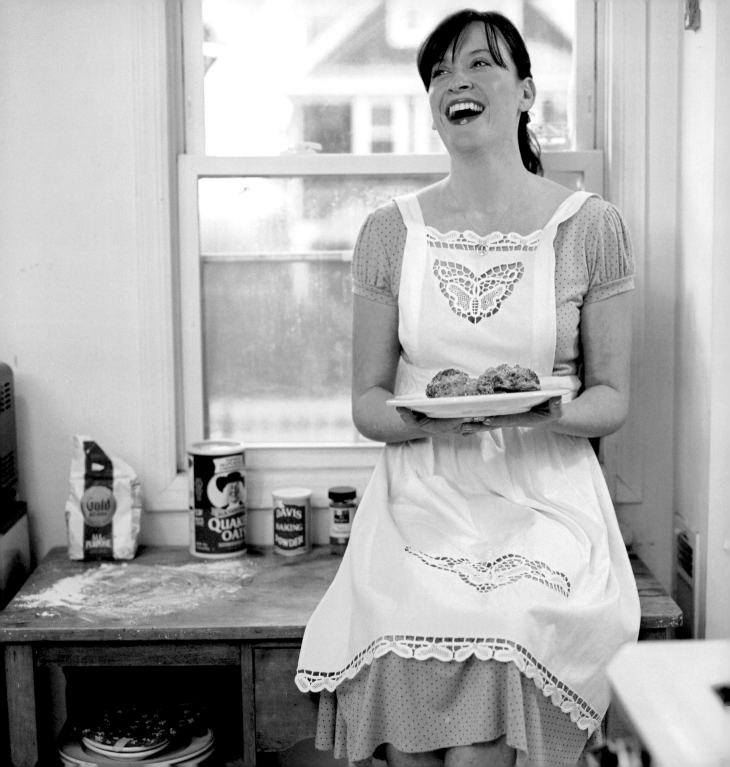

"Fake it 'till you make it, honey."

my Aunt Lily

In an era where everyone is a fledgling foodie, arguing about the future of foie gras or waxing poetic about the virtues of Japanese knives, the expectations for a home chef have risen considerably. But you don't have to hand roll your own sushi or churn your own butter to create masterful meals. All you need is a little kitchen ingenuity and know-how. So whether you're addicted to *Top Chef* or Top Ramen, here's a primer on becoming the doyenne of your domain: practically posh recipes that impress; the truth about buying organic—is it a necessity or luxury?; and tips on how to solve the problems of limited kitchen space (hint: household items that do double duty).

Gaining Your Kitchen Confidence

I once attempted to make a boyfriend a four-star Valentine's Day meal—from scratch. On the menu: sautéed scallops, magret (duck breast) with a port wine reduction, and individual flourless chocolate cakes. I had pored over cookbooks and it seemed totally doable—in theory, anyway.

I spent all day working, then fought through the crowds of the other wait-till-the-last-minute lover's day shoppers at the grocery store, and dashed in the door an hour before my date was. Help! When my beau arrived, bouquet in hand, the table wasn't set, my dress was still unzipped; my port sauce was burning; the duck was languishing in the oven; and the dessert hadn't even been started. After

my date waited impatiently for 30 minutes as I did my best to make a masterpiece out of the madness, I knew a different course of action was needed fast to save this wilting night. I put on some lipstick, popped open a bottle of Champagne, and sauntered over to my date and asked him to help zip up the back of my dress. As he leaned into my body, I looked over my shoulder and purred: "I know the owner of the most amazing restaurant right around the corner. I'm sure he can get us in."

The night was salvaged—but I learned my lesson well: the key to being a practically posh culinary star is to make meals that only *look* like you slaved all day.

Want to wow a dude?

7 SCENARIOS, 7 PRACTIALLY POSH DISHES

Whether it's your first date, or you're trying to win him back, make the man fall madly in love with your cooking prowess—and you—with this surefire dish. Italian is a great choice because it's so inherently romantic. Plus, this recipe is perfect for kitchen novices because the salt and crispiness of the prosciutto add guaranteed flavor and depth to your dish.

CHICKEN SALTIMBOCCA OVER LINGUINE

Ingredients:

1 lb. linguine
Salt and black pepper (optional)
6 (3-ounce) chicken cutlets, pounded to evenly flatten
1 lb. prosciutto, sliced thin
Fresh sage leaves (can use a sprinkle of dried sage in a pinch)
1 cup all-purpose flour
1 cup chicken stock
1 tbsp. butter
Shredded Parmesan

Directions:

In large pot, bring salted water to a boil. Add linguine and cook for four minutes. While pasta is boiling, flatten the chicken breasts with a meat pounder. If desired, sprinkle cutlets with salt and black pepper, but this is not necessary, as prosciutto is salty. Top cutlets with a sage leaf. Press one slice of prosciutto atop each cutlet. Then dust lightly in flour. Set aside. In a skillet over medium-high heat add one cup of chicken stock and one tbsp. butter. Place cutlet in skillet and cook with prosciutto side down until golden brown, about four minutes per side; add chicken stock as needed and simmer 8-12 minutes. Remove chicken from heat. Drain pasta and add to the chicken broth in skillet for two minutes. Sauté some sage leaves while you assemble pasta and cutlet on a plate. Top with shredded Parmesan and crumbled sage leaves as garnish.

The morning after

So he spent the night, and you actually want him to hang around the next day. Instead of heading to a bustling brunch place, hang out at home and make him your famous pumpkin pancakes. A study by The Smell & Taste Treatment and Research Foundation in Chicago found that the combination of pumpkin pie and lavender was the most sexually arousing to men. So make a batch of these easy-as-pie pancakes, splash on a little lavender spritz, and spend the day indoors.

PUMPKIN PANCAKES

Ingredients:

1 ¼ cups unbleached all-purpose flour
3 tbsp. sugar
2 tsp. baking powder
1 tsp. cinnamon
½ tsp. ground ginger
¼ tsp. nutmeg
1 ⅓ cups whole milk

¾ cup canned pure pumpkin
4 large eggs: egg yolks
½ stick unsalted butter, melted
1 tsp. vanilla extract
¾ tsp. salt
egg whites
1 ½ cups Vegetable oil
Maple syrup

Directions:

Place first six ingredients in large bowl to blend. Separate eggs. Set whites aside. Place milk, pumpkin, egg yolks, melted butter, vanilla, and salt in medium bowl and blend well. Add pumpkin mixture to dry ingredients; whisk just until smooth (batter will be thick). Using electric mixer, beat egg whites in another medium bowl until stiff but not dry.

Fold whites into batter in two steps. Brush large nonstick skillet with oil; place over medium heat. Working in batches, pour batter by ¼ cupfuls into skillet. Cook until bubbles form on surface of pancakes and edges are dry, about 1 ½ minutes per side. Repeat with remaining batter, brushing skillet with oil between batches. Serve with syrup.

Turn leftovers into dinner for two

I know you're staying in alone tonight, but bypass the prepared food section at Whole Foods (too expensive) and treat yourself to an actual meal. The process of cooking will help you unwind after a hectic day, plus you can use some of the remaining ingredients from last night's success.

PASTA WITH PROSCIUTTO AND ARUGULA

Ingredients:

1 lb. penne
½ lb. thinly sliced prosciutto, chopped
1 lb. arugula (4 bunches), coarsely chopped
$^2/_3$ cup freshly grated Parmesan (1 ½ oz.)
½ tbsp. fresh lemon juice
salt and pepper
¼ cup olive oil

Directions:

Cook pasta in an eight-quart pot of boiling salted water for six minutes. Reserve one cup cooking water, then drain pasta. Return pasta to pot and toss with prosciutto, arugula, Parmesan, lemon juice, and salt and pepper to taste. Drizzle oil over pasta and toss to combine. Add some of the reserved cooking water if pasta seems dry.

Foodie friends

So your annoying friend who's a killer cook has shown off her mad skills enough that it's time to repay the favor and have her over for dinner. Don't even try to compete on her level; she's had years of practice, and an actual interest in cooking behind her.

My friend, it's time to pull out the race card. What's your background? Italian, Puerto Rican, Swedish, Bulgarian? It's time to use what you've got, ladies. Whip up Grandma's meatballs, curry, or moussaka. Even if you got the recipe from epicurious.com, and not a handed-down recipe book, who's going to know? Just make up a story to serve along with it: "Babushka used to make this for us every Sunday." Your guests will be enchanted. Plus, even if it's a tad overcooked, no one will say anything: who dares insult Granny?

One of my patented Mexican dishes is steak tacos. I've found most people prefer simple food that tastes good over a lot of bells and whistles, so this is always a winner. I use steak instead of chicken, which is a bit fancier, and garnish with sliced radishes and cilantro, like we do it back in the homeland. I serve it with homemade salsa for authentic overkill.

SKIRT STEAK TACOS

Ingredients:

2 lbs. skirt steak
2 tbsp. chili powder
2 tsp. ground cumin
4 tbsp. olive oil, for marinade
1 tsp. salt

4 garlic cloves, chopped
10 corn tortillas
6 radishes, sliced
1 bunch cilantro
2 cups tomatillo salsa

Directions:

Rub the steak with salt, chili powder, cumin; place in a baking dish with olive oil and garlic to marinate for 15 minutes. Remove from marinade and cut the steaks in half. Add one tbsp. of olive oil to skillet on high heat and sear the steaks for three minutes on each side, less time if your prefer more rare. Slice steak against the grain in ½" slices and place in tortillas. Add radishes, cilantro, and tomatillo salsa as desired.

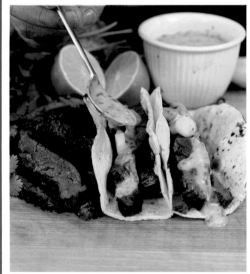

TOMATILLO SALSA

Ingredients:

1 ½ lb. tomatillos
1 tbsp. fresh lime juice
¼ tsp. sugar
½ cup chopped white onion
½ cup cilantro leaves
2 jalapeño peppers, stemmed, seeded, and chopped
Salt to taste

Directions:

Remove husks from tomatillos and rinse. Cut in half and place cut side down on a foil-lined baking sheet. Place under a broiler for five to seven minutes to lightly blacken the skin. Place tomatillos, lime juice, sugar, onion, cilantro, and jalapeños in a food processor (or blender) and pulse until all ingredients are finely chopped and mixed. Add salt to taste.

Lazy ladies night

The babes are coming over for some vino and so-bad-it's-good reality TV. Forget the take-out Thai, and treat your ladies to a super-quick homemade meal. An added bonus: the antioxidants in the dinner work to counter the effects of last night's debauchery.

HONEY AND PEPPERED SALMON

Ingredients:

1 lb. fresh salmon fillets, skin removed
½ cup honey
Fresh ground black pepper
1 tbsp. lemon juice

Directions:

Heat a skillet to medium heat. In a small bowl, coat the salmon fillets in honey and lemon juice. Sprinkle with black pepper. Add to skillet and cook 1 ½ to 2 minutes on each side. The honey should caramelize. Remove from heat and serve over a bed of instant couscous.

SPICY CREAMED BROCCOLI

My little sister turned me on to this recipe. Broccoli is so healthy, but repeatedly served steamed can be become a bore. The yogurt and chili flakes in this recipe make it seem a tad exotic.

Ingredients:

1 tbsp. olive oil
5 garlic cloves, chopped
Pinch red pepper flakes
1 bunch broccoli, chopped
1 cup chicken stock
¼ cup plain yogurt
Salt and pepper to taste

Directions:

Heat olive oil in a saucepan over medium heat. Add garlic and pepper flakes. Stir in broccoli, making sure it gets coated. Pour in chicken stock and cover to steam for 10 minutes. Drain broccoli from chicken stock and mash in yogurt. Season with salt and pepper.

Dinner for real adults

Your parents, your man's parents, a visiting aunt and uncle; whoever the guests, show off your mature side with this affordably simple yet sophisticated meal.

PORK TENDERLOIN WITH SPINACH SALAD

Ingredients:

2 strips pork tenderloin
4 tbsp. honey
2 tbsp. soy sauce
1 oz. black peppercorns
Sea salt
Olive oil

Directions:

Marinate pork loin in honey and soy sauce for an hour. Then encrust with fresh whole peppercorns you crushed with a mallet. Place the loin on a baking sheet brushed with olive oil and cook for 12 minutes at 450°F. Drizzle with a little more olive oil, rotate loins, and cook for 13 more minutes. Add sea salt to taste.

SPINACH SALAD WITH BALSAMIC VINAIGRETTE

Ingredients:

5 tbsp. aged balsamic vinegar
3 tsp. Dijon mustard
2 garlic cloves, peeled and crushed through a garlic press
¾ cup extra virgin olive oil
Salt and freshly ground pepper to taste
1 bag or bunch spinach, washed and dried
1 small red onion, sliced
1 pkg. peppered goat cheese, crumbled

Directions:

Mix together balsamic vinegar, mustard, and garlic. Slowly stir in olive oil. Add salt and pepper to taste. Serve over spinach and garnish with sliced onions and crumbled goat cheese.

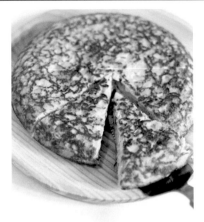

Book club brunch

It's your turn to host and you have to feed five girls. Forgo din-din and have a brunch. A Spanish tortilla can feed hordes, is an Iberian twist on the classic quiche, and the ingredients couldn't be cheaper (potatoes and eggs)—perfect elements to make your affair practically posh.

SPANISH TORTILLA OMELET

This version is adapted from the one served at my cousin Javier's Basque restaurant, Pintxos, in New York City.

Ingredients:

2 large potatoes, peeled and sliced
1 large onion (white or yellow), cut into strips
1 red pepper, cut into strips
Pinch salt
5 extra large eggs
1 cup vegetable oil

Directions:

Mix potatoes, onion, red pepper, and salt in a bowl. Place oil in skillet over medium heat. Place potato mixture in pan, stirring lightly so mixture does not stick. Cook until potato mixture is soft, but not mushy. Strain potato mixture. Beat all five eggs in separate bowl. Mix potato mixture with beaten eggs. Warm about a teaspoon of oil in a nonstick pan, place potato mix in the pan, even it out flat like a pancake. Cook mixture for five minutes, place lid with handle on pan (or a plate) and gently flip pan over without spilling. Return to pan, cooked side up. Cook for five minutes.

Key cookbooks
TO INSPIRE YOUR KITCHEN

Though most recipes can be easily found online, having these culinary bibles on hand make for interesting reads on relaxed nights. Because most new cookbooks can be pricey, check out the new and used section of amazon.com for gently used, less expensive versions.

How to Cook Everything
by Mark Bittman
The basics, plus easy recipes for great dishes.

The Provence Cookbook
by Patricia Wells
You're sure to become a French food master with this book.

Essentials of Classic Italian Cooking
by Marcella Hazan
This classic is the perfect primer for creating inspired Italian dishes.

Nigella Bites
by Nigella Lawson
The domestic goddess shows you how to make kitschy and comforting recipes.

Household items that do double duty

Next time you're cooking and find you're lacking a utensil, save yourself time and money by trying one of these MacGyver-like moves.

CAN'T FIND A ROLLING PIN?
Grab a wine bottle, wrap it in plastic and start flattening.

NO SPACE FOR A COOLING RACK?
Make your own by lining up chopsticks. Place three parallel, cross three on top, and you're good to go!

WANT TO DECORATE YOUR CAKE, BUT DON'T OWN A PASTRY BAG?
Make your own by filling a Ziploc bag with frosting, snip the corner, and start writing away.

NEED TO LIGHT A DEEP CANDLE?
Grab a spaghetti stick and use as a long match.

How to Save at The Grocery Store

I used to go to the grocery store with an item or two in mind, and would end up walking out with an overflowing cart, a streamer-size receipt, and buyer's remorse as I ended up not eating half of my purchases. Having a little strategy (and a snack beforehand) will keep you from overspending at the supermarket.

PLAN MEALS AHEAD

Take two hours this Sunday afternoon and plan your meals for the week. It may seem laborious, or downright lame, but if you shop for specific ingredients for recipes as opposed to random items, you'll save so much money. Envision the cash you'd save buying only the two tomatoes the recipe called for, instead of the six you bought because they were in such a pretty red cluster. Save more money by visiting the Web site of your favorite store to see what will be on sale this week and downloading any coupons available (or pull out the weekend circular to get menu inspiration from sale items. Whole chicken's on sale? Guess who's going to be eating chicken salads all week?)

FACTOR IN YOUR APPOINTMENTS

Do you have a lot of lunch or dinner plans this week or will you have to pull some late nights at work? Being realistic about your schedule will help you buy and waste less.

SAVING IN THE STORE

Don't fall for convenient packaging. Resealable bags of cheese, dried fruit, and nuts are huge wastes of money. They are more expensive than their regularly packaged counterparts and often give you less for your money, not more. Buy in bulk, Ziploc them yourself, and save some *dinero*.

You can also forgo the imported foreign water and buy local flat and sparkling water. It's just as good, half the price, and environmentally friendly. Even better (and cheaper): drink tap water.

Produce 101

When you're enthusiastically tossing veggies and fruits into your cart, it's easy to forget the reality of your busy life. Love the good intentions, but are you really going to steam that artichoke? Produce spoils quickly so err on the side of caution. If you want to satiate your veggie fix, don't turn your nose up at frozen veggies. Because most frozen veggies are picked and frozen at the peak of their freshness, most nutritionists say they may be healthier than a veggie (or fruit) that has traveled miles to your store. Buying frozen broccoli, peas, corn, and berries will lower your shopping budget, but not your nutritional value.

A cut above the rest

Depending on what you are making, you may be able to go with a less expensive cut of beef. Reasonably-priced flank steak is great for fajitas. When making burgers, forgo the more expensive lean ground beef for the regular version. The fat makes the burgers juicier anyway. Hankering for a ribeye? Go for a boneless beef chuck eye steak, which is its much cheaper cousin. And if you want to get fancy, pick a juicy pork tenderloin over a beef fillet any day.

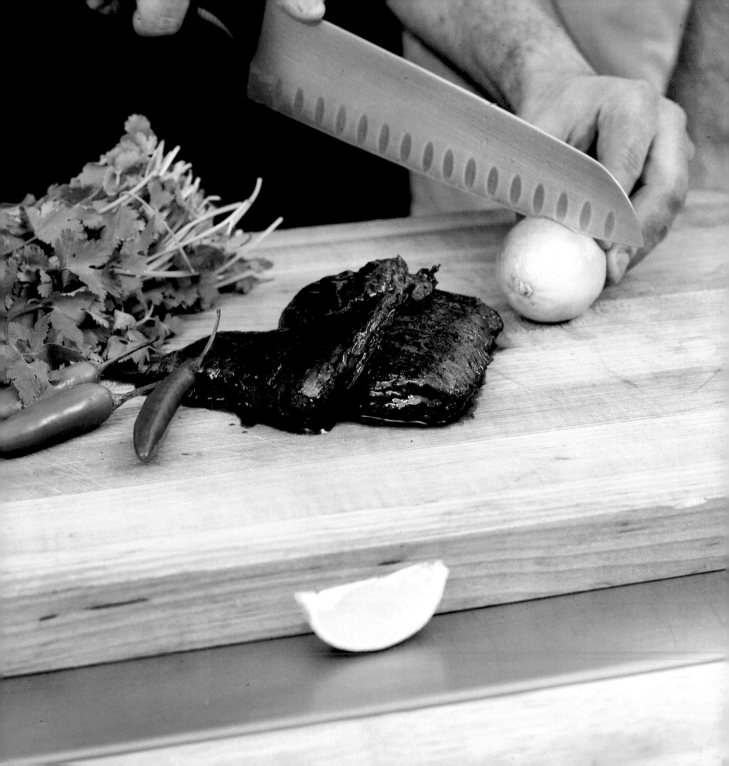

Products to avoid buying at the supermarket

Toiletries and paper goods
You're paying for the convenience of one-stop shopping. Head to your local warehouse or drugstore and stock up; you can easily save twice as much.

Prepackaged lunches sold in dairy case
Make your own salad or sandwich and you won't have to scrape off what you don't like.

Individual packages of chips and cookies
Buy large packages and then split into individual portions yourself. It's less expensive and a great way to control how much you're eating.

Fancy cheese
I know this can be blasphemy. I adore artisanal cheeses as much as the next snob, but for everyday living, you don't *need* a $12 lb. of Vermont cheddar. Save the pricey stuff for special occasions and stock up on deli-aisle goat cheese, mozzarella, and other everyday necessities like pepper jack instead.

Finally...check it twice
The easiest way to save money at the grocery store is to keep your eyes focused on the register at the checkout counter. It is estimated that Americans lose between $1 and $3 billion a year in scanning errors, either because of a human mistake or because the sale prices have yet to be entered into the computer.

Take your breakfast and lunch to work

We all know about the latte factor, but grabbing a muffin or bagel every morning can rack up the dollars—and the pounds—since the size of those breakfast breads is usually bigger than my head. I usually make a tin of muffins ahead of time, freeze them, then pop one into the toaster oven for breakfast, so warm and yummy. If you don't have much of a sweet tooth, quiches are the absolutely easiest things to make. Plus, you can make them as healthy as you want: veggie, egg white; the possibilities are endless. When it comes to lunch, I totally understand the pleasures of eating out with friends or coworkers, so go for it. But when you don't have plans, usually the other three or four times a week, bring your own lunch.

A practically posh girl's shopping list
THE BASICS

A busy babe knows that with a few ingredients in the kitchen,
she can whip up a tasty dish in no time. So try to keep on hand these
kitchen essentials:

IN THE FRIDGE

Bottle of Cava, Prosecco, or Champagne

Olives

Hummus

Tortillas

Cheese: hard, soft, spreadable

Coffee beans

Dijon mustard

Eggs

Leafy greens

Seasonal veggies

Seasonal fruit

Lemons

Milk

Butter

Chicken broth

IN THE PANTRY

Black/pinto beans

Wheat pasta

Olive oil

Red wine vinegar

Brown rice/couscous/quinoa

Cans of tuna in oil

Soy sauce

Bread

Garlic

Yellow onions

Nuts

Crackers

Honey

Sugar

With any of these ingredients you can have quesadillas, salad niçoise, veggie couscous, ratatouille, or even something of your own creation, in minutes.

DID YOU KNOW?

Certain produce like apples, bananas, pears, and tomatoes give off a gas called ethylene, which speeds up ripening. If you have a green avocado or mango you want to eat, put it in a paper bag with the gassy fruits, wait a couple of hours, then enjoy.

Organic 101:
WHEN TO SAVE AND WHEN TO SPLURGE

Eating organic has become übertrendy, but eating an all-organic diet can be costly and isn't totally necessary for food peace of mind. (To be labeled certified "organic" means that the food is produced without synthetic fertilizers, chemicals, or irradiation, isn't genetically modified, and contains no hormones or antibiotics.) The Environmental Working Group, a public health and environmental organization, says that consumers could cut their pesticide exposure by almost 90 percent by avoiding the most contaminated fruits and vegetables.

BUY ORGANIC: The 12 most contaminated fruits and veggies, often referred to as the "dirty dozen," include apples, peaches, nectarines, strawberries, cherries, pears, imported grapes, spinach, lettuce, sweet bell peppers, celery, and potatoes.

BUY ORGANIC: MEAT, POULTRY, DAIRY, AND EGGS
It makes sense that whatever animals eat will be passed into your body. So to avoid ingesting growth hormones, antibiotics, and toxins, it is better to buy organic animal products. It's also good to note that animals fed on grass ("pastured") tend be healthier, as they're eating a more natural diet.

BUY CONVENTIONAL: The EWP's list of cleanest (low- or no-pesticide) foods include onions, avocados, broccoli, sweet corn, cabbage, asparagus, sweet peas, pineapples, mango, kiwi, bananas, and eggplant.

BUY CONVENTIONAL: SEAFOOD
While fish does have a country of origin label, the USDA has not yet developed organic certification standards for seafood, so many fish, whether wild or farmed, can be labeled organic despite the high presence of contaminants such as mercury and PCBs (polychlorinated biphenyls), a cancer-causing compound once used in industrial insulators.

If you're trying to get pregnant, the Environmental Protection Agency recommends you avoid swordfish, shark, king mackerel, and tilefish, and only eat 6 oz. of tuna steak per week.

BUY LOCAL AND SEASONALLY

"You don't have to eat an all-organic diet to be healthy," says Nina Planck, author of *Real Food: What to Eat and Why*. "Eating organic is positive," says Planck, "but it's just as important to buy from local farmers and producers when possible. Organic produce can still take days to get to you, while those found at a farmers market were probably picked the day before."

According to the USDA, the presence of farmers markets nationwide has increased by 20 percent, which means it's now easier than ever to buy fresh food straight from the source. While prices at Farmers markets can seem high compared to their mass market competitors, if you get to know your tomato guy on a first-name basis, there is a

good chance he will cut you a deal or throw in some free produce every now and then. Also, try visiting a market at the end of the day when many vendors will slash prices to get rid of their remaining inventory. Plus, sustainabletable. org found that for every dollar you spend at the grocery store, only 3.5 cents goes to the farmer. Buy at farmers markets and they are sure to receive much more (if not all) of the profits.

Buying produce when it's in season and doing without when it's not will save you money because of the sheer supply and demand. Haven't you ever noticed the price fluctuation of blueberries? Plus, in-season products are higher in flavor and nutritional value.

Hip Hosting

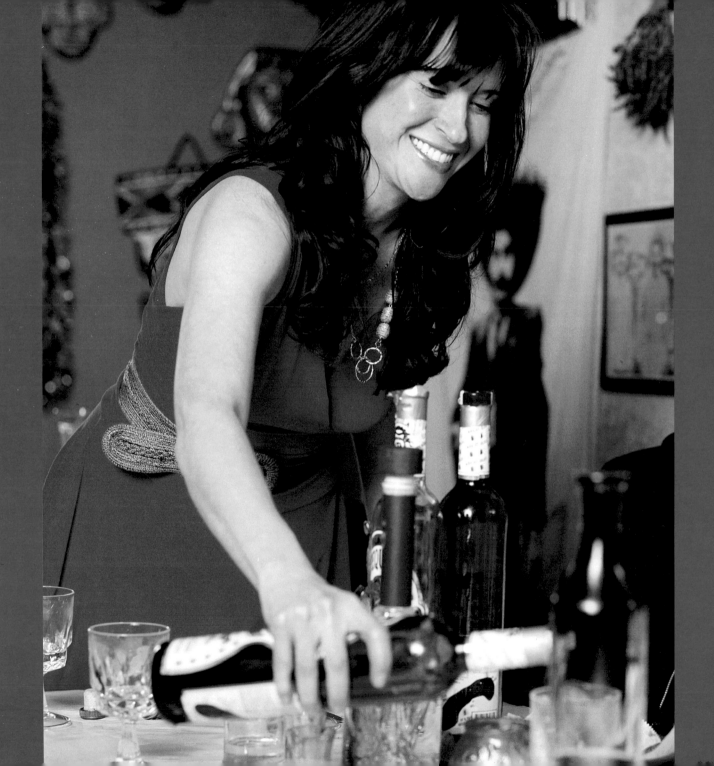

"Whether you live in a basement with the income of a ten-year-old girl or on a saffron farm in Southern Spain, the spirit of hospitality is the same: it's the giving of yourself, a present of you to them."

Amy Sedaris

While you've had much success in the past working with the theory that a good hostess only needs two parts charm and one part open bar to have a great party, you're going to have to step it up a bit now that you want to turn up the poshness in your life. I'm not talking about spending more time or more money on food, but rather refining your sense of panache—in a practical way. When in a pinch, use a little trickery.

Posh Hostess Guidelines

1. ALWAYS BE PREPARED.

You never know if a cute neighbor will stop by or if you'll get some good news: a relative won the lotto, Johnny Depp broke up with his baby-mama. So always have some *vino* or cocktail ingredients on hand. And don't be afraid to uncork that bottle of Veuve your client sent you. It's Friday; what other reason do you need to celebrate? And because man can't live on drink alone—lest you want your guests puking in your plants—be sure to stock your cupboards with noshy foods like Swedish crackers (they'll last *forever* in your cupboard), hummus, dried fruits, nuts, and cheese.

2. BE THE FIRST AND LAST PERSON THE GUEST SEES.

A good party needs a present leader, or it can be like a boat astray: Who's steering this thing? Keep the food simple so you're not stuck in the kitchen all night. Mingle, flirt, act like a guest, just don't get so drunk that you find yourself passed out in bed while the party continues on without you.

Robyn's Tip

I once invited my new guy and his friends over for a quesadilla party. Since they were all from Europe, they thought this was so imaginative. Instead of keeping it simple—wanting to impress my new *amigos*—I skipped the effortless jalapeño jack cheese or chicken versions, and opted for more gourmet 'dillas: chorizo, spinach, and goat cheese. They did turn out great; but soon enough, the hungry crowd demanded more, and I spent all night stuck in the kitchen like the tortilla maker at a Mexican restaurant. The takeaway: Less is more. Save the flash for when you have more time and help.

3. HAVE ENOUGH FOOD ON HAND

Even if it's Doritos and salsa. Don't you hate parties where the host puts out three carrots and a half-eaten container of hummus? Lauren Purcell, coauthor of *Cocktail Parties, Straight Up!*, recommends adhering to what she calls the rule of five, which means serving five types of food:

+ One heavy appetizer, like meatballs or empanadas, so people who haven't had dinner will be satiated

+ One medium appetizer, like bruschetta or mini tarts

+ One small appetizer, like veggie hors d'oeuvres or a dip

+ One light option, such as crudités

+ One bowl item, like nuts or olives

I've found it's good to spread the grub around (especially bowl items) to avoid congestion at the food table, and to make the party look bigger with clusters of guests throughout. Bringing out food throughout the night buys you time at the beginning of the evening and helps the party escalate.

4. HAVE A GOOD PLAYLIST

 I swear nothing gets a party started, or kills one quicker, than good or bad music. A couple birthdays ago I had the best party ever—strangers had sex in the backyard, a dude passed out underneath a table, we invented a dance called floor swimming—and I owe it all to my playlist. Well, that, and potent margaritas.

I like to start out nice and easy with some chill tracks from artists like Bebel Gilberto or Paris Combo. I then segue into some groovier music like The Brazilian Girls, LCD Soundsystem, or Amy Winehouse. When I want to get the party started, I break out music everyone knows—like cheesy hits from the '90s. When things heat up, I drive the crowd wild with salsa, and then for late-night booty shakin'—when the party turns into what I like to call "The Grinder"—I pull out the hip-hop.

5. KEEP YOUR BAR MENU LIGHT

No need to be fussy. All you need to serve is beer, wine, and easily mixable liquors. In the summer go for the white spirits, like vodka, gin, and maybe tequila, and in winter sub out for bottles of bourbon, rum, or scotch. If you want to go fancy, posh out on the condiments. Lay out lemon twists, lime wedges, olives, sprigs of fresh mint, lychees, and Hawaiian umbrellas. If people can't have fun with that, then they are lacking in imagination. And last but not least: Tell people to bring bottles of wine and liquor. You deserve a hostess gift. Ain't no shame in it!

Robyn's Tip

Keep cheapie frozen cheese pizzas in the freezer. You can quickly poshify with your own toppings, like prosciutto, arugula, or sautéed mushrooms, and it looks like you put in a bit more effort than you really did.

6. DITCH THE DECORATIONS.

Unless you're having a theme party (see page 74), skip the streamers and confetti and instead splurge on some nice candles and fresh flowers.

7. DO DISPOSABLE PLATES.

If you're having more than 10 people over, it's a total no-brainer, as it will expedite cleaning immeasurably. Partycity.com has 19 colors of dinnerware to choose from, and 24 plates only cost $5. If you want to be an eco-chick, check out recycline.com. Their Preserve line of plates is made from recycled plastic, is reusable, and totally affordable.

CLASSIC VODKA MARTINI

Ingredients:

Dry vermouth
2 ounces vodka, chilled
olives
lemon twists

Pour a little bit of dry vermouth into a chilled martini glass and swirl to coat the inside of the glass. Dispose of excess vermouth. In a shaker full of ice, gently swirl or stir the vodka before straining into glass. Garnish with olives or a lemon twist, and serve straight up or on the rocks.

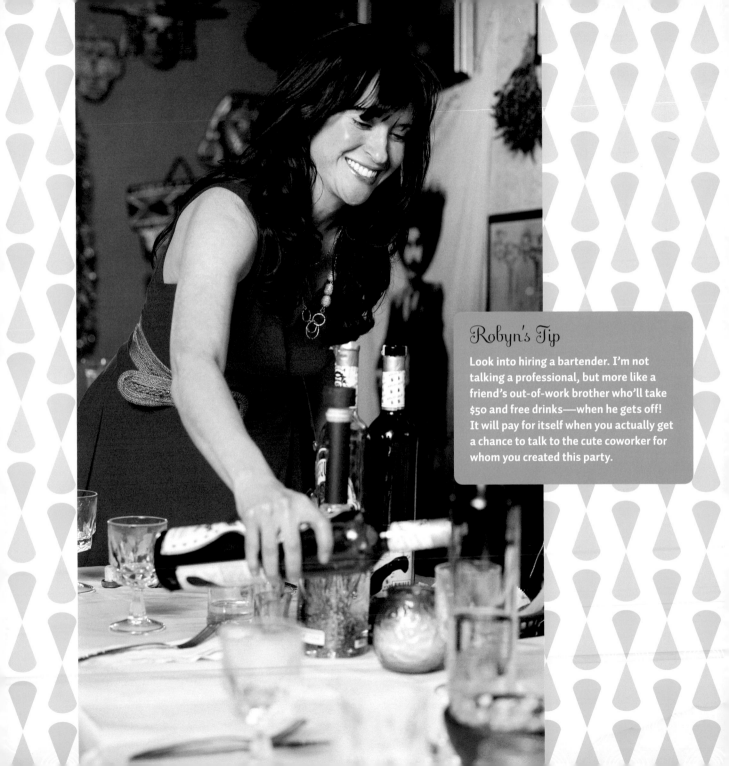

Robyn's Tip

Look into hiring a bartender. I'm not talking a professional, but more like a friend's out-of-work brother who'll take $50 and free drinks—when he gets off! It will pay for itself when you actually get a chance to talk to the cute coworker for whom you created this party.

How to power-clean your place

Pick your battleground. Guests won't be privy to every corner of your place, so just tidy up the common spaces, like the bathroom, living room, and kitchen. Shut the doors to the other rooms.

Swipe and stash
This is not the time to scrub your tub or arrange your drawers. Instead, just wipe down all surfaces: tables, counters, sink, and toilet. Close the shower curtain and hide all clothes, papers, pets, and clutter.

Spray and light
A good scent gives the impression of "clean," so spray extra-stinky spots with Febreze to neutralize odors, then light candles and essential oils, or incense—if you must.

Hide your valuables
You know your nutty-but-life-of-the-party friend is going to show up with some weird or shady characters. Stuff your jewelry box in your hamper, put away any fragile collections, and hide all your really good wine and liquor.

Cordon off your place
If you don't want people to smoke in your *casa* or shag in your bed, you better lock doors or post "keep out" signs and let the heathens fend for themselves.

Robyn's True Tale

I was once dating a wine salesman who let me have a party at his great apartment while he was away. Being generous, he left me several bottles on his kitchen table saying to enjoy, but with one caveat: Please don't touch any of the bottles in his wine cooler. *No problemo!* Well, soon enough, the party was jumping and the wine was waning, and boozers found their way into the coveted cooler. Ahhh! Luckily, I intercepted the bandits (one of whom was my sister!), but not before they had opened two bottles of wine so valuable that the labels were numbered, as this vintage was very small. To add unbearable insult to injury, the thieves didn't even savor their spoils, but instead used the wine to make sangria. Animals! I tried in vain the next day to replace the bottles, but to no avail. Luckily the dude was forgiving and for future parties I knew to throw a tablecloth over the cooler.

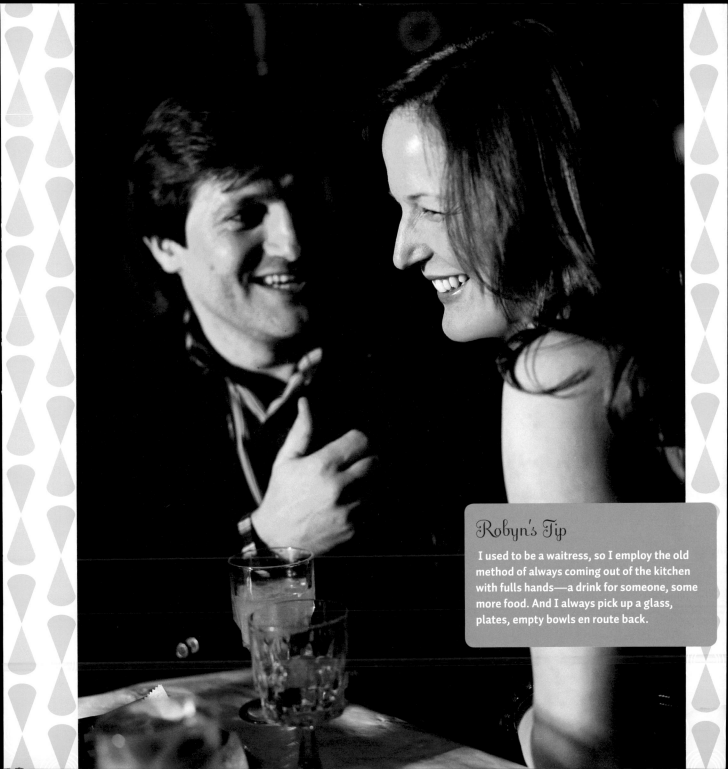

Robyn's Tip

I used to be a waitress, so I employ the old method of always coming out of the kitchen with fulls hands—a drink for someone, some more food. And I always pick up a glass, plates, empty bowls en route back.

DIFFERENT TYPES OF

Affordable Fêtes

THE BRUNCH

Hosting an afternoon shindig always adds an extra layer of cheer, as how fun (and carefree!) is it to drink during the day? What is especially good for *you* is that you don't have to spend nearly as much on liquor, since most people tend to get drunker during sunlit hours, and they tend to limit themselves, as they might have a later engagement.

For the menu, simply serve a Quiche Lorraine or a Spanish Tortilla (see recipe in Chapter 2), a mixed green salad that you can dazzle up with pine nuts and feta, and muffins or scones (homemade or bought) for the sweet-tooth brigade. Serve coffee, juice, mimosas—made with sparkling wine—and spicy tequila sunrises.

Soundtrack: Put it on the jazz station and call it a day.

GIRLS' NIGHT

Good friends are like any long-term relationship: you gotta spice things up every now and then. Rather than just having your babes over for a bottle of wine, why not make it a tasting party? Someone just come back from Japan? Have a sake-trying party. Someone swooning over Blue Agave tequila? Drink up and learn the difference between premium liquor and the poison you passed out on during spring break. Not only are you and your friends enjoying each other while learning, the party is affordable because everyone is responsible for pitching in.

Soundtrack: Girls just wanna have fun! Play whatever bad music you're too embarrassed to play around your man!

> ### Robyn's Tip
> **Avoid putting scented candles on the dining room table. The odors can conflict with the flavors of the food and wine. Go with tea lights instead, or use odorless candles and light essential oils in another room.**

DOABLE DINNER PARTIES

Don't let the thought of cooking a fancy meal sway you from entertaining like a grown-up. Dinner parties are a little like trying to lose those last five pounds. If you waited until you had a day off, or extra money to afford ingredients for a gourmet meal, you miss out on the fun you could be having now! Besides, most people prefer tasty food and good company to pomp and circumstance.

The menu: Anything vegetarian is great because it's super-healthy and much less expensive than meals with meat or seafood. You'll look indie and progressive, instead of cheap and hurried. This is a great time to experiment with exotic foods like Thai and Indian, which have tons of flavorful veggie dishes. Plus you'll start smart conversations about global warming, and the virtues of farmers' markets and eating locally. Another fun group food idea is fondue. Steal a set from your mom, or pick one up at a garage sale. The ingredients—cheese, bread, veggies, and cold cuts—can't really get any cheaper, and it'll satiate both the veggies and the carnivores in the group.

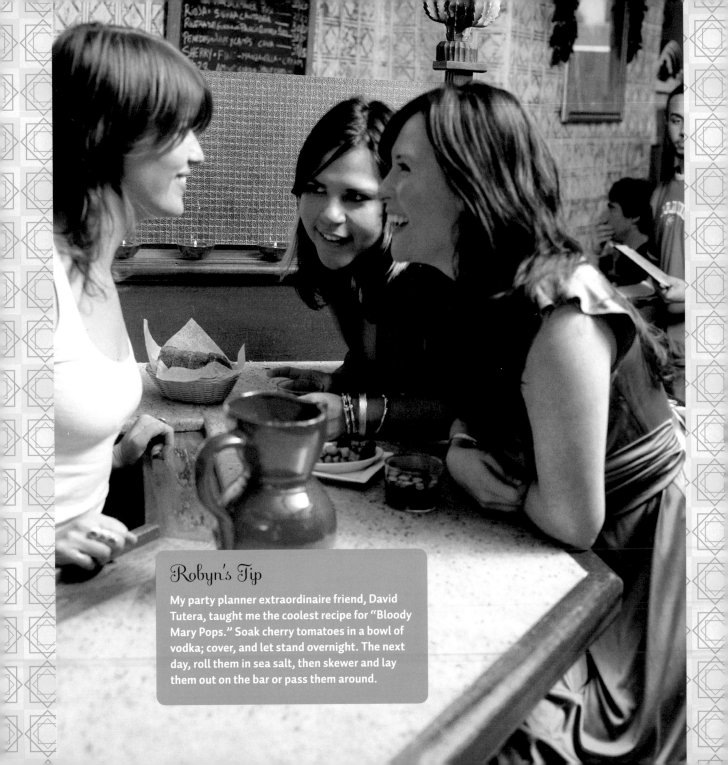

Robyn's Tip

My party planner extraordinaire friend, David Tutera, taught me the coolest recipe for "Bloody Mary Pops." Soak cherry tomatoes in a bowl of vodka; cover, and let stand overnight. The next day, roll them in sea salt, then skewer and lay them out on the bar or pass them around.

Whom to invite?

A party is only as good as its guests, so planning wisely makes a big difference.

The party boy/girl: Your ADD hilarious friend can always be counted on to keep the party flowing with his or her zany tales and quick retorts. The only problem is you have to stock up on extra booze.

The singles: Isn't it fun to play matchmaker? Plus, you get to invite fringe friends into your circle. Who cares if they detest each other? Their awkward exchanges only make for better dinner theater.

Your mousy but sweet friend: Always early, you can put her to work. And as a teetotaler, she's a great balance for the ADD Mr. Personality above.

Your abnormally smart friend: His obscure knowledge of all things weird—from aliens to Asian porn—keeps the masses oddly entertained.

The bohemian: Even though you probably have to make her a special macrobiotic meal, she's sympathetic enough to hang out with the quiet people at the table. She can always be counted on to pull out her tarot cards after dinner.

The power broker: He'll probably talk about his work (and conquests) all night, but you know he'll bring an expensive bottle of wine, and you need him to underwrite your next project.

Robyn's Tip

In this era when people are using evite.com even for their weddings (my friend did it!), receiving a proper invite in the mail looks ultra-posh. My favorite way to keep the costs down is to buy colored stock, decorate the front, and split the message and address on back like a postcard. Sending as a postcard saves your money on postage. If you want to look sleeker, target.com has downloadable templates for all occasions.

THE DRINKS

For an aperitif, start off with sparkling wine. Because true Champagne is produced exclusively in the Champagne wine region of France, it is super pricey. However, superb sparkling wine is made all over the world, and can be highly affordable. Try Cava from Spain, Prosecco from Italy, Crémants from the Loire and Alsace regions of France, or sparklers from California, Oregon, and even New Mexico; all of them can be found for under $20. At dinner, serve wine—it goes better with food than liquor, and you'll save cash on designer spirits.

DESSERT

The kind of dessert I serve depends on the amount of time I have. A free Saturday afternoon I can whip up cupcakes—red velvet are always a hit. Another easy party fave are chocolate chipwiches. I just throw some instant cookie dough into the oven, soften the ice cream in the microwave and stuff! What's forgiving about these is that if they fall apart you have a parfait! If I'm too busy to bake, I break up bars of chocolate and serve on a plate with store-bought cookies. (Carr's Ginger Lemon Cremes are particularly lovely.) An instant petits fours plate.

DID YOU KNOW?

Wine is usually served too hot or too cold. The quick rule of thumb is to take white (not Champagne) out of the fridge 10 minutes before you serve it, and put red in for 10 minutes before serving. (If you have a mediocre bottle of wine, serve it well chilled, since the warmth will highlight the flaws.)

Robyn's Tip

A study in England found that taurine (the main ingredient in Red Bull) may actually help protect the liver. Maybe that Red Bull and vodka wasn't such a bad idea after all.

Hangover cures

People came, you partied, and now your mom is coming for brunch in two hours—Help! Try one of these remedies.

1. The night of, alternate drinks with a glass of water. Yes, this is totally easier said than done, but prevention is the best medicine.

2. Keep vitamins and aspirin next to your nightstand so you can pop some before you go to bed.

3. If you wake up feeling like you just got run over, steady yourself and head to a boozy brunch.

4. Eat the greasiest dish possible.

5. Sleep.

HANGOVER TIPS FROM AROUND THE WORLD

South Texas: Menudo. This spicy soup made from cow tripe and hominy (whole corn kernels) is supposed to help ease the pain the tequila wrought.

Poland: Pickle juice. Slurp down several glasses throughout the day. The infusion of salt may help with hydration, or the overbearing sourness may distract from your pounding head.

Brazil: Coconut water. The juice from fresh green coconuts is filled with electrolytes that will nourish your beaten body. How Blue Lagoon! Leave it to the Brazilians to come up with such a sexy cure.

England: A full English breakfast. Baked beans, bacon, toast, sausage, eggs, and tomatoes. Hmm, kind of makes me queasy, but England is famous for knowing how to put away a pint. Maybe they're onto something.

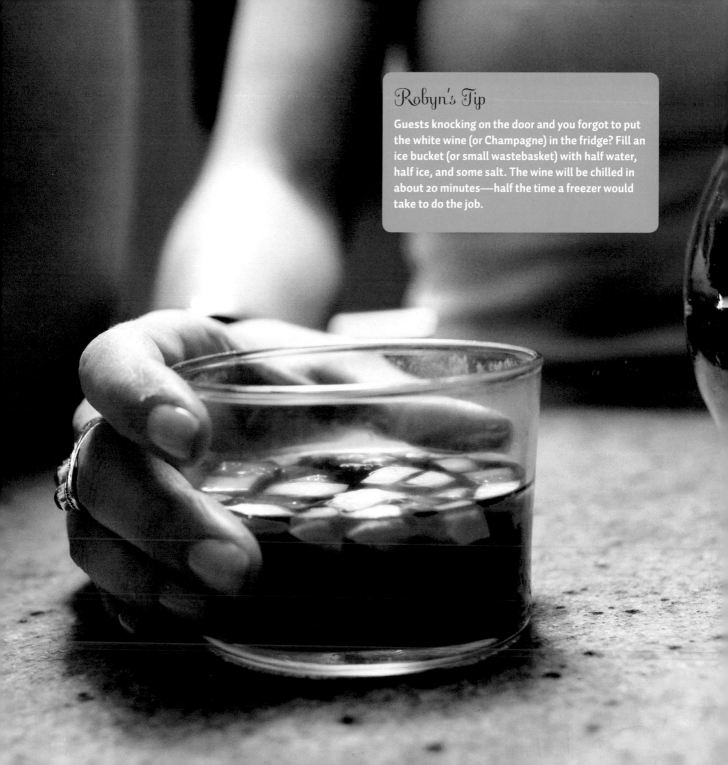

Robyn's Tip

Guests knocking on the door and you forgot to put the white wine (or Champagne) in the fridge? Fill an ice bucket (or small wastebasket) with half water, half ice, and some salt. The wine will be chilled in about 20 minutes—half the time a freezer would take to do the job.

Three Theme Parties

Who said theme parties were cheesy? Okay, maybe they are, which is why you only need to have three a year.

CHINESE NEW YEAR'S PARTY

This is a perfect way to celebrate New Year's with your friends after you've all gone your separate way for the holidays. Always held in late January or early February, celebrating the Chinese New Year is also an ideal way to break out of the winter doldrums.

The menu: Don't be afraid to order from your favorite Chinese takeout—it's cheap and you get a lot for your money. Symbolism is key at your Chinese feast. Poultry and fish symbolize happiness and prosperity. Order chicken and shrimp dishes, and place them on lettuce leaves for P. F. Chang–style appetizers. Dumplings symbolize wealth, so serve wonton soup to warm up the winter night. Oranges signify wealth and good fortune, so serve sesame beef with oranges. Noodles represent longevity, so enjoy veggie and chicken lo mein as a side dish. Serve the dishes on family-style plates.

Decorations: Find cheap decorations at your local Chinatown, or visit online Chinese purveyors like www.PearlRiver.com, www.OrientalTrading.com, and www.PlumParty.com. Because whole fish represent abundance and extra-good luck, place fun gummy fish on everyone's plate.

Drinks: Inexpensive Riesling goes swimmingly with Asian food. Beer is always a no-brainer.

Soundtrack: Download some songs from Chinese pop stars like Jay Chou, S.H.E., or Jolin Tsai.

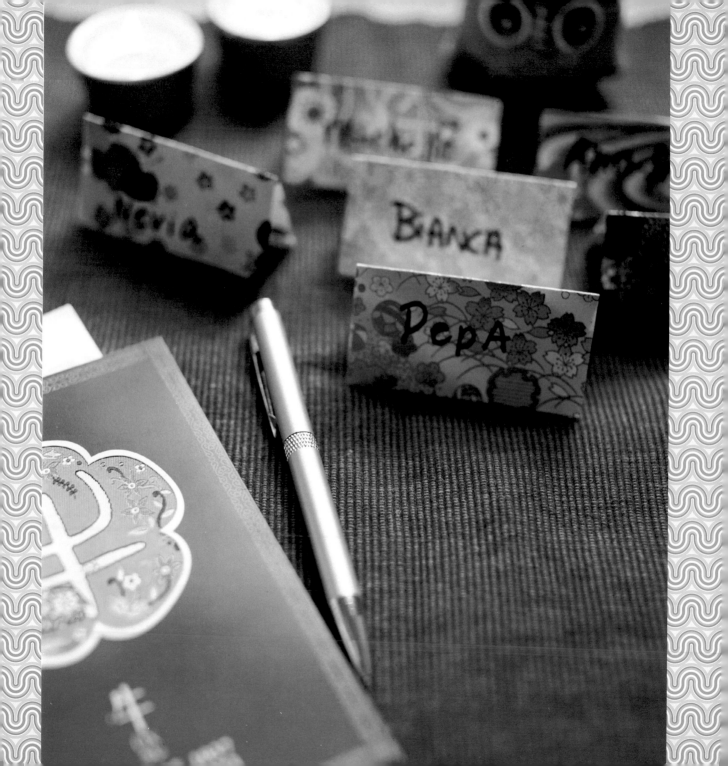

SUMMER TAPAS

Celebrating your first tiny apartment? Have a tiny tapas party and welcome guests with hot and cold foods. This theme is perfect in July, when the bulls run in Spain and the weather warrants some sangria.

The menu: Buy yourself time by first offering cold tapas like roasted red peppers, olives, *jamón serrano*, and Spanish cheeses. Later bring out hot dishes like skewers of beef, chicken, or shrimp with yummy Manchego stuffed mushrooms. My friends Carolina Buia and Isabel Gonzalez wrote a gorgeous book called *Latin Chic*, and this is my favorite recipe from the collection.

Decorations: Almodóvar movie posters, castanets, hang a red sheet from a tree and run through it screaming olé!

Drinks: Keep your bar *tranquilo*, and serve red sangria and white albariño.

Soundtrack: Manu Chao, Ojos de Brujos, and old school Julio Iglesias.

RED WINE SANGRIA
(Serves 12)

Ingredients:
3 bottles red wine
½ cup sugar
2 cups gin
1 bottle sparkling water
1 can of frozen lemonade
2 lemons, cut in chunks
2 oranges, cut in chunks

Directions:
Pour the bottles of red wine into a pitcher and stir in sugar with a wooden spoon. Then add the ingredients in the order they are listed and stir again. Pour over ice and serve!

MANCHEGO CHEESE STUFFED MUSHROOMSS
(Makes 32)

Ingredients:

32 cremini or white button mushrooms
1 tbsp. unsalted butter
1 shallot, minced
Salt and pepper
⅛ tsp. grated nutmeg
6 oz. Manchego, coarsely grated
¼ cup breadcrumbs

Directions:
Wipe the mushrooms clean with a damp towel. Trim and discard the bottom of the stems, about ¼ inch. Gently detach the remaining stem from the caps and finely chop these.

Preheat oven to 350°F.

Melt butter in saucepan over low-medium heat, add mushroom stems and shallots and sauté for 7 minutes, until shallots are translucent and mixture is dry. Add salt, pepper, and nutmeg. Let mixture cool.

In a small bowl, combine mushroom-shallot mixture with cheese and breadcrumbs. Fill mushroom caps with mixture. Place on baking sheet and bake until cheese has melted and tops are golden brown, 10-15 minutes. Serve warm.

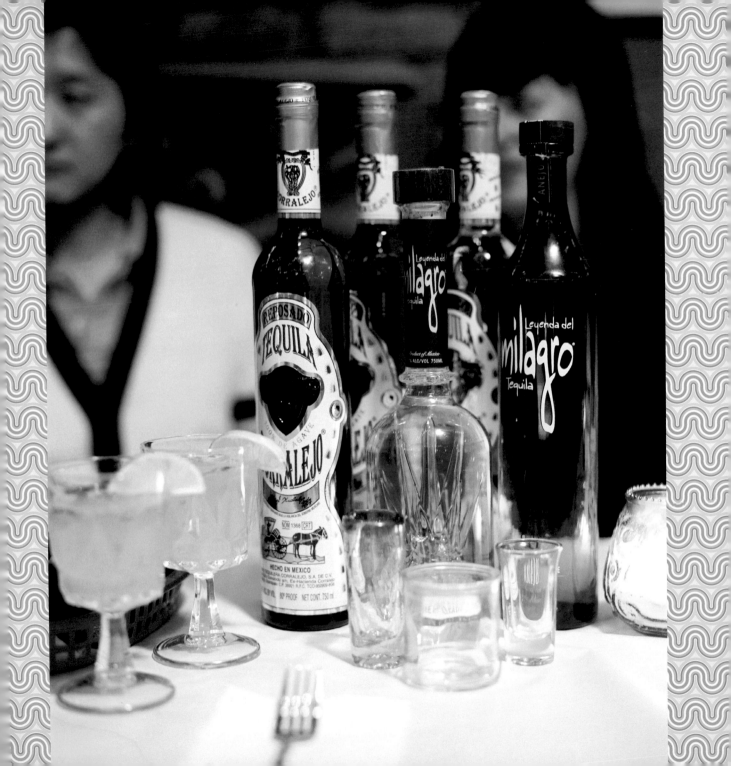

MEXICAN INDEPENDENCE DAY FIESTA

Forget Cinco de Mayo and instead have a 16th of September party! This is the holiday most Mexicans actually celebrate, so you'll look like an expert. Not to mention you'll be dying for a party once you're back at work after the summer holiday.

The menu: In lieu of guacamole, which can be expensive and can turn brown quickly, make a flavorful dip of black beans and corn to serve with chips.

For your main course, take things easy and create a taco bar. The DIY setup is beyond easy, superfun for your guests, and you get more time to mingle and savor some margaritas.

Taco bar fixings:

Cooked and seasoned ground beef

Cooked and seasoned ground turkey

Grated cheese

Shredded lettuce and diced tomatoes

Pickled jalapeños

Flour and corn tortillas

Salsa (see recipe in cooking section)

Serve with a platter of instant rice to look like your abuela made it, and you're done!

Decorations: Throw a serape on the couch. Now's the time to pull out all your kitschy Mexican folk art. Display three clear vases. Add red food coloring to one vase, green food coloring to another, and keep the third clear creating a Mexican flag. Let Frida adorn the walls, and *por favor*, get a piñata!

Drinks: Margaritas, what else? Splurge on a fancy bottle of tequila, like Milagro or Don Julio.

Soundtrack: Selena, Café Tacuba, or a compilation of mariachi songs from Vicente Fernández.

CHAPTER 4

Workin' It

"Work is either fun or drudgery.
It depends on your attitude. I like fun."

Colleen C. Barrett
PRESIDENT OF SOUTHWEST AIRLINES

I've been working since I was 13 years old, when I scored my first job as a checkout girl at the La Fiesta supermarket in San Antonio. Bagging my friends' and their parents' groceries was certainly no party, but receiving my first paycheck and promptly spending it on Guns N' Roses tickets made it all worthwhile. Oh, sweet job of mine! Since then, I've had a string of positions, some enjoyable (hotel concierge), others exhausting (waitress at Planet Hollywood).

I learned invaluable skills (like how to carry four plates full of hot food at a time—I always gallantly offer to help at dinner parties so I can show off my moves), I made great friends, and I met memorable characters, but most important, I made a living.

Even though practically posh babes are rich in resourcefulness, a lady's got to have some dough, yo. To get our due share, we have to ante up the labor. But remember, the practically posh clever girl's motto is to work *smart*, not hard. That doesn't mean you won't have to spend long hours on projects or deal with nitwits who drive you nutty. What it does mean is that you will always be working toward a goal, and *always* in a way that benefits you. Because if work is what we spend almost two-thirds of our life doing, can't a girl have a little fun?

Playing the Game

HOW TO GET PROMOTED

So you've scored a job, have been busting booty for a while, and now you're ready for some posh recognition. In a frenetic workplace, you're going to have to toot your own horn, lady.

"Women tend to downplay their successes, and that impacts their promotability," says Caitlin Friedman, coauthor of *How to Be a Boss Without Being a Bitch*. As women, we've been taught to be demure, but being modest will get you nowhere in the workforce, missy, except passed ov-ah. Step up your game and learn to bask (or at least be comfortable) in the spotlight. Speak up at meetings, suggest—or better yet—implement a new policy that streamlines office procedures. Make yourself invaluable to your boss. Be überorganized when she can't even use Excel, and take enough initiative that she sends you to business meetings by yourself. A good rule of thumb is that you're ready to be promoted when you've already mastered the job above you.

WHAT TO KNOW BEFORE ASKING FOR A RAISE

This is one conversation that you don't want to wing, so be practical and plan well for it. Some things to consider: Is your company in good enough financial shape for you to get a raise? How long has it been since your last raise? It's conventional wisdom that the perfect time to ask for a raise is right after you've come off a huge success and everyone thinks you're the bee's knees. So wait for your glory moment, then strike.

When making your spiel, be specific. It's OK to be proudly posh when outlining your achievements, but be practical when noting the monetary value you've brought to the company, the market value of your job, and exactly what you want in terms of title, position, and maybe more vacation time. They'll appreciate your forthrightness. It's much more effective than just walking in and complaining about your lousy position or salary.

And be assertive! You've shown your worth. As Deb Condren, author of *Am.bitch.ous*, says, "Make 'em pay, don't give it away."

The importance of negotiating

According to the book *Women Don't Ask: Negotiation and the Gender Divide* by Linda Babcock and Sara Laschever, women who consistently negotiate their salary earn at least $1 million more during their careers than women who don't. And 20 percent of women say they never negotiate at all, even when they know they should.

Okay, forgive me for summoning Dr. Phil here, but we teach people how to treat us. So, if we don't ask, how will we receive, pray tell? I was working as a Web editor at a magazine, which was a fun but insanely busy job. Because we were so understaffed, I was not only writing and editing, but producing photo shoots, creating Web videos, and serving as the spokesperson for the entire magazine. I was working easily 50 hours a week, and on nights and weekends. The intense pace was grueling, but what really gnawed at me was the fact that I couldn't do all the parts of my job really well. I was certainly getting the job done, but I found that the aspects I particularly enjoyed, like doing TV segments or producing great stories, were suffering because of the day-to-day minutiae I was handling—tasks I felt I was too senior for.

I did hire an assistant (read: intern), but was still dissatisfied. I was going against my practically posh mantra. I was working way too hard and not strategically or smart at all. I was going to need a raise. I started researching competitive salaries, when it occurred to me that what I really wanted was a lighter workload, not more money. So my focus switched. Confidants informed me that to cut back on hours is even harder than getting a raise, and many trusted friends and colleagues were skeptical. But I couldn't get past the idea that I would be truly happy, and a better employee, if I were able to pursue the parts of my job at which I excelled—the duties

no one else in the company could do as well as I—and forgo the assignments others could do easily as well, if not better. I mulled this over for weeks, and finally my day of reckoning came after a confrontation with my boss about turning an assignment in late. I finally confessed that I was overworked, essentially was doing the work of two positions, and I wanted to switch to part-time. Instead of throwing something at my head like I imagined, she totally agreed with my proposal and asked why I hadn't come to her sooner. Not only did I negotiate to work part-time *from home*, but I was also able to keep my 401(k).

It's posh feeling when you finally open your mouth and ask for what you want—and often *need* to stay sane—whether it's a promotion, raise, time off, or just a lightened workload. And it's not about playing hardball, though I admit the ability to walk away from something if you don't get what you want does make you bolder. Really in the end it's about asking for what you feel is fair and respectful. *Pink*, a women's business magazine, found that nearly half of the 2,400 women surveyed had not asked for a raise, additional benefits, or a promotion in the past 12 months. And alas, they're missing out, because 72 percent of those who did ask got what they wanted, according to the survey. Don't be a negative statistic! Be a positively posh ass-kicker. So ask for what you're worth! And after you've celebrated your raise or promotion, big shot, start preparing for the new challenges ahead.

Taking advantage of your employee benefits

From free language lessons to tax-free designer glasses, discounts on museums, and sporting events, there are loads of practically posh perks you should be enjoying. If you have to work for the man, *love*, make him work for you.

1. DIG FOR DISCOUNTS

Stay at your desk one day and flip through your employee benefits manual. I bet it yields some intriguing possibilities. I worked for a French company that offered to pay 80 percent of the cost of French lessons at the local cultural center. *Très* cool! Through my company, I also received free admission to stellar museums for me and a guest, and discounted tickets to the ballet or opera. If you're a fitness hottie or hope to jump on the bandwagon, most employers partner with a health club to offer a corporate discount. Some corporations even offer on-site gyms or child-care centers, so those should definitely be utilized, if applicable. If you work for a retailer, family discounts are helpful and always welcome, especially around the holidays. Ring up your HR person for any clarification you might need on programs or incentives, and ask her if there are any others you're not aware of. Don't pussyfoot around, lady. You are *entitled* to your benefits. Demand she give up the goods! Cultivate a relationship with your HR person to find out what your company has to offer.

2. GET FRIENDLY WITH FLEXIBLE SPENDING

Flexible spending accounts let you set aside pretax earnings for important expenses like health care, prescriptions, day care, and transportation. The way a practically posh babe benefits by enrolling in this plan is that you don't have to pay federal, state, or FICA taxes on the money that you designate for these plans. This could potentially save you between 15 and 40 percent (depending upon your tax bracket). So basically, at the beginning of each year, you let HR know that you want, say, $2,000 set aside in your flexible spending account. You then use that money for co-pays at doctors' visits, bus passes, toll fees, prescriptions, and anything else allowed in your company plan. You submit your receipts to your HR at the end of each month, and get reimbursed from your flexible spending account. It is very important you use all the money you've allotted, as many companies have a "use it or lose it" policy. So at the end of the year, if there is anything left in the account, your employer gets it, those buggers! But as long as you stay organized, it's a huge pocket-friendly perk. My friend Anne used her flexible spending for LASIK eye treatments and approximated that she saved about $600.

USE YOUR FREE TIME WISELY

Most companies offer some kind of tuition reimbursement, whether it's in a field related to your job or not. Working this program is one of the smartest things a p-squared girl can do. If you've resigned yourself to sticking out this job for two years, doesn't it make sense to increase your market value in the meantime by taking night classes or earning a degree? If you've been at your company a while, look into sabbatical opportunities where you can take a year off—paid or unpaid—to travel the world or to just take a break. It's also important for you to take all of your vacation days (a third of American workers don't), since more and more companies are switching to a "use 'em or lose 'em" attitude. If you find that you won't end up taking all your vacation days, inquire, if your company has a "shared leave" program. This policy allows you to donate unused personal, vacation, or sick days to someone who has used all of theirs but needs them for unusual circumstances, like an illness in the family.

GET SPECIAL 401(K)

Every financial guru tells us to invest in our 401(k), and they are totally right. My friend Carmen Wong Ulrich, a financial expert (and total fox) actually calls this the "magical 401(k)," because investing in one, and having it matched by an employer, is essentially free money.

For those of you who might be unfamiliar with this program, a 401(k) allows you to save some of your earnings so you can build your own retirement fund. A wonderful benefit is that most companies will match your savings after you've been there a year or so, doubling your nest egg.

If you're unsure how much to contribute, commit to at least the percentage that your company will match. To get an idea of what different percentages of contributions will do to your take-home pay, check out a financial calculator at www.choosetosave.org. If you haven't started investing in your 401(k) yet, stop kicking yourself and start saving.

THE NEW AND IMPROVED 401(K) ROTH

A new, often more beneficial option, is to enroll in 401(k) Roth. So check out if your company offers them. Unlike traditional 401(k) plans, which are funded with pretax dollars that grow tax-free until withdrawn, a Roth 401(k)'s earnings are tax exempt, and are funded with after-tax dollars. So participants pay taxes on the income contributed today in exchange for tax-free withdrawals at retirement.

DID YOU KNOW?

A third of all workers do not participate in their employer's 401(k), and 20 percent don't contribute enough to get the full employer match.

(Source: Hewitt Associates, benefits consultants)

Robyn's Tip

While team building at a bar can be beneficial—maybe your shy coworker will come out of her shell, or you'll discover that your earnest assistant actually has a sense of humor—moderate your drinking. You want your team to respect you, and there is nothing practical or posh about dancing on the bar or snogging the bartender in front of your employees.

Why can't we be friends?

Professionally progressing faster than your friends is a very sticky situation, and also one that most of us will find ourselves in—usually, we become good friends with the people we work with. I've seen people handle this badly: They try to be "cool" (and, frankly, unprofessional) with their friends and coworkers. It can end up costing them their job. The reality is that your job *has* changed and you can't pretend otherwise. But if everyone does their work and gives mutual respect, all should be fine.

HOW TO DEAL WITH A BAD BOSS

We've all had them. Whether insecure, passive-aggressive, or just plain socially retarded, bad bosses suck, and can seriously affect your job performance.

Ask yourself if this is something you can live with or if you are learning enough in your job to make the pain and crying at your desk worth it. If you can't, then you need to start looking for another job pronto, or at least inquire about moving to another department. If you have an enviable job or if you want to wait it out a year, try to come in early, stay late, and work as hard as possible so she has nothing to reproach you for. It's also good to take lots of yoga classes and come up with your own morning mantra, like, "O Divine Light, please give me the strength to handle the evil dragon lady today. Let me have compassion, as she has awful style, is not cute, walks horribly pigeon-toed, and hasn't had sex in five years. *Namaste!*"

HOW TO BE AN EFFECTIVE BOSS

More than Friday after-work happy hours (beware) or midafternoon cupcakes, employees crave recognition above everything else. So be generous with praise when someone does a good job. E-mail your boss about an employee's merits and CC the employee on it. Also, when assigning tasks, be crystal clear about what you want, how you want it done and when it is due. Setting clear expectations makes things easier for everyone. If you don't offer any direction, then it's not fair to be unhappy when your employee turns in something you're unsatisfied with. Your employees shouldn't have to guess what you need from them. Most of all, don't settle for mediocre work. If you expect the best from your team, they will start delivering. If you settle for less, your team will begin to lack motivation, and the results will be disappointing.

HOW TO FIRE SOMEONE

Letting someone go is one of the hardest parts of management. Unlike Ari Gold from *Entourage*, who relishes making people cry, taking away someone's livelihood is no small deed, even when people bring it upon themselves.

1. Always make a case and keep a documented list of infractions so that you're covered and have written proof that you are doing the right thing. If you work at an office, contact human resources and let them know the situation, as verbal and written warnings are usually handed out first.

2. Talk to the employee about their problems when they first arise. Many times it can be good to clear the air and give someone a chance to be heard. If the unacceptable work persists, it's time to make them walk the plank.

3. Don't try to sugarcoat it with the "it wasn't a right fit" speech. Instead, be specific about what you were unhappy with. This will hopefully allow someone to learn from their mistakes, rather than leave the company thinking she'd been treated unfairly and was the victim of a witch hunt.

4. Know that you're doing the right thing: for your company, for the person getting fired, and for you. A practically posh boss develops her leadership skills in good and in bad situations.

HOW TO HANDLE GETTING AXED

I have been fired before. The causes range from that time I got fired for being late to my job as a legal intern to being laid off because of company cutbacks. Either way, I ain't gonna lie, it's an ego blow. But when you're down and out is the *exact* moment when your self-preservation kicks in, when you find out what you're made of. Play the theme from *Rocky* in your head and start plotting your comeback. There is nothing more American than a great redemption story. From Star Jones to Bill Clinton, we love resilience. Besides, getting fired is often the universe's way of telling you that you should be doing something else, so take that severance check and journey to Bhutan. Need inspiration? Here's a list of famous people who have been fired:

Vanessa Williams was dethroned after being crowned Miss America; she rocked a decade-long singing career and is now on one of the hottest shows in TV and will soon have a multimillion-dollar cosmetics deal.

Marc Jacobs was fired from Perry Ellis, but now is arguably the hottest designer in fashion.

Comedian **Bill Maher** was famously fired from ABC after remarks he made about the World Trade Center attacks; now he has a thriving uncensored show on HBO.

Madonna was fired as the hatcheck girl at New York's Russian Tea Room because her downtown style of dress didn't fit their uptown image; now she's the embodiment of confidence and style, and fierce as ever at almost-fifty.

Robyn Moreno (I'm not really famous, I just wanted to be next to Madonna) was fired from The Limited store in high school for calling in sick to go to a party. She's now a successful author and journalist. Take that Marty Valdez, and your perfectly folded Firenze sweaters, too.

J. K. Rowling was fired from a secretarial job because she was found writing creative stories on her computer. She used her severance to write *Harry Potter and the Sorcerer's Stone* and is now a gazillionaire.

How do you know when you've outgrown your position?

If you can do your job blindfolded and are no longer being challenged professionally, then it's time to think about bouncing.

TOP FIVE WAYS YOU KNOW YOU'RE READY TO GO

1. Your employer constantly busts you for checking out job-recruiting Web sites.

2. You can't seem to tear yourself away from the fourth hour of the *Today* show, so you keep getting to work later and later.

3. You spend your day looking for good airline deals instead of completing the project that's due at the end of the afternoon.

4. You complain so much about your job to your coworkers that they run when they see you coming down the hall.

5. You keep screwing up at work, hoping to get fired so you can claim unemployment.

TOP FIVE EXCUSES FOR CALLING IN SICK

1. **Foodpoisoning.**
 Always works. It goes away quickly and is icky enough that no one bothers you.
 What it really means: Hungover.

2. **Stuck in airport.**
 Fairly viable, especially if the weather is bad.
 What it really means: You want to keep shagging your new long-distance love.

3. **My dog is sick.**
 Somehow, this elicits more sympathy than ill children.
 What it really means: You need the day for beauty appointments and errands.

4. **A leaking ceiling or bathroom.**
 If not used often, totally possible.
 What it really means: You want to hang out with a visiting friend or relative.

5. **Flu/Cold.**
 Pretty generic, but you muster up a sniffle.
 What it really means: You have a new job interview.

> Everything starts
> as somebody's daydream.
>
> *Larry Niven*

Moving up, Moving on to your dream job

JUST DO IT

I was so miserable at one of my office editing jobs, my coworkers started avoiding me because all I would do was complain. Now, I have a theory. When you're unhappy and want to change something, the first step in the right direction is to vocalize your dissatisfaction. Initially, it's good. You start sounding things out, and seeking advice. However, you can't be all talk. You have to get to a moment of action.

DO WHAT?

So now you know you want to leave your present job, but where to go? Meredith Haberfeld, personal coach and owner of the Meredith Haberfeld Coaching, actually suggests staying put for a while. "The best way to start moving toward your dream job is to do great work in your existing job—starting now," says Haberfeld. While that sounds totally counterintuitive, not to mention totally *loco*, since, hello, you want to *leave*, not stay, look at it like a relationship. You have to dig in and work a bit harder, so when you leave you'll have the peace of mind of knowing you gave it your all. It's the difference between being given a party on your last day and being escorted out the door at 5 p.m. sharp, if you know what I mean. And who knows, maybe you'll be such a star that you'll get a raise, or when you land another job, your boss will counteroffer. And then you can gleefully tell her no.

Homing in on your dream job

If you're unsure exactly what you want to do, try writing down all the possible dreams that have crossed your mind. Go ahead, throw in a contestant on *Dancing with the Stars*. Write down dreams that have been talking to you for years, but that you keep ignoring because they're silly sounding, or maybe because you're scared.

After you have your list, rate them in order of passion: which you want the most, and which you're most willing to work for. Now pick your top five and write down *why* you want these jobs. I had a friend who kept saying she wanted to own her own store, but when I asked her why, instead of saying she loved to design, or loved being creative, she said, "So I can wake up late, hang out with my friends, and be known as the cute shop girl." Nowhere in this scenario did she actually conduct any kind of business in the store, she was just besotted with the image of herself as chic entrepreneur. Now, I have friends who actually own retail stores; I promise you it involves much more than just hanging out in cute clothes all day, waiting for *Lucky* magazine to come do a story on you.

CLASSES AND APPRENTICESHIPS

I am a big proponent of taking classes in the field you're interested in. Whether it's cooking or fiction writing, you'll find out quickly if this field is posh or poppycock. Another good resource is to apprentice in your desired career. Most people are amenable to hiring seasoned professionals for entry-level positions, as they value the experience and, frankly the maturity level. My cousin Deb decided to switch careers after years of running a successful restaurant in New York City, so at the ripe age of 40, she went to work as an assistant at a real estate firm, a profession she found to be both very woman- and age-friendly. She worked long and hard learning everything about the real estate market, attending after-work functions and mixers when she just wanted to go home to her kids, and even sacrificing to work one Mother's Day at an open house because everyone above her in the firm wanted the day off. Her doggedness paid off, and she's now a thriving real estate agent.

THE IMPORTANCE OF FOCUS

I know a lot of women who envision themselves as chefs, lawyers, musicians, and poets simultaneously, and then they have a hard time choosing one profession. While it's admirable to be a Renaissance woman, all too often you spread yourself too thin. Rather, I think being great at something requires constant practice and consistent attention. I read a great article in *O, the Oprah* magazine, in which Mira Nair, the director of *Monsoon Wedding* and *The Namesake*, recalled learning a valuable lesson from her sitar teacher. As an adolescent, Mira wanted to do everything: paint, write, *and* be a world-famous sitar player. Luckily, her parents supported her and paid for her sitar lessons. Well, it turned out that because of all her hobbies, her sitar playing wasn't totally up to snuff. Her teacher told her, "To be great, Mira, you have to possess great focus." After receiving this gem of wisdom, she chose filmmaking as a career and kept with it, even when she wasn't getting work. Instead of quitting during an especially unsuccessful time, she decided to create her own project about a club in India whose members' sole purpose was to get together and laugh. Her documentary, *The Laughing Club of India*, was well received, and she garnered the attention of producers who were looking for a director for *Monsoon Wedding*. She was hired, and then became the director of one of the top-ten grossing foreign films of all time.

WHY IT'S GOOD TO BE AMBITIOUS

Way too often, ambition is perceived as a bad word. We women tend to downplay our desire to succeed by calling ourselves "motivated" or "aspirational." These play-it-safe adjectives are, frankly, generic. Every girl needs a little good old-fashioned ambition racing through her veins. Did Madonna embark on a "Blond Hopeful" tour? No! She had a badass "Blond *Ambition*" tour. When it comes to getting what you want, you have to be devotedly determined and purposefully posh.

Create your own luck

I had dreamed of working at *Latina* magazine since I first read an issue when I was in college. It was genius: a lifestyle magazine focused on Latinas. I could pursue my love of fashion and travel and be able to highlight the best of my culture. I soon moved to the Big Apple. I waited tables at my cousin's Mexican restaurant, and obsessively checked *Latina*'s Web site for job listings. After two months of slinging nachos, I saw a posting for an assistant editor and decided to make a move. So I drafted a cover letter, a résumé, and, not having much else to do, I decided to drop off the application in person. I didn't know at the time what a good move that would turn out to be. I soon found myself walking into a skyscraper in the heart of Times Square, expecting to leave my package with a receptionist. Instead, the building's lobby reception let me go up to the floor where the *Latina* editorial offices were, and all of a sudden I was at a glass-doored entrance. Should I just ring the doorbell? Luckily, a cute girl walked up as I stood there clutching my résumé. "Can I help you?" she asked. I think all I could manage to whisper was "I want a job." Luckily, she heard me, then summoned another woman who again asked the obvious, "Can I help you?" I stammered that I was applying for a job I saw posted online and thrust my résumé into her hand. She simultaneously started closing the door. But thankfully she happened to glance down at my résumé, and then look back at me.

"Can you come in for a second?"

"Sure," I replied eloquently, and we went into the conference room.

"This is really weird," she said, "but I'm looking for a fact-checker. And your cover letter is really well written. Do you know how to fact-check?" she asked.

"Sure!" I enthusiastically chirped again, even though I had no idea what "fact-checking" meant. She took me in to meet the editor in chief, they offered me a job, and I started the following Monday, and within two weeks I was assigned my first article. That, to this day, is still one of the best experiences of my life. Whether it was the law of attraction, or just that I had nothing to lose, I got what I wanted.

So even if you're terrified of taking that step, move through the fear. As Woody Allen said, "Eighty percent of success is just showing up."

Seven steps for starting your own business

I interviewed a great variety of hardworking dames who had the nerve and tenacity to go after their dream job, even when everyone around them thought they were foolish. Here they share their tools for success and how they got the last laugh.

1. CREATE A BUSINESS PLAN.

"If you put things on paper, you make them happen," says celebrity-wedding planner Sofia Crokos, who left the fashion public relations world after she planned her own wedding. Crokos says her mantra is, "If you talk about something, it's a dream; if you envision it, it's a possibility; if you schedule it, it's real." What's lovely about a business plan is that it will help you flesh out your idea and make the vision of your business more concrete. What's the name of your business? Where will it be located? How much money will you need to start? All of these things will come to the surface when you write a business plan. You can download a template at www.score.org, the Web site for Counselors to America's Small Business, a nonprofit dedicated to entrepreneur education. You can also get tips from the Better Business Bureau at www.bbb.org.

There are many great how-to books that can help you with practical business information. *"Made in America* by Sue Pekarsky Gary and Connie Ulasewicz, was my bible," says lingerie designer Wendy Glez. "It taught me how to run a fashion manufacturing business. I bought all the editions."

2. WORK YOUR CONTACTS.

Oftentimes, hearing about a great job opportunity comes not from the classifieds, but from cocktail hour or conferences. In every field, from design to publishing to public relations, there exists a plethora of networking organizations where you can meet members and make those oh-so-important contacts. I met my publisher—the publisher of this book and my last one—at a meeting of Hispanic journalists.

Another stellar organization is Ladies Who Launch, a group that offers networking events, workshops around the country, and great resources for starting your own business. They have a neat program called the Incubator where you meet with a group of ten women for a month. One by one the group workshops everyone's business idea, offering advice and suggestions. Check out ladieswholaunch.com for a workshop or chapter near you.

DID YOU KNOW?

Women start businesses at twice the rate of men.

(Source: Ladies Who Launch, a networking organization)

3. CREATE YOUR OWN BOARD OF ADVISORS.

Debra Condren, the author of *Am.bitch.ous,* recommended this to me when I was stuck coming up with a name for this book. She told me sternly, "Call your friends and create your own board of advisors. Ask their opinions, get their feedback." I thought, "I like the idea of being chairman of the board, like Frank Sinatra, but I don't want to bug anyone; everyone's so busy." But when it comes to going after your dream, asking for help is not embarrassing, it's survival! So, I put a call out to my favorite ladies, and guess what? They were genuinely happy to help me brainstorm. Thanks, to my practically posh posse!

4. TRUST YOURSELF.

Beware of naysayers and haters. When you declare your dream, there will be many people telling you that you're nuts—people who are close to you. I remember when I first told my then boyfriend that I wanted to pursue a TV career. This was a big admission for me; I had kept pushing this dream aside thinking it was silly. But it felt so good to finally have the nerve to say it out loud. The response wasn't what I expected. He looked at me with doubt in his eyes, while he mumbled some feeble words of encouragement. I remember thinking, "Wow, he doesn't believe in me." It was a scary revelation. I felt like I was really on my own. But I knew what I wanted. I soon began appearing as a lifestyle expert on the most popular morning show in America so even though I was disappointed, I wasn't discouraged.

Meredith Haberfeld left her job as a vice president of a global advertising agency at age 26 to start her own personal coaching practice. Her parents—two Harvard Law School–educated attorneys—thought she was crazy. "They were like, 'What on Earth are you doing leaving a lucrative, successful business?' " she remembers. "They thought I was a moron and proceeded to tell me that for years." But she agrees: There's nothing that feels better than pursuing your real dreams, what your heart wants most. She now has a thriving coaching career and gets paid to travel to cool locales—like the Bahamas—giving seminars and workshops. Crazy like a fox!

5. DON'T EXPECT SUCCESS INITIALLY, BUT DON'T SETTLE FOR FAILURE, EITHER.

Life has an ebb and flow. Sometimes you're busy, busy, busy—networking, promoting yourself, and creating a strong product. The next thing you know, you're waiting, like a nervous hostess just before the first guest arrives. Don't stress when it seems like nothing is happening and no one's calling back. These are those frustrating times that author Lynn Robinson calls "life pauses." Take a deep breath and keep plodding along. Trust me, soon enough the phone's gonna be ringing off the hook, and you'll be pining for your downtime.

6. WORK HARD AND GET REWARDED.

Just because you've succeeded doesn't mean you can kick back. On the contrary, you'll find yourself working harder to stay fresh and competitive. "You're only as good as your last job," says Crokos. But you will find contentment in the fact that at least you are working for yourself, on projects you're interested in. And there are even other unexpected perks: Haberfeld says one of her favorite things about going after her dream job was it helped her develop the qualities she always wanted but had never possessed. So if you're a bit shy and wish you could be more charismatic, don't worry, after rounds of networking you'll be throwing out the quick one-liners and air kisses like nobody's business. Or perhaps you're a tad messy and envy organized people. "There is nothing that will make you more organized that running your own ship," says Robin Bump, co-owner of Making Milestones, a pediatric speech and physical therapy facility.

7. GIVE BACK.

Whether you accept a phone call from a fledgling entrepreneur or agree to a lunch with a girl who wants to pick your brain, this is good karma. Undoubtedly, you're standing on the shoulders of countless women who helped you in ways big and small. That said, you can certainly say "no" to annoying people or when you simply don't have enough time. Remember: Running a successful business with integrity is an inspiration on its own.

Rules for women who work from home:

- ✦ You must get dressed, at least out of pajamas and into cute sweats.

- ✦ Keep Internet dillydallying (and visiting gossip Web sites) to a minimum.

- ✦ Stay away from the fridge.

- ✦ Set work hours.

- ✦ Stay away from the fridge!

- ✦ Take an exercise break.

- ✦ Okay, take a lunch break.

- ✦ Create your own work space; don't just work on the kitchen table. It'll just make you hungry. You need a separate work area that you leave at 6 p.m. and don't have to go back to until the next day.

- ✦ Buy yourself flowers; you deserve it.

Smart Style

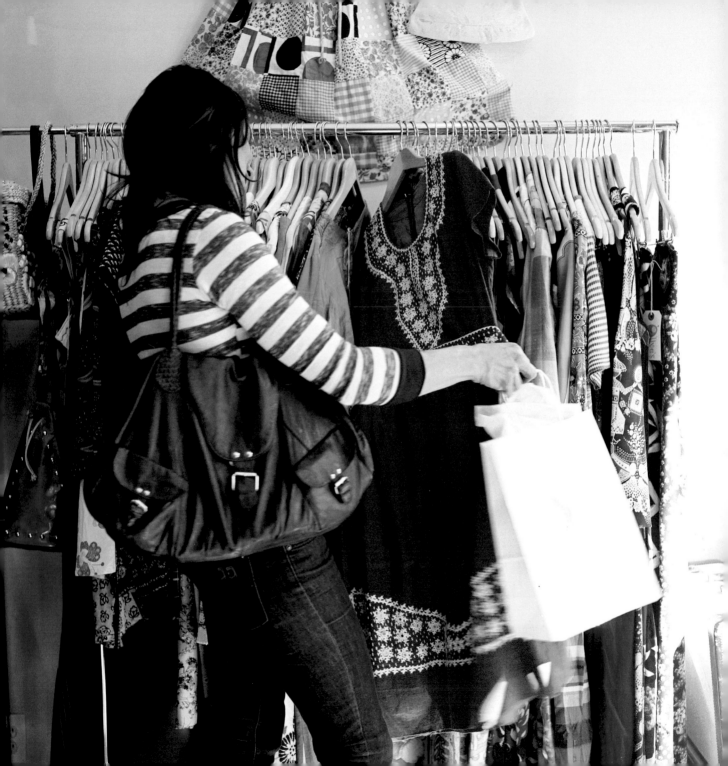

"Nothing makes a woman more beautiful than the belief that she is beautiful."

Sophia Loren

Growing up in a family of women—three sisters, seven aunts, eleven female cousins and one supremely stylish granny—I learned a thing or two about fashion. But it was my mom who taught me the best sartorial secret: style doesn't have to be expensive.

With four daughters and a middle-class income, my mom couldn't always splurge on big-name labels. But what she lacked in means, she made up in moxie when it came to stocking her wardrobe.

She frequented retailers who extended a generous layaway policy; she befriended the salesgirls at department stores who would notify her of upcoming sales, and she could spend hours at a thrift store sifting through clothes, delighting equally in pieces that were over-the-top-campy and those that whispered couture.

Rummaging through bric-a-brac and piles of secondhand clothing is where I fell in love with vintage pieces, and trained my eye to separate the cheap from chic. And watching my mom work her mojo in stores, sales, and in front of a mirror made me both a resourceful shopper and inevitably a better stylist.

Find your own style

This is the best time in the world to be an obsessed shopper. With big fashion houses creating lines for stores like Target and H&M, it's more affordable than ever for women to stock their closet with designer duds. But while we all benefit by high fashion's availability to the masses, how will we stand out from the crowd? There's nothing worse than a "Who Wore It Better!" showdown between you and your office nemesis when you both show up in the same new frock.

HOW TO DEVELOP YOUR OWN LOOK

1. Know what looks good on you and, more important, what doesn't.

It will be easy to incorporate, and bypass, seasonal trends if you know what and what not to wear. Got a big booty? Skip jeans with huge back pockets, which will only highlight your monster *culo*. Retro pinafore-style dresses are sweet, but if you're sporting an ample rack, the look will turn to dirty schoolgirl quickly. Know your body, so you can play up the best and minimize the rest. (See problem areas, page 113.)

2. Ease into it.

If you've never fancied yourself a style maven, transitioning from conservatively dressed to Kate Moss can be a big leap, and one that you don't have to make overnight.

Accessories are a great way to start experimenting with style. Add instant flair to your ensemble by donning your mom's cocktail ring or brooch at your next soiree. It may feel a little silly at first, but keep it on all night. Your confidence will rise as the compliments start rolling in. Keep test driving different pieces: preppy headbands, higher-than-normal heels, a string of pearls. You'll quickly discern what works from "what-was-I-thinking?" and have a lot of fun along the way.

3. Pay less attention to the runway, and find your own inspiration.

Following fashion can be a confusing prospect. Rather than try to keep up with what's "in" or "out"—which you can easily glean from any fashion glossy or even your own mall, since Forever 21 is the king of knock-offs—get influenced from art, movies, travel, or maybe your aunt or granny's closet. This is, in fact, how designers get ideas for their own lines. If you haven't seen *Unzipped*, the documentary about Isaac Mizrahi, rent it immediately. It follows Mizrahi as he conceives a collection that is part Eskimo-chic and part sixties-mod. His inspiration strikes after watching a 1920s movie about Inuits coupled with *Mary Tyler Moore* reruns. Cultivate your personal line and people will start taking cues from you.

4. Don't go overboard with one look or mix together too many conflicting ones.

While you certainly get an *A* for effort, wearing one theme head-to-toe is more folly than fetch. Sport the nautical look by wearing stripes or red flats, but forgo that hat, Skipper! Likewise, wearing a mélange of fashion trends at one time is overkill, and defeats the purpose when everything on your bod is competing for attention.

My best friend, Lisa, is a fashion adventurer, and has had her fair share of hits and misses. I tease her endlessly about the time she arrived for drinks wearing a denim cheerleader-cut miniskirt, black leggings, pink cowboy boots, an off-the-shoulder blouson top, a pink puffy ski vest, gold-hooped earrings, her hair in a high ponytail à la Gwen Stefani circa 2003, *and* a kerchief tied around her neck.

Only in New York can you dress like this with no one batting an eye, and as we sauntered into a sleek hotel for cocktails we spotted tennis star Serena Williams at the bar. Today Serena has her own clothing line and is notoriously fashion-forward. That night she was wearing a bootylicious, body-hugging, brightly printed dress from Dolce & Gabbana. Being big fans, we went over to say "Hi" and the first thing she did was look Lisa up and down and exclaim, "Girl, you're brave!"

5. Embrace a color.

A quick way to up the wow factor is to infuse some hues into your closet. Black is smart for sure, but color is spirited and can express a medley of moods. Feeling flirty? Think pink. A little bohemian? Lay on the lilac. And the skin-brightening factor shouldn't be ignored. Dark skin is luminescent in yellow, emerald green dazzles on fair redheads and brunettes alike, and everyone looks grand in some shade of blue. And like Bill Blass said, "When in doubt, wear red."

6. Make sure your clothes fit.

Tim Gunn of *Project Runway* says the number one mistake American women make is wearing their clothes either too loose or too tight. I couldn't agree more. I, myself, am a recovering sausage-outfit girl. Come spring, I'd walk out my door practically naked. Once I pranced out wearing a miniskirt that barely hid my bum and a shrunken tank that kept riding up my belly. Sexy! My Italian neighbor looked at me confused and yelled "Ya going to the beach?" "No, I'm going to brunch!" I breezily replied, as she watched me sashay down the street probably convinced I was looking for my next trick.

I'm not quite sure if I watched too many *telenovelas*, but my long-held motto was supertight meant slimming and sexy. It took a while for me to realize that look was really just inappropriate and uncomfortable. Here's a hint: If your shirt gapes open between your about-to-pop-off buttons when you sit, it's too tight. If your back fat and bra line is bulging out of the back of your dress, sorry, sweetie, but you need a bigger size.

No smirking, muumuu lovers! Sporting misshapen potato sacks is not attractive either. In fact, saggy mom-jeans are the international symbol of antisexy. If you're trying to hide your weight under billowing dresses and stretched-out shirts, think again, because these actually make you look bigger, *and* sloppy. Remember, clothing that shows off your body's natural silhouette, without stifling it, will always make you look neater and thinner.

7. Cop an attitude and some good posture.

My mom's performing background as a dancer gave her a love of flourishes, and her two favorite accessories were red lipstick and high heels. Even though she was only five feet tall, her four-inch heels and dancer's grace gave her a regal posture that made her seem much taller, and thinner. And paired with a killer red lipstick, she exuded easy confidence, regardless of what she was wearing.

Robyn's artistic inspiration

DALLAS

Growing up we'd pile around the TV to watch *Dallas*, and as everyone was riveted on what evil JR would plot scheme next, I kept my eyes on what Sue Ellen, Pam, and Lucy were wearing. As opposed to *Dynasty*, which was all shoulder pads and gowns, because the Ewings lived on a ranch, their look was more Texas chic: strapless dresses and cowboy boots and blue jeans with silk pin-tucked blouses. I still love this hi-lo, moneyed maverick look.

DR. ZHIVAGO

Julie Christie in her puffy white fur hat is just too much. It makes me want to move to Russia and fall in love with a count named Yuri. I think I moved to New York just so I could wear fur hats in winter. I haven't yet rocked the muff, though.

REAR WINDOW

The fifties are really one of my favorite eras: so posh and glamorous. I find the feminine silhouette supersexy: pencil skirts, tight sweaters. My sister makes fun of me because I'll wear a cocktail dress to Thanksgiving lunch. She calls me "Caller 13" because she says I'm like some weird woman who won a ticket to an event on the radio and shows up inappropriately overdressed. I don't care. What's wrong with wanting to add a little poshness to your life?

THE QUEEN

Watching this movie made me go out and buy some faux pearls, and wear my rain boots everywhere. I find this preppy, utilitarian look ironically kind of sexy.

SEX AND THE CITY/THE DEVIL WEARS PRADA

Although a lot of Pat Fields's styling is over-the-top, I do admire the theatrics of it. And when she's restrained you take notice. One of my favorite outfits of Carrie's is when Big is moving to Napa, and she comes over with pizza wearing black capris, a tight black T-shirt, and a cream wrap sweater: super, understated, and effortlessly posh. It sort of proves people don't have to be pigeonholed in what they wear.

PROBLEM AREAS AND HOW TO A-DRESS THEM

FAT ARMS: Avoid cap sleeves at all costs. The flutter sleeves that hit right on the shoulder draw eyes right to your beefy limbs. I once did a *Today* show segment, and because it was summer, I wore what I thought was a cute polka-dot, cap-sleeve dress. As soon as my appearance was over, my mom called my cell, not just to congratulate me, to let me know how huge my arms looked on TV. "I couldn't stop staring at them," was her exact quote.

Go for three-quarter sleeves, they hide the fleshy bits, but still show some skin.

FLABBY MIDDLE: Whether you just had a baby, or you're a tad out of shape, avoid looking like a little Buddha by skipping dresses that tie or cinch at the waist. Instead, pull out that oldie-but-goodie empire dress that brings attention to your slimming neck and pretty face and away from your burrito belly.

LOG LEGS AND CANKLES: Cankles are a common problem. Some women have undefined calves and ankles, making the leg one width from knee to foot. While most women with this affliction tend to wear jeans most of the time, skirts and dresses are a possibility. Pass on the knee-length pencil skirts and hip-hugging dresses that emphasize your legs and instead go for just-below-the-knee A-line skirts that flare out and minimize your gams, suggest Trinny Woodall and Susannah Constantine in their book, *What Not to Wear*.

Also stay away from ankle-strap shoes that draw eyes straight to your thickness. Try, instead, open-toed slides that extend your leg line down to your toe and wedge heels that can balance out thick legs.

SADDLEBAGS: Rein them by avoiding stovepipe jeans, which make your bum and hips look absurdly huge. Instead, go for thinning dark-wash jeans in a bootcut that balances out your hips. Also, skip on bias-cut dresses and skirts that will cling to your curves and make a beeline for A-line-cut clothing that hides your baggage.

MONSTER BOOBS: Never let the girls out without some support. Google a picture of Drew Barrymore from the 2006 Golden Globe Awards and use that as a cautionary tale. Dresses and tops with sweetheart necks are eternally flattering because they show just a hint of cleavage without looking vulgar. And try to accent your waistline with wrap dresses or belts, as full cups tend to make women look heavier than they are.

NO BOOBS: What's nice about small breasts is that you can get away with wearing trendy clothes from cheapie stores because they're often cut for teenage girls. That's some consolation, isn't it? If you want to feel more bosomy, pick up a padded bra. There's a reason these bras start with superlatives like wonder and miracle. And if you're feeling au naturel, wear a sexy halter-cut dress or top that highlights your shoulders and décolletage.

Always have three go-to outfits

Because a practically posh babe's life is built on spontaneity, make sure to have three ensembles handy so you're prepared for any sartorial situation.

1. A SEXY DRESS YOU CAN PLAY UP OR TONE DOWN.

Whether your boyfriend surprised you with last-minute opera tickets, or you received a 5 p.m. invite to a fashionable event, it's imperative to have a dress that's sexy, stylish, and doesn't require ironing, so you can throw it on and head out the door.

2. A PROFESSIONAL OUTFIT.

Whatever your poison: tailored blouse and slacks, a tasteful dress (hopefully not a matching suit), you need something that's smart so any potential employer, loan officer, or landlord knows you're someone to be reckoned with.

3. COMFY BUT CHIC CASUAL DUDS.

You're hung over and you have a brunch date in 20 minutes. Your friend pulls up proposing an impromptu road trip. You started your period but can't call in sick. Regardless of the occasion, you need an outfit that is fashionable but forgiving.

DID YOU KNOW:

Eight out of ten women wear the wrong bra size because they haven't been fitted in years. I recently lost weight, and while I was thrilled with my new svelte figure, my boobs not only shrank, but looked a little deflated. I was bothered enough that a boob job didn't seem reserved just for strippers anymore. Then I went lingerie shopping and discovered the virtues of padded bras—it was a truly enlightening experience. If you can't remember the last time you bought a bra, run, don't walk, to a lingerie or department store. Many stores, like Nordstrom, offer free fittings, so take advantage and learn what size cup and band measurement you are. They also offer great pointers about adjusting bra straps for perkier boobs, and finding a size that lies on—not digs into—your back; both slight adjustments that can make you look taller and skinnier. Check out Nordstrom.com and maidenform.com for fit information.

ODE TO DRESSES

Want to get dressed in a flash? Throw on a dress, necklace, and shoes and you're out the door. Dresses have become my hallmark, because I'm embarrassingly lazy, and most of the time I can't deal with coordinating and accessorizing separates. The Gap makes a pretty and affordable line of dresses, and if you want to splurge, yet save, check out edressme.com, a site that sells designer frocks for up to 70 percent off.

HOLLYWOOD STYLE SECRETS

Starlets use a lot of gimmicks and trickery to keep their bits in the right place. Stock these body helpers in your lingerie drawer and always look ready to walk the red carpet.

Spanx: A favorite of Gwyneth Paltrow and other post-baby celebs, Spanx are body-shaping undergarments—like bike shorts—that suck your belly in and smooth your derriere for a streamlined look under tight clothing. Target carries Spanx's equally flattering but less expensive line called Assets. Target.com

Flower petals: Sported by Posh Spice, these flower-shaped adhesive pads cover your nipples when you go braless. Because they are textured, wear them with a dark or thick shirt so no one's onto you. FigLeaves.com

Shoe pads: There is nothing sexy about your toes hanging ten out of your open-toed stilettos. Keep those piggies in place by using shoe pads under the balls of your feet. Much more comfortable and certainly more attractive. Drscholls.com

Get supported: Keep your boobs pert the next time you wear a strapless dress with an adhesive underwire bra from Victoria's Secret. It's lightly lined for no show-through, and can be worn up to ten times. VictoriasSecret.com

Gaffer's tape: Used by J.Lo and Teri Hatcher, taping your rack to boost up, out, and together is an age-old beauty trick. Sounds kind of scary, but is cheaper than a breastlift. And getting the tape off is slightly less painful. Amazon.com

READY TO SHOP

Unlike in Europe, where they have just two sales seasons, good deals can be found in the United States year-round. The best time to shop for sales is Thursday evenings. That's when the weekend sales begin and the inventory hasn't been picked over yet, says Kathryn Finney, author of *How to Be a Budget Fashionista*. She also says if there's an out-of-your-price-range item you're coveting, try waiting a month. Vendors start slashing prices on merchandise six weeks after it hits stores to make room for newer items.

FIND A GOOD TAILOR

You can get huge bargains on quality clothes by having items tailored. It's common knowledge that if something is too big, a seamstress can make it smaller for you. But it's good to keep this fact in mind when perusing sales racks at department stores and boutiques; be on the lookout for higher-end labels because not only do they use nicer fabrics, they tend to cut their patterns fuller, allowing for seams to be taken out and made bigger. (Cheaper brands tend not to waste the fabric.) So if you see a skirt you really like that's a size too small, check out the inside seam, because that's how much you'll be able to take out. I have a friend who found a teeny Betsey Johnson dress and was able to make it bigger by two sizes.

You can also do this with knitwear, utilizing a process called knit blocking, where the knit is steamed and stretched. So if you find a Missoni dress or a DKNY sweater on sale, you should be able to make it a size and a half bigger, maybe even two. Just be sure you leave this job to a pro. And always consider the cost of tailoring before you take on the trouble. Don't forget the old maxim: You should never buy something on sale that you wouldn't buy full price.

BEST TIME OF YEAR TO GET GOOD DEALS

January/February: This is when most retailers have blowouts on winter clothing and accessories. Department stores nationwide, like Saks, Macy's, and Nordstrom, as well as regional stores, like Barneys Co-Op and Louis Boston have sales up to 50 percent off. Pick up expensive winter boots and coats, but stay away from the trendy ones. These have to last you until next year. And stock up on lingerie for Valentine's Day, Victoria's Secret has their semiannual sale now with sultry apparel up to 60 percent off, as do more upscale lingerie shops.

March/April: This is when resort wear goes on sale, the line of cruise wear aimed at the jet set who hit warm weather destinations December through March. Expect discounts on vacation-type clothes like caftans, summer dresses, sandals, beach totes, and high-end bathing suits. I bought a knit Ashley Paige suit for 60 percent off!

May/June: Memorial Day kicks off the spring/summer sales. Nice time to stock up on dresses, white pants, and other summer apparel as well as expensive sunglasses. Handbags will be on sale now, too.

July/August: Second round of blowout sales! Intermix and Hermès both have huge sales in stores and online. Look for darker-colored summer dresses, tops, and pants you can wear into fall.

September/October: September finds big discounts on denim, and beginning October, fall clothing, like trench coats, wool pants, suits, and turtlenecks are starting to be marked down.

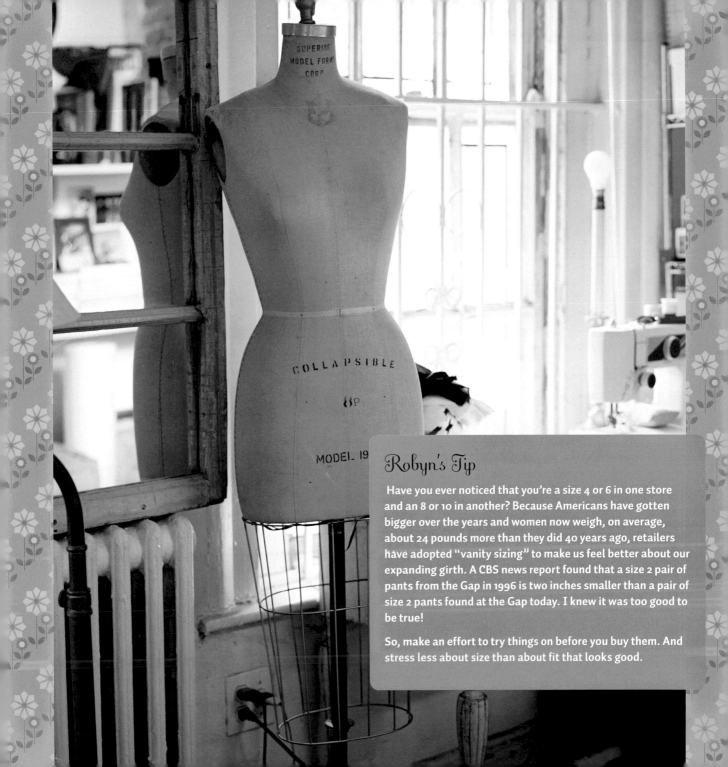

Robyn's Tip

Have you ever noticed that you're a size 4 or 6 in one store
and an 8 or 10 in another? Because Americans have gotten
bigger over the years and women now weigh, on average,
about 24 pounds more than they did 40 years ago, retailers
have adopted "vanity sizing" to make us feel better about our
expanding girth. A CBS news report found that a size 2 pair of
pants from the Gap in 1996 is two inches smaller than a pair of
size 2 pants found at the Gap today. I knew it was too good to
be true!

So, make an effort to try things on before you buy them. And
stress less about size than about fit that looks good.

November/December: Black Friday sales are chaotic, but really do yield big savings; not only is regular price merchandise half off, but sale items are as well. And, for incentive to skip the crowds, some retailers—e.g., The Express—have special morning sales that last from 8 a.m. to noon, so check in with your favorite store to see what they're offering. Buy Champagne and cashmere during the holiday season. Because competition is fierce among retailers of these luxury goods, we see the cheapest prices of the year. After Christmas Day is the best time to score your New Year's Eve party dress and jewelry. In addition to national retailers, online stores have huge price slashes, too. Maxandchloe.com, which specializes in boutique jewelry from Yochi Design and Kenneth Jay Lane, has sales up to 70 percent off. Bluefly.com, which sells trendy designer garb, offers huge discounts as well.

OTHER PLACES TO SCORE GOOD DEALS

NEW AND IMPROVED OUTLETS

Outlet malls tend to have a tired reputation because of their off-the-highway locations and cookie-cutter settings. But no longer just home to Nike and Ann Taylor, outlet malls now feature tony brands like Catherine Malandrino, Celine, and Burberry, and outstanding savings. According to *Consumer Reports,* you can expect a 30 percent discount on merchandise, which makes a day at the outlets a worthy trip.

People get good deals because outlet malls are where many retailers send their overstocked products. And some companies, like Gap and Coach, make products specifically for outlets, often utilizing leftover material, which also translates to lower prices.

THE BEST OF THE COUNTRY'S OUTLET MALLS INCLUDE:

Las Vegas Premium Outlets. Located in Las Vegas city limits, this posh outlet has Miss Sixty, Burberry, and Etro. Trolleys are available on the Strip to the outlets for $2.50.

Gilroy Premium Outlets. Highlights of this mega-store mall just south of San Jose, California, include DKNY Jeans, Michael Kors, and a Puma store.

Grapevine Mills. This Texas mall outside of Dallas includes an Abercrombie & Fitch outlet, Nine West, a Sanrio store, and an on-premise movie theater where you can park your boyfriend.

Orlando Premium Outlets. Minutes away from Universal Studios, the mall features top-notch brands like Diesel, MaxMara, and Armani.

Woodbury Commons. By far the chicest outlet in the country, the mall, situated an hour outside of New York City, boasts big-name houses such as Prada, Yves Saint Laurent, and Gucci, as well as favorites like Theory, Bottega Veneta, and Juicy Couture.

Vintage 101

I have been scouring thrift stores and flea markets since I was a wee lass. Here are my top ten rules for getting the most of your vintage shopping experience.

1. Go with a fellow bargain lover or go it alone.
I've excitedly taken friends to thrift stores only to have them sit on a musty recliner and shoot me dirty looks after I was still browsing an hour and a half later. Digging for treasure requires time, so fly solo or go with someone who enjoys the chase as much as you.

2. Embrace the hunt.
Even though mining through endless racks of clothing is daunting work, it pays off handsomely when you stumble on a Schiaparelli riding hat or a flouncy, tiered Valentino skirt, two of my favorite finds. Keep in mind that these are true vintage pieces (usually apparel from 1920–1960) and exceptionally good scores. What thrift stores consistently produce are of-the-moment trendy pieces at rock bottom prices. If you want an '80s-inspired look, why spend $50 on a white belt when you can go to a thrift store and cruise through a selection actually from the '80s that sell for $5 a pop. And the quality is invariably better than at a cheap trendy store. Thrift stores also offer a great selection of inexpensive costume jewelry, bags, and coats.

3. Make sure it's in good condition.
If it's stained, yellowed, stinky, or made of cheap fabric, it's not worth it, even if it's only $5. Look it over in good light to spot discoloration (especially armpits) and to examine the fabric and lining for no tears or damage. Missing buttons and zippers are easy to repair.

4. Hit out-of-the-way thrift stores.
Because people are so fashion savvy these days, thrift stores in trendy cities like Los Angeles and New York are really picked over, and prices are always more expensive. Deals can be had for sure, but for more options and better scores try to squeeze in a visit to a thrift store the next time you visit relatives in Ohio or have a work meeting in Orlando. I had to go to Las Vegas for a conference and found my way to the best thrift store ever. It was overflowing with cute summer dresses, embroidered tops, adorable shoes. I bought a pair of brown round-toe wedgies, similar to a pair that I had just seen at DKNY, for $7! I left with a bagful of clothes for barely $100. And the only reason it wasn't two bags was because my friend forced me out of the store! (See Rule #1).

5. Drive to estate sales.

Unlike garage sales, which tend to be more down market, estate sales by their very nature are a higher quality affair. (Antiques collectors are big frequenters.) These types of sales tend to be in suburban areas, so a trek might be a bit time consuming. But the finds can be very good. My friend Jen, who owns a vintage store in Brooklyn, gets many of her more expensive pieces at estate sales. Check the real estate section of your weekend paper for listings.

6. Shop late.

When shopping at flea markets or Vintage Expos that bring together many vintage retailers, try going at the end of the day on the last day it's held. My sister used to sell at a flea market and she would give drastic deals when she was closing up because she didn't want to carry all her inventory home. Ditto for Expos. I went to visit a friend who was selling, and when I made my way to her booth at the end of the day, she wasn't even there! *She* was shopping because so many vendors were marking down items. My late-day score: vintage high-heel, lace-up granny ankle boots in soft black leather. I won't tell how much they were; it would just be bragging.

7. Prepare to pay.

True vintage shops are a pleasure to browse through, especially if you're a clothes connoisseur, but they are not cheap. It's not uncommon to see price tags comparable to high-end boutiques. But if you fall in love with a bewitching frock, you can justify your $200 purchase with the pretty safe assurance that no one else will be wearing it.

8. Cybershop.

Shopping for vintage online can save big money because of the lack of overhead. FRay has a huge selection of vintage clothing at competitive prices. Just make sure they have a money-back policy in case it doesn't fit or is damaged (most sites are very good about relaying size, but to be safe, pay attention to measurements). If something is too good to be true, it probably is, so be wary of fakes, especially when it comes to handbags. Good sites to check out are olivesveryvintage.com, fashiondig.com, rustyzipper.com, kingpoodle.com, vintagecouture.com, and enokiworld.com.

9. Consignment stores.

These stores offer newer designer inventory than vintage stores, usually just one season or older, and are pricier than thrift stores. Still, if you crave contemporary fashions for less, they should not be overlooked. You can also try selling some of your castaways, or maybe making a trade, so check out their policy.

10. Wash, then wear.

Most thrift store finds can be machine or hand-washed, while gentler vintage pieces should be dry-cleaned. This is also a good time to make repairs or updates. I bought a boy's blue pea coat for $40 at a thrift store, and changed the plastic buttons to matte gold ones embossed with an anchor for a spiffier look.

SAMPLE SALES

Designers, big and small, open their showrooms at least once a year to sell their clothing samples at prices up to 80 percent off. Though these events are famously crazy—classy broads lose their cool quick when it comes to half-off Manolo Blahniks—the chaos can be worth it to own a nice piece by a really high-end label.

But don't let the excitement of the crowd cloud your judgment. Last year I went to a Stella McCartney sample sale and was so itching to score a deal, I walked out with a too-small, white one-piece bathing suit and white lace-up ankle-strap stilettos. At least I have an outfit handy should Pam Anderson invite me to party on a yacht in Saint-Tropez. For a schedule of sample sales near you, visit www.dailycandy.com. New York seems to have sample sales every week. Next time you're in town check out www.newyorkmetro.com for a list of sales. For the ultimate in one-stop shopping, Billion Dollar Babes is a giant traveling sample sale that brings over forty designers from Europe and America. For a schedule of sales, visit billiondollarbabes.com.

CLOTHING SWAP PARTIES

Before you log on to eBay to sell that skirt you meant to return but never did or that killer sale score you have yet to wear, try swapping out your loot with your girlfriend. Every girl has a bag of unwanted clothes sitting in her closet, so invite your stylish lady friends and their pile of goods over, open up a bottle of wine, and let the auction begin!

SHOP YOUR CLOSET

I once house-sat for a coworker, and decided one of the perks of the favor was to raid her closet. I chose a BCBG leopard-print dress paired with a turquoise Juicy Couture cardigan: sexy yet sweet. My outfit was a hit at work, and when my friend returned I 'fessed up to what I had borrowed. "Interesting," she said. "I haven't worn that dress in ages, and I never would have put those two together." She began to reappraise that outfit and her own wardrobe altogether, and our game of "shop your closet" was born. Have a friend whose style you admire come over one night and help pick out outfits from your closets. You'll discover—with some updated accessories—you can get a great second life out of your wardrobe.

ONLINE SHOPPING

The convenience of online shopping can't be beat. What else would you do at work? And because online retailers don't pay the overhead of brick-and-mortar stores, most of the savings pass on to you. But it's still a wild world out there on the Web, so buyers need to be aware of a few things.

1. Shop at stores you know. Anyone can open a "store" online under a bogus name. If you're wary, ask for a printed catalog or run their name by the Better Business Bureau.

2. Familiarize yourself with the company's refund and return policies *before* you place your order. Whether it doesn't fit quite right, it doesn't look like you imagined, or someone else doesn't like their gift, it's not unlikely you'll be shipping something back to the sender.

3. Pay with a credit card. If you do so, your transaction will be protected by the Fair Credit Billing Act. Under this law, you have the right to dispute charges and withhold payment while the creditor is investigating them. If someone did make unauthorized charges on your card, you generally would be held liable only for the first $50 in charges. Certain retailers even offer an online shopping guarantee ensuring you will not be held responsible for any unauthorized charges made online.

4. Keep a record. Always print a copy of your purchase order and confirmation number and file it in a folder. And just like a receipt, keep it for the length of the return policy, then toss it.

RENT IT

If you're pining for this season's new "it" bag, but thought it was way out of your budget, think again! At Bag, Borrow, or Steal, a Seattle-based accessories rental company, you can pay a monthly membership fee, and borrow the latest purses and jewelry from big-name designers like Balenciaga, Chloe, and Louis Vuitton for as long as you want. Similar to leasing a car, when you tire of your bag or bijoux, you can trade it in for the new must-have model. Don't worry if you fall in love with your purse; you can buy it at a discounted price. And if you like the feeling of ownership you can browse their online "outlet store," begborrowandsteal.com, which has big bargains on used bags.

Caring for your clothing

Whether your closet is filled with pieces from Fendi or Forever 21, taking good care of your clothes will make them ready to wear season after season.

IT'S ALL IN THE DETAILS

Like a scratch in a CD, a missing button or a hanging hem interrupts the flow of your rockin' outfit. If you don't have time to make the repairs yourself, invest in some HeatnBond Hem Tape. This iron-on adhesive tape is stupidly simple to use: place the tape between the fabric of your hem, press to stick, and then go over with an iron to set. Voilà, fixed hem in five minutes. It's available at Wal-Mart and craft stores, like Jo-Ann's.

No time to sew on a button? Reach for Fast Fix Buttons, which are temporary buttons that clasp on to your clothing, allowing you to pop one on and run out the door. One of life's little miracles! Buy a package of four for $5 at fastfixbuttons.com.

Robyn's Tip

Learn how to sew. Brush up on what you learned in Home Ec, and relearn how to sew on a button, or fix a tear. Not only will you resurrect clothing that's been sitting in a pile in your closet, but it's just a practical skill to have, especially when your hem falls or you bust a shoulder strap on the way out the door.

OUT, DAMNED SPOT!

Had a blast last night but woke up this morning to find red wine splotches on your new silk jersey dress? Stop cursing and start working. The number one rule of stains is to treat them stat! If a spot sits untouched longer than a week, there's a good chance it has set and will not come out at all.

To know how to treat a stain, you first have to determine if it's oil-based or water-based, says Steve Boorstein, the "Clothing Doctor." If it's an oil-based spill such as olive oil or butter, it's best to send it to the dry cleaners quickly because they specialize in treating those stains. If you have a water-based stain, such as blood, coffee, or wine, you can take these out yourself with over-the-counter products, but remember to move quickly!

Boorstein also cautions to blot, not rub, stains, which can spread the mess and damage the fabric and color.

Robyn's Tip

Always take time to let your deodorant, perfume, and hair products dry before you get dressed. It's the best way to avoid stains and the annoying hassle of having to change right before you run out the door.

HOW TO SAVE MONEY DRY CLEANING

1. Dry Clean vs. Dry Clean ONLY. Clothing that just says Dry Clean means it's machine washable. Dry Clean Only objects need the care of a professional. As a rule, pieces that are labeled Dry Clean Only are usually materials that don't work well in water, like rayon, silk, and linen.

2. Do like Mom told you and hang up your clothes. Half of the reason people take their clothes to the cleaners is for the pressing. And no more wire hangers: pants and jeans hung over wire hangers develop a hard-to-get-out crease, while dresses and blouses often get stretched out in the shoulders. Instead, use wooden or padded hangers, which are better for keeping the natural shape of your garment. Also, invest in a steamer. A handheld one is only around $60. It's easy to handle and will prevent you from visiting the cleaners every week.

3. Women's clothes often cost more to dry-clean because they have more details, like ruffles, or beading, or trim that require hand-cleaning and hand-pressing. But, if you have plain button-down shirts they should be laundered for the same price as men's shirts, so ask your cleaners.

4. Wash your sweaters and jeans by hand. Many clothing experts suggest caring for your cashmere and wool sweaters at home, because the solvents used in the dry-cleaning process can be too hard on these fine fabrics. Hand-wash sweaters in Woolite or the Wool & Cashmere Shampoo from The Laundress and lay flat to dry. And save dough on dry-cleaning your expensive denim by caring for it at home. The Laundress makes a special detergent aimed to soften denim, and they also have a dark wash detergent with a color guard to protect dark blue and black jeans. Don't forget to air-dry to avoid fading.

Budget Beauty

"Beauty, to me, is about being comfortable in your own skin. That, or a kick-ass red lipstick."

Gwyneth Paltrow
ACTRESS

*T*he challenge of the practically posh dame is to know when to reel it in, and when to go for broke. This dilemma is probably nowhere tougher than when it comes to our looks. I mean, you may be low on dough, but are you going to walk around with callused feet and chipped toenails just to save $20?

But you don't want to sway the other way either, charging up your credit card for the $350 cream at Saks that's packaged so beautifully it *has* to be the elixir of youth—though the ingredients read the same as any drugstore lotion.

Ah! What's a babe on a budget supposed to do? Don't stress, my pretty, it'll wrinkle your face. You don't have to go to either extreme. Here are some of the best ways to improve what Mother Nature gave you, and some money-saving tricks for those days you need a little makeup magic.

Start from the inside out

The truth is, it does not matter how much we spend on cosmetics and hair products if our skin is dull or our hair is fried. Makeup is a wonderful beauty boost, no doubt, but if we have healthy hair and skin, it will matter much less if that lipstick is M.A.C or Maybelline.

START A RELATIONSHIP WITH A DERMATOLOGIST

I *heart* my dermatologist. Besides just checking for cancer moles, she gives me pointers on keeping my skin looking good, and helps me clear up annoying skin problems, like my horrendous hyperpigmentation (brown spots on my face). To find a dermatologist you love, start by asking friends or your primary care doctor for a referral. Besides the usual skin cancer checkup, speak up about any skin issues you have: acne, irritations, dry patches, or skin discoloration. A good derm can usually diagnose and treat such things quickly, saving you money on a myriad of ineffective or inappropriate over-the-counter products.

Kick your bad beauty habits

STAY OUT OF THE SUN

"Sun exposure is responsible for about 90 percent of wrinkles women have," says Dr. Doris Day, M.D., a New York City-based dermatologist and author of *Forget the Facelift*. This means if you want to preserve your skin, your days of lying out in the sun are over. I totally get that people look great with sun-kissed skin; I am a recovered sun worshipper myself. But is a fleeting tan worth the wrinkles, moles, sagging skin, enlarged pores, and increased risk of skin cancer? I think not. Instead, skip the sun *and* tanning beds, which also cause a laundry list of skin damage, and opt for a good self-tanner.

Even if you are not a bronzing addict, normal daily exposure to the sun can cause cumulative damage, so be sure to wear sunscreen daily with an SPF of at least 15 and year-round, in sun and shade, and whether you're fair or dark. Look for a cream that protects against UVB rays, which cause sunburn, but also defends against the UVA rays, which trigger skin aging. Neutrogena makes an inexpensive one, and is a derm favorite because it has a high SPF and doesn't irritate the skin. I especially like Anthelios SX, which celebs have been bringing back from Europe and Canada for years, and is now available at some drugstores.

P.S. Don't forget to also apply to your chest and neck if they are exposed. The décolletage is such a sexy part of a woman's body, and because it doesn't produce as much oil as your face, it's much more prone to wrinkles and sun spots.

TAKE IT EASY, ROCK STAR

Part of the charm of a practically posh babe is she loves herself a party. But while meeting up with friends for cocktails or enjoying a nice bottle of wine at dinner is fun and relaxing, indulging in a rager a little too often will wreak havoc on your skin over time. Alcohol is dehydrating, so not only do you get that debilitating hangover, but your skin will also be robbed of its dewy glow.

BUTT OUT

I know I'm starting to sound like a real killjoy, but that innocent, occasional cigarette you start to crave after a drink or two does have consequences. Smoking constricts your blood vessels, depriving your skin of oxygen and nutrients needed for cell renewal. In her book, Dr. Day cites studies that show people who smoke appear to be 10 to 20 years older than nonsmokers by the time they reach middle age because of their pronounced wrinkles and sallow, sagging skin. So not cute. Visit cancer.org for information and resources on how to quit smoking. Today.

DID YOU KNOW?

Using straws can cause those same feathery lines around lips that smokers get because of the puckering action.

GET SOME ZZZ'S

The most underrated, and effective, beauty remedy is a good night's sleep. When I don't get enough sleep, oh how it shows. The skin under my eyes gets dark and puffy, and the rest of my face looks less taut and firm. I usually refer to this look as "busted." Whether we're overstressed or overworked, not getting a full eight hours of sleep a day causes us to not only look tired, but makes us more irritable and sensitive, less focused, and more prone to eating badly.

Dr. Loretta Ciraldo, author of *Six Weeks to Sensational Skin*, recommends trying to add 30 minutes of sleep a day by going to bed a little earlier or waking up a tad later. This little change can make a big difference in your visage. To help you get ready for a good sleep, avoid anything with caffeine late in the day, try to avoid heavy foods like tacos or lasagna at dinnertime that might upset your stomach, or desserts that give you a sugar high, and try winding down an hour before you go to bed. Turn off the tube to prevent stimulation, and start turning down the lights earlier—this releases melatonin in your body, which prepares you for sleep. For extra relaxation, take a warm bath filled with a couple drops of lavender essential oil, or put on some lavender body lotion; lavender is a proven sleep inducer.

DID YOU KNOW?

Sleeping on your back helps prevent face and chest wrinkles. Rubbing your face into a pillow all night can cause skin pulling. Sleeping on your side can increase the amount of creases in your chest. If you're reluctant to sleep on your back because it is uncomfortable, try putting a pillow under your knees to alleviate pressure. If you have sinus problems or are a big snorer, sleeping on your back can exacerbate that, so invest in soft bed linens that won't rub against your face like 100 percent cotton pillowcases instead.

Robyn's Tip
POST-PARTY FACE SAVER

I know that all work and no play makes a practically posh babe stressed out and a bit boring. So if you had a raucously good time last night, but look like hell today, save your face by replenishing your body with:

1. Water. Lots of it.

2. Vitamins and antioxidants: Fish oils and vitamin C are especially nourishing for the skin. Dissolve an Emergen-C packet in water and take with two fish oil supplements. Follow with a fistful of blueberries.

3. Drink green tea with honey.

4. I know you want the burger, but pass on the fries and go for a side of broccoli.

5. Slap on some Crest WhiteStrips. White teeth give the appearance of younger skin.

6. De-puff eyes with cucumbers. Use Visine, and lots of mascara; you'll look more wide-eyed and awake than you feel!

DON'T SKIP YOUR VEGGIES

Only about 25 percent of Americans eat the recommended allotment of five servings of fruits and veggies a day, according to the Centers for Disease Control and Prevention. I know eating well can be a challenge when we are short on money and time, but making sure everything we put into our mouth has some nutritional value will not only improve the quality of our skin and hair, but our overall health.

You don't have to spend extra money on trendy "super foods" like goji berries, hijiki (a sea vegetable), or pomegranate juice. Most normal fruits and vegetables contain either antioxidants that stop the free radicals, which cause cellular damage like aging and cancer; fiber, an important ingredient for detoxifying our system and eliminating waste; or a cornucopia of vitamins and minerals that feed our skin.

Adding these healthy nuggets to your diet is easier than you think. We all know blueberries are antioxidant superstars, so toss a handful into your morning oatmeal, or into the blender for a shake—frozen blueberries are as rich in antioxidants as wild ones. But did you know pinto beans are also one of the richest sources of antioxidants? Burrito lovers everywhere, rejoice! And while walnuts and almonds are lauded for their shiny-skin-loving omega-3 fats, the lowly peanut is high in protein and has as many antioxidants as strawberries. PB&J, anyone? For dessert, pass on the ice cream and enjoy a cup of frozen grapes. In his book, *The 150 Healthiest Foods on Earth*, Jonny Bowen calls grapes a "pharmacy of nutrients," because among their many advantages they contain resveratrol, a dramatic antiaging compound. The best source of resveratrol is found in the dark skins—which is why it's also found in red wine—so eat the red and purple varieties.

Robyn's Tip

If all of this health talk is making you dream of a doughnut, then do what my fitness trainer friend, Francesca, recommends: follow the 80 to 20 percent rule. If you eat well 80 percent of the time, making good choices, and passing on the sweets and fries, then for 20 percent of the time, you can eat whatever you want. The idea is that after being monastic for a spell, you'll be less likely to pig out if you know a cupcake is around the corner. Besides, once you see your skin improve, you'll probably lose your taste for that Krispy Kreme, anyway.

DID YOU KNOW?

Too much salt intake can cause bloating and eye puffiness. So chill out with the salt shaker, since most cooked food is already salted. And stay away from packaged, processed, and fast foods that are loaded with sodium.

EAU DE VIVRE

Our bodies are made up of 70 percent water, so it makes sense that H_2O is an integral part of staying healthy. Drinking seven to eight glasses of water a day helps your liver metabolize fats, flushes waste, and keeps your skin more plump and resilient.

Exercise

Staying active is equal to eating well in having a profound effect on our skin and overall well-being. Aerobic exercise increases blood circulation, delivering oxygen and nutrients to skin cells. Our sweat also releases toxins—which is why a workout is good for you if you've had too much to drink, eat, or smoke the night before—and activates the production of sebum, which is our skin's built-in moisturizer. Exercise is also a stress reliever and can help combat acne. Plus, exercise releases endorphins, which simply make us feel good.

And you certainly don't have to join a gym to get some exercise. When I'm traveling, or want a quick workout, I do my own mini circuit of push-ups, tricep dips on a sturdy chair, lunges, squats, and crunches. These old-school exercises work wonders on firming your body fast.

One of the most effective and cheapest workouts is walking or running. If you need to get out of the house or burn off some stress, put on your running shoes and hit the pavement. To break up the monotony, try increasing your speed for the entirety of a song on your iPod. Interval training like this speeds up your metabolism and helps to burn calories.

If you want a calmer workout, try yoga or Pilates, which strengthen and lengthen your body. If you're new to these practices, take a class so you can get your form down to prevent injury. Once you know how to perform a plow or a plank properly, you can buy a workout DVD and do it at home. It's the perfect Sunday morning routine, you don't have to set your alarm to make class, and you can use your saved money for a yummy post-workout brunch.

For a more varied workout, take a dance class. My friend, Shirley, dragged me along with her to a ballet class and we had a blast! I felt like I was five again. It was a great workout because I challenged parts of my body that I don't exercise in conventional workouts. I sauntered out with much better posture and a tighter behind.

If you're up for a bit more action, sign up for salsa dancing or hit a club with your friends. After all, boogying the night away whittles your waist, gives you a sexy cardio workout, and provides an evening of fun.

ONE A DAY

While you should get most
of your vitamins from food,
it's still good to take a
multivitamin. If you want to
improve your skin and hair,
take fish oil supplements with
fatty omega-3 acids.

DID YOU KNOW?

Exercising intensely three times a week
(for 30 minutes or longer) has the same
effect in curbing depression as taking an
antidepressant drug.

Cleanse, moisturize, and exfoliate

You know the drill. Perform this holy trinity regularly (cleanse and moisturize nightly and exfoliate—weekly for dry to normal skin, more often for oily) and your skin will stay nourished and polished. You don't need expensive products, either; drugstore brands can do the job perfectly and practically. I am the biggest fan of Cetaphil Gentle Skin Cleanser, which cleanses and hydrates my skin for $12.

As with cleansing, when it comes to moisturizing, higher prices don't necessarily mean a better product. It is important to consider the type of skin you have: Do you need rich cream or face oil? A lighter lotion (which has more water than oil)? Or an oil-free lotion or gel? No matter how much money you spend, if you don't choose the right product, you will not get the effects you desire.

My friend, Anne, is a beauty editor and a big fan of Olay products. Their Renergist line is dermatologists' favorite because it contains antiaging amino-peptides. Other brands at the drugstore can provide you with antioxidants, which work to repair damage brought on by sun or smoke; retinols, which exfoliate and replenish skin; peptides, which are effective wrinkle erasers; and ceramides, which help keep moisture in the skin. These are comparable to the bigger brands at a much better price. Regardless of what you choose, remember to use a daily moisturizer with SPF for the daytime, and a more emollient one for evening, since we lose more water at night.

Want to freshen up your skin quickly? Exfoliate. Exfoliation is a mini miracle because it removes the top dead layer of skin, revealing a smoother, cleaner, and more youthful face. Mass-market exfoliators like Biore, Aveeno, Clean & Clear, and St. Ives are longtime favorites. But the best and tastiest scrubs can easily be made at home. See our at-home treatments.

Robyn's Tip

Have sex as often as you can get it. "I need sex for a clear complexion," crowed silver screen legend Joan Crawford, "but I'd rather do it for love." A roll in the hay doesn't just feel good: as your heart rate climbs, more blood gets pumped throughout your body, feeding your cells with yummy skin-loving oxygen. Plus, sex is a boon for your confidence, and that is irresistibly attractive.

ORANGE YOGURT MASK

This is a home version of the facial I get at the Mario Badescu Spa in New York City (they're practically posh gold stars), which includes an antioxidant Vitamin C mask. The yogurt nourishes dry skin while the AHAs in the orange repair and rejuvenate. The treatment is also cool and relaxing.

Ingredients
1 tbsp. plain yogurt
Fresh juice from ¼ orange

Directions
Stir together in small bowl. Smooth onto face. Leave on for five minutes and then rinse.

OATMEAL HONEY SCRUB

Oatmeal has long been used as a gentle exfoliant, and honey moisturizes. A quick way to get a good scrubbin' is to add a tablespoon of raw oats and two teaspoons of honey, organic if possible, to your morning cleanser. Top o' the morning to you!

EASY SUGAR SCRUB

Sugarcane produces glycolic acid, one of the natural alpha hydroxy acids that exfoliate the skin. Mix two teaspoons of white cane sugar with two teaspoons of face wash in a small bowl and rub gently onto your face in a circular motion. Rinse off the warm water. It's okay if you lick your lips!

DON'T FORGET YOUR EYES

Besides the classic cucumbers, you have tons of stuff in your kitchen to help alleviate tired puffy eyes. Potato slices or chilled chamomile bags act as an anti-inflammatory. You can also use cotton balls dipped in ice-cold whole milk or cream for five to ten minutes to de-puff and refresh. And even just placing the back of a chilled spoon over your eyelids is supremely soothing.

Robyn's Tip

If you have dry skin, try using a tissue-off cleanser instead of one you remove with water. Because water is a natural astringent, it can leave your face dry and pinched. Use a cream cleanser or an emollient that will cleanse but also moisturize skin.

Self-tanning 101

No longer weird-smelling or oompa-loompa color-inducing, sunless creams, gels, and sprays will make you look naturally bronzed (but without the skin damage). Drugstore brands to try include versions by Hawaiian Tropic, Banana Boat, Coppertone, and L'Oréal.

TO APPLY AT HOME, ALWAYS:

1. SLOUGH IT OFF.
Exfoliating with a loofah before application will leave you softer for a more even tan, and will make your color last longer. Pay special attention to rough areas like knees, knuckles, feet, and elbows.

2. USE A LIGHT TOUCH.
First start with one coat of tanner to see how your shade turns out. You can always add a layer or two for a deeper bronze later. Apply less to your rough areas or they could end up darker than the rest of your skin.

3. PROTECT YOURSELF.
Wash your hands right after applying your self-tanner to avoid dark palms and nails, or wear latex gloves when applying. Putting Vaseline on your eyebrows and hairline will prevent them from getting a tan, too.

4. LET IT SET.
To make your color last longer and to prevent from staining your clothes, wait as long as possible before getting dressed after applying self-tanner. Try to avoid exercising, showering, or swimming for a few hours afterward as well so you won't streak.

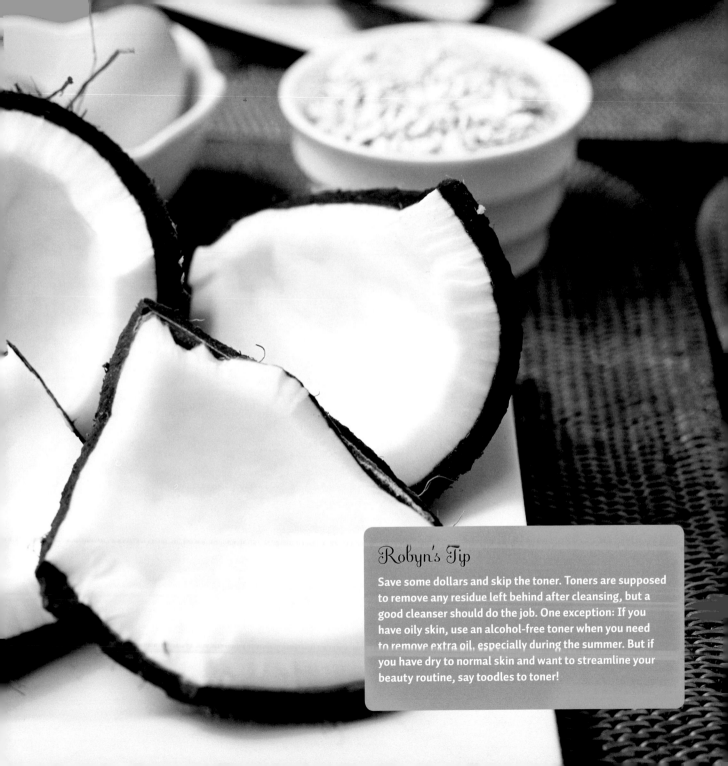

Robyn's Tip

Save some dollars and skip the toner. Toners are supposed to remove any residue left behind after cleansing, but a good cleanser should do the job. One exception: If you have oily skin, use an alcohol-free toner when you need to remove extra oil, especially during the summer. But if you have dry to normal skin and want to streamline your beauty routine, say toodles to toner!

Makeup

WHEN TO SAVE, WHEN TO CAVE

foundation

This is where you're going to highlight and correct your entire visage, so here is where you can dip guilt-free into your makeup budget. The benefit of buying at a makeup counter instead of a drugstore is that you can try on the foundation to ensure a good match. Also, bigger-name brands tend to offer more variety for different skin types (oily to dry) and coverage types (heavy to sheer).

To make sure you achieve an even coverage, apply foundation to a moisturized face and always apply in good light: natural for day, and white versus yellow lights at night. (Yellow lights tend to be too fuzzy and forgiving.)

POSH OUT
lipstick you love

There is a reason the multibillion-dollar makeup industry does well even in recessions: it makes you feel pretty. Nothing can change your look or attitude quicker than a coat of lipstick. So if you find a swanky one that makes you feel like a seductress, go for it!—$25 is a pretty tame

indulgence, and you can placate your wallet with the knowledge that high-end lipsticks do tend to contain more pigment for a richer color and better stay-on quality.

POSH OUT
makeup brushes

A quality brush set elevates a quick makeup application to a beauty ritual, and they are invaluable in helping your makeup look naturally contoured. Plus, they make the best of cheap makeup. Look for brushes that have natural bristles instead of synthetic; they absorb and apply makeup better.

Ask for one as a Christmas present, or splurge and buy yourself a set. M.A.C. makes a nice five-piece set that they sell around the holidays. Keep in mind that you really need only a blush, a powder, and an eye-shadow brush. Although a lip brush is good for getting the most out of a lipstick, it needn't be expensive. You don't really need a brush for foundation or concealer, since you can apply it lightly with your fingers like many makeup artists do.

Robyn's Tip

Keep makeup remover pads by your bedside for those nights you're too exhausted to wash your face. One swipe and you're out!

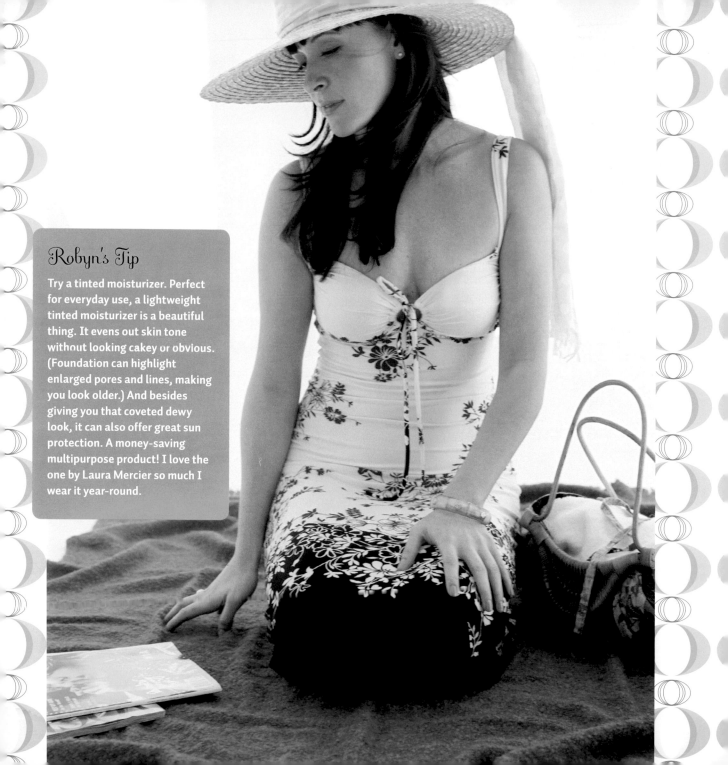

Robyn's Tip

Try a tinted moisturizer. Perfect for everyday use, a lightweight tinted moisturizer is a beautiful thing. It evens out skin tone without looking cakey or obvious. (Foundation can highlight enlarged pores and lines, making you look older.) And besides giving you that coveted dewy look, it can also offer great sun protection. A money-saving multipurpose product! I love the one by Laura Mercier so much I wear it year-round.

Now that we have splurged, let's fill up our makeup bags with cheaper finds.

Mascara

This is a safe place to go cheap because even makeup artists flip for affordable brands like Maybelline Great Lash, CoverGirl's Lash Exact, and L'Oréal Paris Voluminous Volume Building Mascara.

Eye Pencils

A huge way to save makeup money is on eye pencils. Beauty insiders love Wet n' Wild Eye Pencils, which come in a huge array of colors and are only 99 cents! Other eyeliners can cost up to $24. Maybelline Expert Eyes are also a permanent standout.

Blush

With a good blush brush, almost every brand looks lovely. A perennial drugstore fave is CoverGirl Cheekers, which has hints of shine. If you prefer cream blushes, which give a dewy, natural look since they blend *into* the skin, rather than sit on it, try Stila Convertible Color, my personal preference, which is $20 but doubles as a lip gloss. Just don't use too much, lest you be the subject of the Oscar Wilde quote: "She wore far too much rouge last night and not quite enough clothes. That is always a sign of despair in a woman."

Eyeshadow

Wearing eyeshadow is always tricky for me, so I turned to Carmindy, the makeup artist on *What Not to Wear* and the author of *The Five-Minute Face* for application advice. For a natural look, she recommends applying a highlight shade (like a light pink, pearly white, or soft metallic) under the eyebrow and in the tear duct area. This creates an open, bright-eyed look. For nighttime, you can get more crazy and play with a plethora of shimmers and popping colors. Try to use bright colors up and away from your lashes so it's flattering and not overwhelming, and opt for shades opposite your own eye color for contrast. Good buys are L'Oréal Paris Wear Infinité Duos, and Revlon ColorStay 12-Hour Eye Shadow Quad.

Lip Balm

Everyone has a personal favorite, whether it's Kiehl's #1, Burt's Bees, or Bonnie Bell Lip Smackers, (I like Rosebud Salve). In addition to being inexpensive, you get a lot of bang for your buck—lip balm is applied every day (several times for some), and can be used to moisturize cuticles and even smooth flyaway hair.

Robyn's Tip

Makeup brushes should be cleaned regularly. For a quick cleansing, use baby wipes. They grab all the gook and are gentle on bristles.

Other good stuff you can pick up in the drugstore aisles

Cutex Nail Polish Remover: It's under $3 and works like a charm.

Nivea Cream: So rich, it works on tough bits, like elbows and knees, and in your hair as a mask. Apply to dry ends on a lazy Sunday afternoon and keep on while you read the paper—a practically posh version of Kersastase Masquintesse.

Visine: Gets the red out and makes you look instantly fresher after flying the red-eye or the morning following a night out.

Aquaphor: This healing ointment from Eucerin is a celeb favorite for hydrating lips, hands, feet, and other scaly spots.

Alberto VO5 Hot Oil Treatments: Heat up and put on for instant hair help.

Palmer's Cocoa Butter Formula with Vitamin E: Softens skin, prevents stretch marks, and is soothing après sun—plus it smells yummy.

Baby powder: Perfect for taking the oil out of dirty hair, absorbing oil stains on clothing, and for lightly setting makeup.

A body brush or a loofah: Dry brushing your skin is an effective exfoliator that not only makes skin smooth, but stimulates circulation and boosts lymphatic drainage, which are two alleviators of cellulite. For optimal results, brush before you shower when your skin is dry, brushing in upward strokes toward your heart. Look for a brush with natural bristles, which are more delicate on your skin than synthetic fibers, or use a loofah. And never brush too hard.

Queen Helene Mint Julep Masque: A favorite of Daisy Fuentes and my friend Carmen, whose skin is so gorgeous she looks like a Botticelli painting. This product will shrink pores and draw out blackheads, but people with dry skin should use it sparingly.

Vaseline: A must-have in your cabinet, Vaseline is your backup makeup remover, lip balm, cuticle moisturizer, and body balm.

Tea tree oil: When you have a pimple, a spot of tea tree oil will dry it out fast. If you dab some on an emerging pimple, the product will prevent it from surfacing.

Crest WhiteStrips: One of the ways to look younger, fresher, and more attractive quicker is to have whiter teeth. These strips are affordable, easy-to-use, and they work.

Q-Tips: The perfect makeup tool for smudging eyeliner, cleaning smeared mascara, and applying spot concealer.

Making your makeup last

Instead of tossing all of your half-used lipsticks into the garbage, buy a pill box, and dig out whatever is left in your tube or jar, putting each color in a square, suggests makeup artist Carmindy. Not only can you extend the life of a great shade, but you can even create your own hue by mixing and matching the ones in your new portable "lipstick palette."

You can do a variation on this technique whenever a new favorite eye shadow or blush breaks as well. Instead of throwing them away or keeping them as is only to make a mess in your cosmetics bag, put what's left in empty film canisters and use the products like loose powders.

One way to extend the shelf life of mascara is to not pump the applicator wand, which makes it dry out faster. Instead, twirl the wand inside the mascara, then pull it out. Mascara should be tossed after four months, though, as it's prone to harbor bacteria.

With products such as foundation, face wash, face lotion, and shampoo and conditioner, you can get the most of your buck by remembering a little goes a long way. So only use a dime-size amount each application. But many dermatologists recommend discarding face cream and washes after one year after opening them, as daily exposure to germs (especially via fingers) and oxygen contaminates the products. Plus, products with active ingredients like vitamins A, C, E tend to be ineffective after twelve months. Conversely, glycolic-based washes and creams can become twice as potent and possibly harmful

Hair Care Dos

We've all had our fair share of bad-hair days, that's why hats, and probably chignons, were invented. But with a little care, cut, and color, we can get our tresses to be our crowing glory.

HAIR-HELPING DIET

Foods rich in niacin like fish, beans, and chicken are proven to increase blood circulation in the scalp and stimulate the metabolism of hair follicles. Calcium isn't just for strengthening bones; it is a major contributor to strong, healthy hair. And folic acid (found in fruit, beans, and green leafy veggies) and biotin (found in liver, egg yolks, and soy) are both part of the B-complex vitamin group that helps in the production of hair.

While vitamins are best received through food, try taking prenatal vitamins, which have folic acid, calcium, and niacin. No wonder so many hot moms praise them.

DID YOU KNOW?

According to Paula Begoun, author of *Don't Go Shopping for Hair-Care Products Without Me*, shampoos are the absolute best place to save money in your beauty budget because there's virtually no difference between the ingredients in a drugstore shampoo and a designer one. When it comes to conditioner, there is more variance but there are good buys to be had at your local grocery store.

DO EXERCISE

Working out not only increases our blood circulation so we can get nutrients to every part of our body faster, it also reduces stress, which is one the causes of hair loss.

THE WASH

The best way to get shiny hair is to wash it in moderation. Shampooing too often will strip your mane of its natural oils, leaving it dull and flat. Try washing it every other day—great money-saving tip for people who have dyed hair, as frequent washing will make your color fade faster. To help with limp locks, try a hair powder to absorb the oil. Bumble & bumble makes a great spray-on powder made for different hair colors. A cheaper alternative is to put baby powder or cornstarch in your hair. Sprinkle some in your palm and apply into the roots so it can be absorbed. When washing, you should only shampoo your roots—this way you will cleanse your scalp, while preventing your ends from drying out. The rest of your hair will get cleansed when you're rinsing.

How can I control my life when I can't control my hair?

Anonymous

(BUT WHAT EVERY WOMAN IN THE WORLD IS THINKING.)

Use conditioner sparingly so it doesn't weigh down your hair. Apply in the middle of your hair and work down to the ends, avoiding the roots, which are naturally oilier. Classics like Aussie 3-Minute Miracle Reconstructor and Herbal Essences Conditioner have both won beauty award from CEW (the Cosmetic Executive Women), the Oscars of beauty.

Some of the most inexpensive conditioners—natural oils—are in your kitchen. For instance, mashed avocados and mayonnaise offer hair moisture, and running a little olive oil through your ends cures dryness.

MASSAGE YOUR SCALP

The only part of our hair that is alive is the root, which is embedded in our scalp. Massaging your scalp stimulates the flow of oxygen and blood to the roots of your hair, invigorating it to grow and thrive. The result: healthy hair.

Give yourself a mini scalp massage before you go to bed, it will help you fall asleep and inspire a little Rapunzel action. You can also do it in the morning, at work, or even when you're stuck in traffic. It will make your tresses look better and help keep you stress-free.

Changing the locks

Cutting or coloring your hair is the quickest way to get a makeover, but it doesn't have to be the most expensive.

FINDING A GOOD HAIRDRESSER OR COLORIST

Get a referral. Keep in mind you're choosing someone who is going to be in charge of how you look for at least the next three months. So be picky. Ask friends whose style you dig. Heck, chase that cute girl with the cool do down the street and ask her where she got her hair done. When you end up finding a fantabulous hairdresser, just be sure to pass his/her name on—it's good hair karma.

TRUST YOURSELF

Maybe it's because they're wielding scissors, but for years I would go to the salon with an inspired idea for a haircut yet as soon as the stylist asked me what I wanted, I'd lose my spine and gush, "Uh, like I don't know, whatever. What do you think?" Then I'd end up walking out with a pixie cut when I spent the past six months trying to grow it out. Be sure to articulate what you want and speak up if things aren't going as planned. This is why it helps to bring a picture. Even if the stylist tells you gently that you don't quite have the face shape or coloring for that hairstyle, at least he or she will be pointed in the right direction.

LOVE THE ONE YOU'RE WITH

If you find a hairdresser who gives you a cut you love, it can definitely be worth the expense. I love my hairdresser, Gerald, and whenever he cuts my hair, I feel beautiful and get tons of compliments. He charges a bit more than I was used to paying, and I once cheated and booked an appointment with a less expensive hairdresser, needless to say. I soon ran back to Gerald begging him to fix my hair. He did, and I have never strayed again. Now I feel I actually have a good deal, because since I have such a kick-ass cut, my hair grows out really well and I don't need cuts as often.

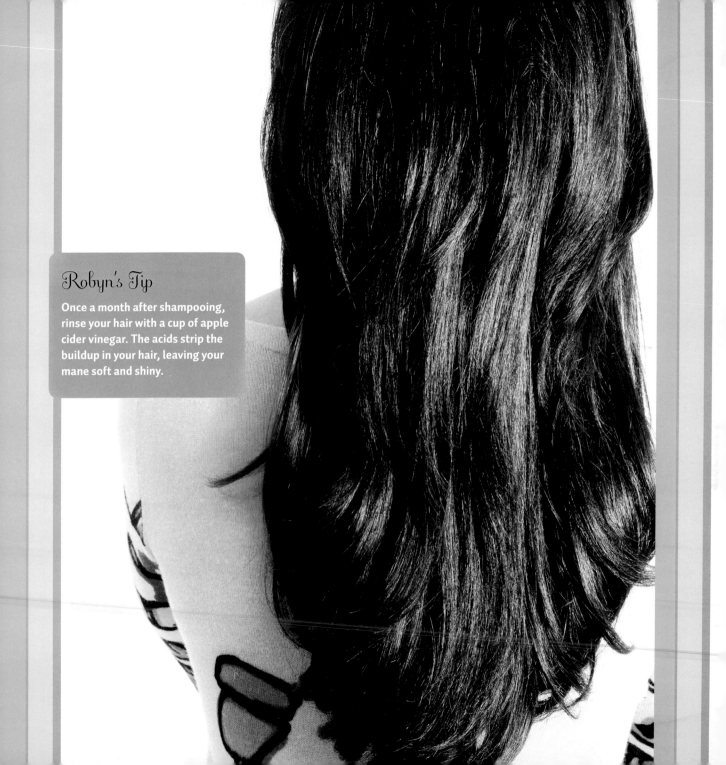

Robyn's Tip

Once a month after shampooing, rinse your hair with a cup of apple cider vinegar. The acids strip the buildup in your hair, leaving your mane soft and shiny.

TRAINING DAY

If you're looking for a top-tier cut at a budget price, call up your local swanky salon and ask them if they have any training sessions available. Training sessions are quite different from visiting a beauty school, where novices cut your hair—here, newly hired stylists learn the salon's signature cuts and styles. These are certified seasoned pros; they are just new to the salon. And in case you're still worried, senior stylists supervise the session so you're in four trained hands. You should expect to be there for a while, from two to four hours, and you'll have to be open to whatever styles they're practicing that day. But if you want a high-end salon experience, there's practically no a better way to get it. Training sessions take place in high-end salons around the country, such as Louis Licari, Bumble & bumble, Frédéric Fekkai, and Vidal Sasson, so if you're open to new things, this is definitely the way to go. The price is usually $50, and many salons also offer coloring services, so inquire about that as well.

Robyn's Tip

Ask your favorite salons about any weekly specials they offer. Many salons offer discounts Monday through Wednesday when business is slow, or even during off-peak hours like 2 p.m. to 4 p.m. Some like XO Blow in New York even offer frequent-customer cards, where you can earn free cuts or blowouts.

COLOR ME HAPPY

Whether it's to color grays or change their look, half of all American women color their hair.

Two factors to consider when choosing a hair color or process are how much money you have and how much time you're willing to invest for upkeep. For instance, do you have dark hair but always secretly dreamed of being a blonde? Well, to achieve that Marilyn look, your hair will have to be double-processed. First, the hairdresser will strip its color, then he/she will dye it golden. Even then your work is hardly done since you'll have to maintain the roots. So unless you have J-Lo dough, stick to a color two shades darker or lighter at the most.

When you're ready for a change, it's worth it to visit a salon to get a consultation with a stylist. They'll help you pick the most flattering hues for your skin tone and the best approach to maintaining your new look. From there you can try doing it at home.

COLORING AT YOUR CASA

Start by testing a strand of hair underneath your mane so you can hide it if things go amiss. If the color looks good, apply dye according to the box's directions. Superior Preference by L'Oréal Paris is a longtime favorite at-home color, but there are so many new products on the market now, feel free to experiment and see what works for you.

Keeping your color: Just like with clothing, hot water can cause hair color to fade. To protect your hair's vibrancy, wash in tepid to cool water, and blow-dry on a cool to warm setting.

THE HIGHS AND LOWS

Highlights and lowlights are fantastic ways to get eye-catching but natural color. Although there are some good at-home products on the market, I would leave this type of coloring to a pro. The simple act of strand wrapping and foiling is exhausting, and you would have to recruit a friend to help you with the back of your head. Way too much trouble.

GO TO A COLORIST INSTEAD AND SAVE WITH THESE HIGHLIGHT-LASTING TIPS:

A clever way to save money and stretch your color budget is to alternate getting a full head of highlights with getting half a head (where they freshen the top part of your hair and around the face, but leave the hair underneath darker).

To freshen your color, try a rinse or gloss on your hair in lieu of another full dye job. If you have highlights, alternate between highlights and rinses. A rinse will freshen your highlights and give hair a much-needed rest from chemicals.

GETTING SERVICED

WHICH ONES CAN BE DONE AT HOME AND OR BEST LEFT TO THE PROS?

Eyebrow shaping: If you have time or money for just one beauty service, get your eyebrows groomed. You can coat on some clear nail polish and wax and shave your hairy bits, but having your brows professionally shaped will make a huge difference in your appearance. Eyes are the focal point of our face, and a nice arch and neat brow lifts and opens your eyes, making them more commanding, and you look more polished and younger. To save money, try to maintain them yourself so you don't have to go the salon as often.

Hair removal: Removing unwanted hair is serious business. I have friends who have their own waxing machines at home to stay on top of their primate-like problem. If you're used to at-home waxing and it seems many of my South American and European friends grew up doing this, then carry on, madam. But if you're not so adept, save it for a professional.

Hair removal options

Tweezing: Invest in good tweezers, such as Tweezerman's. By tweezing sprouting eyebrow, lip, and bikini hairs, you can save money on waxing by prolonging your visit.

Bleaching: This is a good method for light upper-lip hair and hairy arms. If you have a lot of lip hair, go for waxing; bleaching it will only make you look like Hulk Hogan. The same rule often applies for superfurry arms.

Waxing: Reliable and affordable, this method works for just about everything, from mustaches to bikini lines to eyebrows, and even underarms and legs. (Exfoliate your bikini area before your waxing appointment to avoid ingrown hairs. There's a product called Tend Skin that also works well to prevent ingrowns, which can be unsightly and embarrassing, not to mention uncomfortable.)

If you opt to wax your underarms and legs, just know it hurts like hell, and that you'll have to wait until the hair grows hippie-long before you can get waxed. So slide into some Birkenstocks and embrace your granola side for a while.

Threading: Because my skin is so sensitive, waxing my eyebrows and lips used to leave me with scabs. Gross. I finally got hip to threading, a Middle Eastern technique that uses a 100 percent cotton thread to twist and roll along the surface of the skin, entwining the hair and lifting it out from the follicle. The benefit to threading is that the top layer of dead skin is not stripped off in the process. Threading is getting more popular, but if you can't find someone to perform this at your usual salon, ask around. If you have a Middle Eastern neighborhood in your town, try there.

Laser: Permanent hair removal can be expensive, up to $1500 for eight sessions, but if you wax often, it could save you money over a lifetime. Also, if you have unsightly facial hair, it's a worthy investment if it improves your self-esteem.

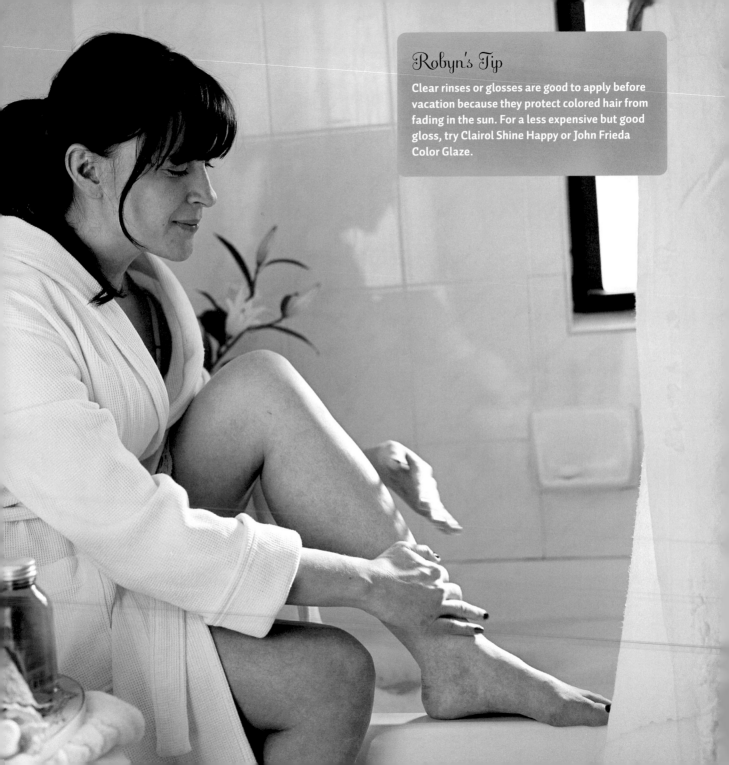

Robyn's Tip

Clear rinses or glosses are good to apply before vacation because they protect colored hair from fading in the sun. For a less expensive but good gloss, try Clairol Shine Happy or John Frieda Color Glaze.

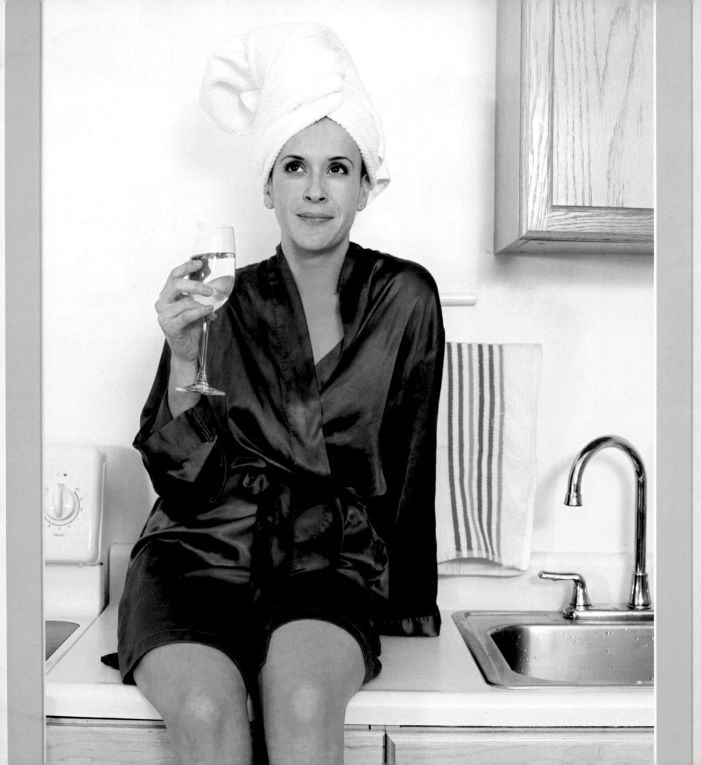

Home Spa

Manicure: Save a salon manicure for a special occasion or indulgence and do your nails at home.

Start by taking off your nail polish with a cotton pad, then clip nails, if necessary. Next, wrap the pointed tip of an orangewood stick (a thin wooden stick with a slant-edge tip at both ends sold in the drugstore nail section) in a piece of cotton and dampen it with remover. Use it to clean under nails.

File your nails in one direction in the shape of your choice (round or square). Make sure you don't file back and forth, which splits your nails. When you're done filing, apply cuticle or olive oil to your cuticles and place your fingers in a bowl of warm soapy water. You can add some drops of essential oil if you have it on hand. Let soak for five minutes.

Push back your cuticles with an orangewood stick wrapped in cotton, moving in a circular motion. Rinse hands in water. Dry hands and apply a hand lotion, giving yourself a mini massage. Before applying polish, wipe nails with a cotton pad soaked in remover to make sure they're dry and not greasy.

Next, apply a base coat and wait two minutes. Dip brush into polish and wipe once per nail. Now paint each nail in three strokes from base to tip: in the middle, then one on each side. Wait two minutes and apply another coat, if desired. Wait two more minutes and apply a top coat. If by now you're in a hurry, apply a fast-drying top coat, but be careful not to mess up your hard work!

Pedicure: Pedicures are glorious, but can be really expensive. Instead of indulging, save up for that girls' weekend; treat the feet at home. The application is the same as above, but for an added indulgence soak your tootsies in a bowl of warm whole milk. The lactic acid softens skin, so after 10 minutes, take a pumice stone to your feet to slough off dead skin.

Facials: Facials are often thought of as an indulgence, but are, in fact, an integral part of a beauty routine. An aesthetician will clean your skin of impurities, which is important because clogged pores will enlarge permanently if not cleaned, and picking at your skin is definitely something you shouldn't do.

Quality facials cost around $60. Try to fit one into your budget at least twice a year: at the end of winter and summer, when your skin is ready for some renewal. In the meantime give your skin a little down-home loving with facials ingredients you can find in your fridge—see recipes on page 142.

Be sure and apply mask to clean and exfoliated skin so the nourishing ingredients can easily access your skin. After you remove your mask, cleanse and moisturize skin, then enjoy the rest of your beatific day.

CHAPTER 7

Poised & Cultured

"Culture is the widening of the mind and of the spirit."

Jawaharlal Nehru
INDIAN PRIME MINISTER, 1889–1964

"Whenever I'm in a situation where I feel underdressed, underestimated, overwhelmed, or out of my league, I ask myself 'What would a practically posh babe do?' and then I'm able to conjure my confidence and poise."

Robyn Moreno
AUTHOR, *A LADY NEVER TELLS HER AGE*

One of the most enviable traits of a practically posh babe is her ability to move seamlessly in all social circumstances. Whether meeting your boyfriend's parents for the first time or being asked to choose the wine at a company dinner, a self-possessed woman can hold her own in every setting and in any conversation. (Or at the very least, fake it like a pro.) There will, of course, always be formidable instances when even the chicest chick can feel slightly Eliza Doolittle-ish. Not to worry, milady. Read on and enjoy this crash course in all things refined.

Meeting The Parents

Things have been going swimmingly and he's asked you to dinner to meet his folks. Before you start flipping through bridal magazines, first focus on getting his parents to adore you. Trust me, getting Mom's approval scores you huge points in the "she's a keeper" category. On the eve of the big night, take a deep breath and follow these guidelines to avoid any awkward encounters.

1. DRESS APPROPRIATELY.

Err on the side of caution here. Don't wear anything too revealing or too fashion-forward. I don't want you to stifle your personality or show up in an outfit so unlike you your boyfriend doesn't even recognize you. The goal here is to let his family get to know you, not your fashion prowess.

2. GO EASY ON THE BOOZE.

This is self-explanatory. Even if his mom gets a little silly on Sauvignon Blanc, staying relatively sober will keep you aware so you can watch the family dynamics unfold clearly, and of course will keep you from getting belligerent, bawdy, or affecting a British accent.

3. SCAN THE HEADLINES BEFORE DINNER.

Know what's happening in the world. A practically posh babe is always on her toes. When Dad starts commenting about relieving Third World debt, you'll be able to chime in with a comment or two, or at least nod your head convincingly.

4. EARN YOUR MEAL.

Offer to plate, serve, or clear dishes. Even if whoever's at helm—Mom or Dad—insists that you're a guest and they've got it covered, give a helping hand anyway. Not only will you show off your good manners, but you'll gain some valuable parent bonding time while loading the dishwasher.

5. DON'T FAWN OVER YOUR BOYFRIEND, BUT DON'T BERATE HIM EITHER.

Be cool. It's okay to laugh at your man's bad jokes, but don't stare at him starry-eyed, lest you look like a crazed stalker. Definitely leave the baby talk and nicknames at home and don't make everyone uncomfortable with overt PDA. (Hands stay above the table!) Conversely, even if you and your beau had a spat right before walking in the door, don't throw out any drunken digs (see Rule #2), call out his bad habits, or try to get his mom to side with you on this squabble. Parents are fiercely loyal, and you'll quickly find yourself on a team of one.

Wining and Dining

Want to impress a boss or colleague? Nab a reservation at an impossible-to-get-in restaurant. (Hopefully, they'll be so wowed they'll foot the bill.)

BE AN EARLY BIRD

Most in-demand places start taking reservations one month prior to the date you desire. Find out if they're listed on opentable.com. If so, get a head start on your competition by visiting the site at 12 a.m. the day the reservation becomes available. Because available tables appear on the site starting at midnight, you'll be hours ahead of someone who *phones* the restaurant's reservation line the next day.

KEEP SOME RESERVATIONS HANDY

Even if you don't have definitive plans, it's worth making random future reservations at a highly coveted spot. My friend Ivette and I started doing this after we scheduled a dinner date and were turned away by our top three choices. Hell hath no fury like a PP babe *denied*. As the date approaches, we start saving money for our expectant meal, which actually turns it into a bit of an occasion. There is something to delayed gratification. If one of us is strapped for cash, we let the other have the reservation to invite a foodie friend, current lover, or someone we hope to dazzle.

FLIRT WITH A CONCIERGE

Have an early drink at a hotel bar, and ask the concierge to see if he can get you a reservation. Because they deal with restaurants regularly, they often have pull at hotspots. A concierge was once able to get me on the VIP list at a supper club when the public relations person at the venue wouldn't even allow me a seat at the bar. In lieu of fabricating that you're a hotel guest, let him know you visit the hotel lounge frequently for business meetings, smile seductively, and give him a nice tip.

Be a practically posh patron

It pays to frequent a restaurant so you get to know the staff, and more important, they remember *you*. My ex-boyfriend has one Italian joint in the Soho area of New York that he's been going to for years. Whenever he needs a table in a pinch, he calls up the owner and gets whisked to a table like Ray Liotta in *Goodfellas*.

The Practically Posh babe doesn't have to spend loads of dough cultivating her contact. Just shimmy up to the bar and order a cocktail and a nibble off the bar menu. The abbreviated menu is usually cheaper, and undoubtedly the bartender or a neighbor will offer to buy the lady a drink.

Überfancy restaurants can be intimidating with their formality and pretense. But a practically posh lovely can easily rise to the occasion with some basic dining etiquette.

SITTING LIKE A LADY

When a maître d' or gentleman pulls out a seat for you, always approach the seat from the right. When you arrive between the table and seat, gracefully pull the chair in from behind you, while the other person helps push you in.

TABLE SETTING

Perplexed by the bevy of cutlery in front of you? The easy rule of thumb is to work from the outside in. A fancy table setting will have a plate at center with a dinner fork at the immediate left, followed by a smaller salad fork, and then a folded napkin. To the immediate right of the plate should be a dinner knife, followed by a salad knife, and finally a soup spoon (if you're having a soup course). Directly above the plate is where the dessert spoon and/or fork will be set horizontally. To the left and above the fork, you'll find the bread plate with a butter knife laid horizontally on top. And to the right above the knives and spoon will be the water glass, followed to the right by a red-wine glass, and then a white-wine glass. Once a utensil has been used, never place it back on the tablecloth. Instead, lay it on your appropriate plate. Soup spoons are placed on the bowl's service plate when finished; teaspoons should be placed on the saucer.

DINNER SERVICE

The first thing to do after being seated at a table is to immediately place your napkin in your lap. When you go to the bathroom, fold your napkin and place it to the left of your plate. (You'll place it on the right after the meal.) When your food arrives, expect to be served from the left and have your dishes removed from the right. When you are done with your dish, your knife and fork should be placed side by side (parallel) on the plate, with the handles at the 4 o'clock position.

PASS ON THE SALT

Don't salt or season your food before you taste it; it's considered rude to the chef. I have been to restaurants where there aren't any condiments on the table at all, so forget about asking for Tabasco, or dear God, A1.

KEEP IT BELOW THE DECK

Women should never place their keys or purse on the table; find a place for it underneath. I usually rest it against the side of my chair. Never apply lipstick, clean your teeth, or pull out a pocket mirror at the table; it's considered *très gauche.*

Robyn's Tip

The proper way to eat soup is to draw the spoon away from you and quietly sip the soup from the side of the spoon. This may feel awkward at first, but it looks very polished. If you want the last drop, you are allowed to tilt the bowl away from you to get the remaining soup—don't slurp!

BE CONSIDERATE

Never order the most expensive item on the menu when you are not paying. Take your cue from the host: if she orders like it's her last meal, you can relax a little with your selections.

GO WITH WHAT YOU KNOW

If you don't know how to eat it, then don't order it. There's no need to have all eyes on you while you attempt to tackle a whole lobster.

NO GADGETS AT THE TABLE

Turn your BlackBerry or iPhone off while you're at dinner, and don't accept calls, sneak a peek at e-mails, or show off photos of your new puppy. This technological embargo will help you practice the lost art of conversation.

NO SPECIAL ORDERS

If you have food allergies or are on some weird diet, call ahead to the restaurant or check out their Web site to have a look at the menu, so you will be prepared. At an upscale restaurant, being a finicky eater screams amateur. However, if you don't know the restaurant you'll be dining at beforehand, play it safe and order the simplest dish.

BECOME A CONNOISSEUR

Wine consumption in America has grown exponentially over the last decade, and it is not uncommon to have someone at dinner carry on about the virtues of a great harvest or some hot new wine region. Display your savvy by joining in the exchange.

Quick wine overview

In America, when we refer to a type of wine, we are usually talking about the varietals or actual grape, like a Chardonnay or Pinot Noir. Some countries like France or Italy identify their wine by the appellation—the place where the wine is grown. Think Bordeaux or Chianti. And last, on the bottle, you'll find the brand, which is the vineyard like Yellow Tail or Mondavi.

An ideal way to learn about wine—to comprehend the different flavors and be able to discern varietals—is to pair it with food. Not only will certain dishes draw out the characteristics of wine, but some combos work to elevate each other. Classic pairings are Cabernet Sauvignon and steak, Pinot Noir with salmon or duck, Bordeaux with lamb, and port wine with blue cheese. My favorite duo is Champagne and salted nuts. The effervescence compliments the salt, kind of like the Coke-and-spicy-peanuts combo I used to love when I was a kid.

So, the next time a sommelier (restaurant's wine specialist) asks what you're looking for, rather than shrugging and looking doe-eyed, consider what you're eating and describe what you'd like in terms of a wine's four main characteristics: body, sweetness, acidity, and tannins.

Body: A wine's body refers to the weight and size of the wine in your mouth. Liken it to the way a steak feels heavy, while a piece of fish can seem lighter.

Sweetness: You can sense the sugar level of a wine on your tongue right off—that's the sweetness level.

Acidity: All wines are acidic, but acids are found more in white wines than red. People refer to the acidity by calling the wine "tart" or "crisp." The presence of acids usually makes you salivate.

Tannins: Tannins are found in the skin, seeds, and stems of grapes. Red wines tend to have more tannins than white wines, because the grapes are fermented with their skins and seeds. When your mouth feels like someone's sucked out all the saliva, you'll know tannins are present.

BEST WINES UNDER $15

THREE THIEVES

Packaged cheekily in jugs, boxes, and bottles, this label makes outstanding wine at inexpensive prices. Serve a liter jug of their Cabernet, and you'll have good accompaniment at your dinner and a great conversation piece. Their individual boxes of Chardonnay are perfect for outdoor parties.

HI WINES

This sleek line is great for curious wine lovers because they specialize in less common—but still lovely—wine varietals, like Garnacha. Their *Wine Spectator*–rated Prosecco is perfect for adding sparkle to your everyday affair.

JEAN-LUC COLOMBO

The premier winemaker from the Rhone region in France makes lush Syrah blends, and their elegant rosés evoke summers in the South of France.

ROBLEDO FAMILY WINERY

The first Mexican-American winery in the country, this family-owned business makes wines with precision and passion. Their "Seven Brothers" Sauvignon Blanc is *sabroso* on its own or when paired with food.

EY WINES

With a portfolio of wines made in French Catalan country on the border of southeastern France and Spain, their red Grenache and Roussillon wines are perfect winter dish alternatives to overpowering Cabernets or Chiantis.

Wine 102

To further your wine knowledge—and impress your friends and dates—move beyond the familiar varietals of Pinot Noir and Sauvignon Blanc. Instead, hit up your local wineshop and try bottles from new regions. "New World" wines—like those in e.g., New Zealand or Chile—can be good bets because they tend to be affordable.

For European varietals, Albarinos from Spain and Rieslings from Alsace are interesting whites, and can be found for $12 or less. If you're more into reds, explore Malbecs from Argentina and spicy Syrahs from the Côtes du Rhone or Australia (where it's known as Shiraz). The best way to be knowledgeable about wine is, frankly, to just drink a lot of it. When your mom raises an eyebrow, tell her you're not a lush, you are an aficionado. When drinking wine, take your time and try to engage all your senses. The more you look at wine in a glass, the easier you'll be able to discern its age and varietal. For instance, Chardonnays have a greenish hue, while a deep amber in whites are usual hallmarks of aged or late harvest wine. Next, swirl it around to help it oxidize and release flavors. Now smell. This is the really fun part. What are you getting? Citrus, butter, pepper, berries? Remember that everyone's palate is different, and there are no wrong answers. And when you taste, consider the aforementioned qualities of body, sweetness, acidity, and tannins. To help you improve your wine savvy, hit up tastings at your local wineshop. Not only are they free, but either the shop staff or a winery representative will be on hand to answer questions. (P.S. ladies. This is also a great way to meet dudes!) And if you've really caught the vino bug, wine schools and festivals across the country take volunteers to help pour at tastings. So sign up, and unleash your inner oenophile.

Meet up with the masters

An easy way to get enlightened is to visit your local museum. In addition to permanent and visiting collections, many museums also hold lectures and film screenings. Most offer free admission at least one day a week. Here's list of some of the best in the country.

NEW YORK CITY

The Museum of Modern Art (www.moma.org)
The recently renovated museum is home to Picasso's *Les Demoiselles d'Avignon* and Dalí's *The Persistence of Memory*. Go for free on Friday nights.

LOS ANGELES

The Getty Center (www.getty.edu)
Home to vivid van Goghs and sweeping vistas, this endowed museum is free every day but tickets must be reserved in advance.

CHICAGO

The Art Institute of Chicago (www.artic.edu)
This museum is home to the best collection of Impressionist art after the Musée d'Orsay in Paris, and it's free on Thursday evenings.

MINNEAPOLIS

Walker Art Center (www.walkerart.org)
With a new addition by renowned architects Herzog & de Meuron, the facade is as intriguing as its vast collection. Go for free on Thursday nights and the first Saturday of the month.

WASHINGTON D.C.

Smithsonian Institution (www.si.edu)
The world's largest museum is actually made up of 13 museums in D.C.—the National Zoo is a gem. It's free every day.

TEXAS

Kimbell Art Museum (www.kimbellart.org)
Home to one of the largest Asian collections in the Southwest, the museum's building was designed by the famed architect Louis Kahn. Go for free any day of the week.

GET ACQUAINTED WITH THE OTHER ARTS: THEATER, DANCE, AND OPERA

DISCOUNT TICKETS

A practical way to check out top-notch performances on the cheap is to go during the matinee, when tickets are usually half price. Also, if you're feeling lucky, go just before a performance is about to begin. Available tickets will be released then, so if you're truly dying to see a show, it's totally worth the chance. New York's famous Metropolitan Opera offers discounted tickets just before the curtain goes up for weeknight performances.

Save your student ID. Many theater and dance companies specifically save "rush" tickets for students.

Be an usher. I saw almost every major Broadway show that ran through San Antonio by volunteering as a seat escort at the city playhouse. This also works splendidly for smaller productions, as burgeoning companies are always in need of volunteers. If you get to know the crew, some opera companies pick their volunteers to be supers (nonsinging, nonspeaking extras) in the show.

Go to a dress rehearsal. Many theater and opera companies offer reduced or free tickets to their final dress rehearsal.

OPERA 101

If a night at the opera conjures up visions of portly men and women running around in Viking helmets screaming at the top of their lungs, it's time to get reacquainted with opera.

Start easy. Mozart's *The Marriage of Figaro* is a good intro to opera, as it is a comedy and the music is fun and enjoyable. Another one to try is the famous *La Bohème*. Puccini's masterpiece is about bohemians living in Paris, and it was the inspiration for the musical *Rent*.

Read the synopsis. Because most operas are in foreign languages (Italian, German, or French), you'll get a better understanding of the action if you read the story, or *libretto*, beforehand. Most librettos can be found online.

Embrace the glamour. In this increasingly casual world, a night at the opera will give a posh babe a gorgeous excuse to dress to the nines. Where else can you wear opera gloves but to the opera, dah-ling.

An architect is the drawer of dreams. —Gracie McGarvie

Have you ever played that game at parties where you take turns and declare what your fantasy job would be? Mine would be to be an architect. (This is truly a fantasy because I can't draw my way out of a Prada bag, and I have only the vaguest concept of engineering.) However, I think architecture is really one of the most dramatic of the arts and usually can be enjoyed free. To get a quick primer, buy an *Architecture for Dummies* book and walk around your town picking out the different styles. You'll undoubtedly get a newfound appreciation for your city and will burn some calories along the way.

How to be a practically posh collector

So you graduated from sappy van Gogh and Klimt posters to sophomoric DIY canvas paintings you and your roommate created in a Jackson Pollock-inspired alcohol frenzy. Well, now that you've evolved into adulthood and all its posh possibilities, it's normal to crave some *real* art for your pad. But when reviewing the bullish art market, alongside your smallish bank account, it might seem like your self-portrait nudes aren't so bad after all. Don't pout, Poshie. Quality pieces can be found to fit your practical budget. You just have to familiarize yourself with the market, and know where to look.

GALLERIES ARE YOUR NEW PLAYGROUND

When it comes to understanding the contemporary art world, the best way to become well-versed in artists and their styles is to study their works. By visiting different exhibitions, you'll become acquainted with the different genres: contemporary painting, photography, sculpture, new media, ceramics, metalsmithing, etc.; and can naturally develop your own aesthetic. The best way to help you make sense of different art genres and recognize recurring themes is to attend a gallery opening. What's especially helpful about these exhibit kickoff parties—besides that most are free, open to the public, and serve wine—is that artists are usually on hand to answer questions about their work and motivation. Lisa Hunter, author of *The Intrepid Art Collector*, says to spare no shame when trying to decipher art. So don't feel shy about approaching an artist and asking them point blank, "What does this weird, I mean *layered*, work mean?" If the artist is unavailable for discussion, direct your questions to the gallery owner about the exhibition and artist. Who is she, what is her background, and straight up, what was she going for here? Asking for guidance will not only help demystify an exhibit, it will help you actually enjoy it. To be alerted of special openings or parties, get on the mailing list of local galleries, in person or via a Web site. Openings are also often listed in the weekend events section of your local paper. Also attend art fairs, art shows, and student exhibitions; or take a studio tour. All of these venues are more casual than tony galleries, so interaction with an artist is usually easier. For a list of these events in your hood, check out galleryguide.org.

How to buy art on the cheap

Having authentic art in your home is not only an investment, it says to the world, "Look at me, Ma, no more museum posters!" The first step in becoming a practically posh collector is to set a budget. Once you have that in mind, the hunt is on! If you have:

$20 TO $200

Prints (Quality paper copies of paintings or photography) are ideal for first-time buyers because they're relatively inexpensive, but are still salable in case your taste changes. Check out www.20x200.com, which sells a batch of 200 small quality prints (photos and works on paper) from emerging artists for $20. They also sell a batch of 20 larger-sized prints for $200 each, get the idea? They introduce two new pieces weekly at 2 p.m. EST on Tuesdays and Wednesdays. Every print comes with a certificate of authenticity numbered by the artist. Also peruse: www.blueflipart.com, www.tinyshowcase.com

$100 AND UP

Original works from students www.Ugallery.com features works from art students across the United States. What's especially helpful about this site is that it lets you choose by price point and genre, plus it has a tool that shows you how big the piece will look in your living room. If you live near an esteemed art or design school, it's worth checking out art shows that are open to the public. Buying work from these fledgling artists will save you a lot of money because once the work makes it to a gallery, you can easily add another zero to the end of that price tag.

$300 OR LESS

Big name photography. The trick to scoring serious photos is to buy through nonprofits that sell them as a fund-raiser. (Nearly all of the top contemporary photographers donate prints to some nonprofit or other.) Check out:

The Museum of Contemporary Photography
www.mocp.org

Aperture
www.aperture.org

Blind Spot Editions
www.blindspot.com

Humble Arts Foundation
www. humbleartsfoundation.org

$500 OR MORE

Original work from unknown artists and limited edition prints from renowned artists. A good place to buy original art is Charles Saatchi's "Your Gallery" Web site (www.saatchi-gallery.co.uk/yourgallery), where artists show their art for free, and you pay no commission. Paceprints.com and villanieditions.com are both reputable print dealers and have a selection of prints under $1000.

For ongoing tips on acquiring affordable art, check out Hunter's "Taste without a Trust Fund" column on her blog: howtobuyart.blogspot.com.

WHAT'S HOT NOW

Anything studio-crafty, like ceramics and textiles, is a burgeoning market right now, according to Hunter. In fact, she likens it to the photography market in recent decades. The key to this wave is accessibility; good pieces can still be found relatively affordable. Try to attend craft fairs and studio shows to understand the market, then forage garage sales for pieces—like wooden bowls from the 1970s—that can be bought on the cheap.

TREASURING YOUR GEM

After you've spent a nice chunk of cash, it's important to properly care for your new acquisition. I know you want to show off your masterpiece by hanging it over the fireplace, but that's the absolute worst place to put it. Because artwork is made of organic materials, it can easily expand or ripple due to heat or light. Make sure to keep your piece out of the sun so the colors don't fade. Also, make sure your walls are strong and that the piece is hung properly, lest it come crashing down during a dinner party.

Robyn's Tip

If you fall in love with an artist's work at an exhibit, but find his or her art is out of your price range, ask if he or she has any limited-edition prints, which are paper copies of works from their collection. These affordable alternatives are the perfect compromise to having your dream piece, and they have their own distinct value. Another way to find a print you like is to research the inspiration of your favorite artist. For instance, if you are a big van Gogh fan, look into buying Japanese prints, because they influenced his work.

Big spender

Whether you have come into some money or are trying to make an investment, if you're looking to pay substantial money for art then buying from a reputable dealer is the way to go. Because forgery is rampant in the art world, and especially hard to detect for the novice, working with an established dealer gives you valuable insurance against fraud. To avoid getting duped by a dealer, do your homework: make sure they are a member of a major dealer association, and feel free to ask for references.

CAROLYN LANCHNER Joan Miró THE MUSEUM OF MODERN ART, NEW YORK

Editions de La Martinière BALTHUS STANISLAS KLOSSOWSKI DE ROLA

PAGES OF PERFECTION

Marshall Jean-Michel Basquiat Whitney/Abrams

Jean Dubuffet 1943–1963 PAINTINGS SCULPTURES ASSEMBLAGES Hirshhorn | Smithsonian

Paul Klee GUGGENHEIM MUSEUM

SURREALISM desire unbound EDITED BY JENNIFER MUNDY TATE

PALADINO Prestel

JOSEPH CORNELL THE MUSEUM OF MODERN ART, NEW YORK
EDITED BY KYNASTON McSHINE

Ben Nicholson

Norbert Lynton CHARTA

BUY SMART

Rule number one: Whether you're buying for investment or fun, you should always love what you're buying— you'll have to live with it. When considering buying for investment, do some research on how much of a market exists already.

And consider that collecting is a lot like the stock market: speculative. The buying low and selling high killer combo is hard to come by, lest we all be Warren Buffetts. But there are some solid "blue chip" artists who retain their value. Hunter recommends buying from an artist who was once hot, but has now cooled, as in art like any cyclical business, there is a good chance they could rise to fame again. Another option is to buy a style that an artist is not particularly known for—like purchasing a sculpture from a painter.

BUYING ABROAD

It's always fun to buy art when you're traveling. I brought back wooden statues from Bali that I absolutely love; in fact, they decorate my living room. But when purchasing abroad, especially in a tourist area, it's highly unlikely you'll encounter a great prize. It's better to think of it as a memento from your trip rather than a major find.

Five easy ways for the PP beauty to look cultivated

1. LEARN ANOTHER LANGUAGE.

There is nothing that makes you look more worldly (and sexy) than speaking in another tongue. You've probably taken a couple of years of some foreign language in high school and college, so just build on that (unless you took Latin like I did, in which case you're screwed). Having an ear for languages is a talent; trust me, I know. I am Mexican American and I still have to take Spanish classes. Look on the bright side. You already know English, and that's an incredibly hard language to learn, or so my English-as-a-second-language friends tell me.

To make things easier—and more affordable—list a posting on the Web site of your local university, looking for lessons from a foreign exchange student. (I vote you learn Portuguese from a sexy Brazilian.) I know a girl who married her Spanish tutor. She and Juan Pablo now have a bun *en el horno*. If you are more pressed for time than money, do as I do and get tutored online. My professor Jorge at Easyespanol.org calls me every Friday on Skype (a program with a cult following, which you can download at skype.com and talk to other Skype users for free) and via webcams and instant messaging, and we have our class. It's *perfecto*, because I'm never late. All I have to do sit upright, and put some clothes on.

WHEN IN ROME

A well-traveled babe oozes sophistication, but even if you haven't summered in St. Tropez or visited the market in Marrakech, being able to throw out a few phrases in another language gives you instant cred.

SPANISH

Hello. Hola.

How are you? Cómo está usted?

Fine, thank you. Muy bien, gracias.

Where is the restroom? Dónde están los baños?

Where is the ATM? Dónde está la ATM?

Where is your favorite restaurant? Dónde está su restaurante favorito?

May I have?... (for ordering in a restaurant): Prefiero

How much does this cost? Cúanto cuesta?

How does this look? Qúe tal esto?

Are you single? Usted es soltero/a?

I have a boyfriend, he's on his way. Tengo un novio, está por llegar.

Want to walk me back to my hotel? Me quieres llevar de regreso a mi hotel?

Want to come up for a drink? Quieres venir a mi hotel por una copa?

That feels good: Qúe bien se siente

Bye: Adíos!

FRENCH

Hello. Bonjour.

How are you? Comment ça va?

Fine, thank you. Oui, ça va. Merci.

Where is the restroom? Où sont les toilettes?

Where is the ATM? Où est le distributeur automatique?

Where is your favorite restaurant? Où est votre restaurant préféré?

May I have... Je prend

How much does this cost? Combien cela coûte-t-il?

How does this look? De quoi cela a-t-il l'air?

Are you single? Étes-vous célibataire?

I have a boyfriend, he's on his way. J'ai un petit ami, il arrive.

Want to walk me back to my hotel? Tu veux me raccompagner à mon hôtel?

Want to come up for a drink? Tu veux monter prendre un verre?

That feels good. C'est bon.

Bye! Au revoir!

CHINESE

Hello. Ni hao.

How are you? Ni hao ma?

Fine, thank you. Hen hao. Xi xi!

Where is the restroom? Xi shou jian zai na li?

Where is the ATM? Qin wen zi dong kuan ji zai na li?

Where is your favorite restaurant? Ni zhui xi huan de chan guan zi na li?

May I have... Wo ke bu ke yi yao

How much does this cost? Zhe ge duo shao qian?

How does this look? Zhe ge hao kan ma?

Are you single? Ni shi dan shen ma?

I have a boyfriend, he's on his way. Wo you nan peng you.
Ta jiou kuai lai le.

Want to walk me back to my hotel? Ni xiang he wo yi qi
san bu hie jiou dian ma?

Want to come up for a drink? Ni xiang he wo yi qi san bu
hie jiou dian ma?

That feels good. Zhi ge gan jiu hen hao.

Bye! Zhi jian!

PORTUGUESE

Hello. Oi.

How are you? Tudo bem? / Como você está?

Fine, thank you. Bem, obrigado (for man) / Bem, obrigada
(for woman)

Where is the restroom? Onde é o banheiro? / Onde é o
toalete? (more formal)

Where is the ATM? Onde é o caixa eletrônico?

Where is your favorite restaurant? Onde fica seu
restaurante favorito? (We usually ask What is your favorite
restaurant? Qual é seu restaurante favorito?)

May I have... Eu gostaria...

How much does this cost? Quanto custa isto?

How does this look? Que tal?

Are you single? Você é solteiro? (man) / solteira? (woman)

I have a boyfriend, he's on his way. Tenho namorado, ele
está chegando.

Want to walk me back to my hotel? Quer ir comigo ao
meu hotel?

Want to come up for a drink? Aceita subir e tomar um
drink?

That feels good. Isso é bom.

Bye! Tchau

2. INCREASE YOUR VOCABULARY.

Throwing out a big word every now and then invariably
makes you seem more learned than you really are. Go
to websters.com, and sign up to get a free "word of the
day" via e-mail. Soon you'll be calling your roommate
"impecunious" instead of "broke-ass." Much more
civilized, no?

3. READ MORE. ALWAYS CARRY A BOOK WITH YOU.

You'll eventually read it on the train, bus, or waiting in line.
I lugged *One Hundred Years of Solitude* by Gabriel García
Márquez around with me for so long that my friends joked
it had turned into *One Thousand Years of Solitude*—so
clever. The point is that I finished it—in considerably less
than a century, thank you very much.

4. BECOME NOBILITY.

If it's just as easy to marry a rich man than a poor one, is
it really so hard to land a count instead of an accountant?
With active monarchies all over the globe—mostly in
Europe, the Middle and Far East, and wherever England
has a principality—it reasons there's a duke just
waiting for his special duchess to walk by. If you can't
jet to principalities like Liechtenstein or Monaco, try
crashing a blueblood event like a polo match in London
or the Hamptons or a sailing regatta in the Bermuda or
Caribbean. Or you could just save up miles for first class:
my friend Monica married a Belgian baron she met on a
plane. Turned out the dude was a little loco, but she walked
away with a title and a bestselling book deal. But you don't
need some Lord to turn you into a Lady, you can actually
buy your own title. The Manorial Society of Great Britain
(www.msgb.co.uk) sells official seated lordships and their
manors for several thousand dollars. But at English Titles
(www.english-titles.co.uk) you can buy a noble title for
the common price of $325 that allows you to change your
driver's license. Marquesa Moreno has a nice ring to it.

Get Packing

"Don't tell me how educated you are,
tell me how much you've traveled."

Mohammad

There is no better setting for a practically posh girl to show off her versatility than when traveling. Effortlessly adaptable and always up for fun, she can enjoy her epicurean side eating rich mole poblano in Puebla, Mexico; she can play the bon vivant sipping champagne while sailing past St. Lucia and she can gamely grunge out in a retro 1970's van while on a cross-country road trip.

The only hitch with travel that a practically posh explorer may face is a shortage of funds or vacation days. But with a little forethought and flexibility, visiting a sublime destination is more doable than you think. Repeat after me: "Travel is not a luxury; it is a *necessity*."

How to make the exotic accessible <u>and</u> enjoyable

Do you fantasize about tangoing in Buenos Aires or scouting the Serengeti? It will be easier to plan around your salary and schedule once you define your dream. Start by considering the type of vacation you're looking for. Do you want to ring in the New Year on a beach in Rio, or would you prefer to meditate with monks in Tibet? Honing in on what type of holiday experience you're hoping to achieve—rugged, romantic, or relaxing—will help you get the most out of your precious time away.

It's also important to update your dreams to suit your current taste. You may have wanted to hike the Inca Trail at Machu Picchu for as long as you can remember, but do you now prefer refined living to roughing it?

"People don't change their lifestyle when they change location," Peter Greenberg, travel correspondent for *Today*, once warned me. So while you don't have to abandon your Machu Picchu fantasy, just make sure there's a posh hotel and a pisco sour waiting for you on top.

Next, consider if your locale can be experienced in a quick jaunt or is better suited for a longer trip. Because we Americans don't have four- or five-week vacations like

our European counterparts, it's important to master the art of the long weekend. Whether you're taking a retreat to a B&B in a neighboring town, or hopping a plane to Reykjavik, Iceland, for a weekend (only five hours from New York), the practically posh traveler knows how to savor her precious days off. Sign up for weekly last-minute deals from airlines like Continental (continental.com) and American Airlines (aa.com), or even travelzoo.com (which compiles the best deals of the week from all carriers) and you'll receive e-mail notification on Wednesday and Thursday telling you what your travel options are this weekend.

The Benefits of Procrastinating

Ha! This may be one of the only times that being late—I mean *spontaneous*—pays off. Check out these Web sites for fantastic last-minute deals:
www.Site59.com
www.Kayak.com
www.Expedia.com
www.Travelocity.com
www.11thhour.com
www.Lastminutetravel.com
www.sidestep.com
www.mobissimo.com
www.orbitz.com

Go with the flow

Someone stole your passport. You spent the better part of your trip in bed, or on the toilet, with a virus. You spent your romantic holiday fighting with your boyfriend because he kept checking his iPhone. Mishaps occur, and bad luck can find you even on vacation. But while you can't always control annoying situations, you can control your reaction to them. It's raining in paradise? At least you're not at work! You have to work? Better here than in the office! Boyfriend's being a jerk? Treat yourself to a massage at the spa, and charge it to his credit card.

Besides, the best travel stories come from supposed catastrophes. I once went spring skiing in the French Alps, but it was so gloriously warm and sunny that the snow turned to soup. After trudging along in the mess for a while, we had to admit defeat, and we left the mountain sweaty and pouty. *C'est triste!* With not much else to do in this adorable but tiny town, we hopped into the car and drove south. We made our way to the wine region of Châteauneuf-du-Pape and wound up having a spectacular dinner. The next day outside the village of Les Baux-de-Provence, we happened upon a small olive oil farm with a tasting room. As the proud owner excitedly gave us a tour, my thoughts turned toward my new life as an olive oil producer. Alas, it was not to be, so I returned home with a suitcase full of tapenade and olive soap, and memories of one of my most favorite trips ever.

Bermuda
CUSTOMS INSPECTED
No 538877

TRAVEL BABE QUIZ

**STILL UNDECIDED ABOUT YOUR NEXT BIG TRIP?
TAKE MY QUIZ AND FIND OUT WHAT KIND OF
JET-SETTER YOU ARE.**

What sign are you?
a. Earth
b. Water
c. Fire
d. Air
e. Dollar

What's your favorite vacation activity?
a. Morning meditation
b. Catching a wave
c. Browsing through a new gallery
d. Cocktails by the pool
e. Checking out the local shops for tonight's outfit

What's the one thing you couldn't leave home without?
a. Travel-size aromatherapy candles
b. Running shoes
c. City guide
d. Wine opener
e. Extra bag to bring home newly acquired purchases

What would be your vacation nightmare?
a. Bad yoga teacher
b. Spraining your leg hiking
c. Museum is closed for renovation
d. Last call is at midnight
e. Maxing out your credit card

IF YOU PICKED MOSTLY As: You're a Zen Mama, and you'll "ohm" and "ah" to your heart's content in yoga retreats and spa getaways. For a practical wellness weekend, visit Ojo Caliente Mineral Springs Resort & Spa in New Mexico. Relax in the centuries-old hot springs, which were used by Native Americans for medicinal purposes. Or sign up for an $8 yoga class. Rooms start at $99, but if you really want to be one with nature, camp along the nearby Rio Ojo Caliente River for $12 a day. Ojocalientesprings.com. For a more eco-posh stay, try the Bikini Boot Camp at Amansala Resort in Tulum, Mexico, where you can lounge in a luxe palapa, dine on fresh seafood, hike ancient Mayan ruins, take a killer yoga class, and enjoy a beachside massage in front of the sparkling Caribbean Sea, all for $325 a day. Six-night minimum. Amansala.com

IF YOU PICKED MOSTLY Bs: You're a Nature Babe, and you crave outdoor beauty and adventure. The North Shore of Oahu is still the premiere surfing spot to catch a choice wave, and flights can be found cheap to Hawaii from the West Coast. On the East Coast, hit Montauk on New York's Long Island. It lacks the pretension of the nearby Hamptons and boasts huge swells and minimal crowds. Stay at the inexpensive East Deck motel where the cute surfers hang. Enjoy a cocktail and killer sunset at the Montauket.

IF YOU PICKED MOSTLY Cs: You're a Culture Chick, and you would be happiest catching a play or hitting a museum. Make a beeline for Los Angeles. It's home to Paris Hilton, true, but from the splendid Getty Center to hipsters in Silver Lake and smart galleries like Regen Projects in West Hollywood, it also has one of the best art scenes in the world. Catch the world-famous Philharmonic at the Hollywood Bowl—that's hot.

If you're closer to the Midwest, make a trip to Minneapolis, Minnesota. Birthplace of Prince, the city has expanded its repertoire and is now famed for its arts and architectural scene. Design buffs can check out the works of renowned architect Jean Nouvel at the sleek Guthrie Theater. And Frank Gehry's trademark ribbon-and-steel–style is on display at the Weisman Art Museum at the University of Minnesota. The city's plethora of lakes make it a lovely summer destination, but don't be scared by the tundra-like winters: the city has created a maze of skywalks that connect its buildings, so you can explore Minneapolis without braving the cold. The trendy Graves 601 Hotel offers deep discounts in winter.

IF YOU PICKED MOSTLY Ds: You're a Girl Gone Wild, and you are in your element in trendy bars while kissing foreign men. Head to steamy Buenos Aires for its burgeoning nightlife. My friend Holly, a travel blogger at lostgirlsworld.com, loves partying with the *porteños* and enjoying a three-course meal with wine for $15. You can also grab your girls and fly to cosmopolitan Mexico City. Stay at the ultracool, yet reasonably-priced, Hotel Condesa (Gael García Bernal is a regular!) and practice your Spanish with the town's glitterati.

IF YOU PICKED MOSTLY Es: You're a Shopping Maven, so make a beeline for The Big Apple, home to unarguably the best fashion in the world. From big-name stores like Barneys to the affordable small collection pieces at The Young Designers Market in Soho to trendy discount retailers like H&M, and one-of-a-kind finds at Olive's Very Vintage in Brooklyn, a practically posh shopper will have a heyday in the cit-ay.

Shopping abroad

The Euro is a killer, but if you find yourself abroad, ATMs give the best up-to-the-minute exchange rates, so opt those for cash withdrawals, and skip the money exchange booths. ATM machines do come with transaction fees though, so find out what your bank fees are before you go, and minimize them by making fewer and larger withdrawals. (Keep your money safe in a hidden waist belt or a thigh band.)

Get money back on purchases, by applying for a Value Added Tax (VAT) refund. South Africa, Canada, and many European countries offer tax back on items you purchased while abroad. Basically, a VAT is included in the price of a product, but because you are a foreigner, you are eligible to get your money back. Ask about it at the store where you bought your item (probably not applicable with street vendors) and they'll give you a form to fill out or will stamp your receipt. Take this form and your receipt to the VAT window at the airport, and they'll either give you cash or refund your credit card. It could be up to 15 to 25 percent of the total purchase. They usually want to see your goods, so do this before check-in.

Movie and book-inspired travel

A great way to come up with a travel destination is to visit the setting of your favorite movie or book. Last year I visited Bali after reading *Eat, Pray, Love* by Elizabeth Gilbert, a travel memoir about a woman who travels to Italy, India, and Indonesia after going through a bitter divorce. Her vivid descriptions of Bali's beauty and its people beckoned me. I even tracked down the ninth-generation medicine man she descriptively wrote about. Meeting him—Ketut—was such a surreal experience. It was like having a character come to life, which I guess he was. Not to mention he endeared himself to me when he read my palm and told me I was going to be very successful, happily married, and would live to be 115.

OTHER GREAT CINEMATIC AND LITERARY DESTINATIONS:

Visit Marrakech, Morocco—a highlight of romantic North Africa written about by Paul Bowles in the classic *The Sheltering Sky*.

Stroll through the Palace of Versailles outside of Paris, home to Marie Antoinette and where Sofia Coppola's biopic was filmed. Continue your indulgent tour by enjoying a pricey cocktail at the Bar Hemingway at the Ritz Paris. A favorite of Coppola's, it was also frequented by Papa himself, as well as writers James Joyce and Graham Greene.

Stay at the Park Hyatt Hotel in Tokyo, where Bill Murray and Scarlett Johansson met in *Lost in Translation*. Enjoy amazing views of the city and a sake or Suntory at the New York Bar, where Bill Murray spent much of his time. (Drop by before 8 p.m. to avoid a cover charge.)

Follow in the footsteps of Che Guevara's *The Motorcycle Diaries*. Che and his pal left Buenos Aires on a motorcycle and traveled to Santiago, Chile, where they then hitchhiked and sailed their way north through Chile, Peru, Colombia, and finally, Venezuela. In 2004 Bolivia opened the Che Guevara Trail, where Guevara spent his final days before he was murdered. Visit care.org for more information.

Watch grizzlies in Alaska, from a distance, like the ill-fated narrator in *Grizzly Man*. My friend Shirley was so obsessed by Werner Herzog's documentary about bear-enthusiast Timothy Treadwell, who lived, and died, with the brown grizzly bears in Kodiak Island, Alaska, that she took her honeymoon there. Princess and Holland Cruise Lines stop in Kodiak, and you can access the island by air from Anchorage or by ferry from Whittier or Homer.

Traveling on a dime

Now that you know where you want to go, here are some pointers for scoring affordable flights and accommodations.

EMBRACE THE OFF-SEASON

Not only will you get about a 50 percent discount on airfare and hotels, you'll also have great memories of that Thai beach without having to share it with throngs of tourists, or you'll remember the superb service you received from your not-totally-slammed waiter. In Europe, the low season is generally October through April. The Caribbean low season begins in mid-April and continues through mid-December, but try to avoid late August through September because of hurricane season.

GOT MILES?

When a boyfriend signed me up for Continental Airlines' One Pass program seven years ago, I rolled my eyes and almost immediately lost my card. But after sticking with the program, I eventually earned a free ticket to Hawaii: Score! Not only have I seen the light, now I'm a full-fledged mileage addict. And once you get your first upgrade to business class, trust me, you will be, too.

Not only do frequent-flier programs allow you to earn free tickets and free upgrades to first class, but you also get priority check-in, which means you get to skip the miles-long "commoner" check-in line and board first, so there's always room for your overhead luggage. In addition to earning mileage by flying, you can also rack up miles when you sign up for an airline-affiliated credit card, or by frequenting certain hotels and restaurants.

I recommend you be a mileage whore, and sign up for a program with every airline you fly. So whether you're traveling for work or pleasure, you can always be sure to stockpile some mileage. Then you can sit back as the rewards start pouring in. To get started, check out the Web sites of major airlines. If you are annoyingly close to getting a free ticket, but don't have enough miles, try borrowing or buying some from a friend; many airlines let you transfer a certain amount. You can also purchase them from the airline, as long as you are only missing 25 percent or less of your ticket mileage. Many airlines offer partnerships between airlines, so know who the partners are so you can ring up those points as well.

BECOME A MULE

In the movie *Broken English*, Parker Posey and Drea de Matteo, serve as couriers to get airfare to Paris, and one of them hooks up with a hot Frenchman. While the delivery to a handsome stranger may be a possibility, the free passage is not. But you still can get deeply discounted airline tickets all over the world to carry packages or documents for companies. Check out Web sites like www.courier.org or www.aircourier.org, where you can pay a fee for membership (from $35 to $100) and they'll alert you about upcoming itineraries.

MIDNIGHT EXPRESS

You've probably heard of the Eurail Pass, a train pass you can buy that will let you travel to an unlimited amount of countries in the European Union. It may seem very collegiate, but with 18 countries included, from Portugal to Hungary, it's the smartest way to see Europe. Visit www.eurail.com for schedules and passes. Although train travel is less popular in the United States, a great way to see America and our northern neighbor Canada is with the North America Rail Pass. Operated by Amtrak and VIA Rail Canada, the pass provides 30 consecutive travel days with unlimited rides and stopovers throughout the United States and Canada. Visit www.amtrak.com for more information.

Home away from home

If you want to make a home-cooked meal abroad and look at a city through the eyes of a native, renting an apartment is a great option. Check out www.homeaway.com, www.craigslist.org, and www.NewYorkHabitat.com for cool accommodations.

COUCH SURF!

If you're extra-strapped for cash or maybe want to meet some people when traveling, send a mass e-mail to friends and relatives looking for locals to host you. My friend Stephanie, author of *100 Places Every Woman Should Go*, said she made lifelong friends and her fair share of lovers this way. If you're heading somewhere a bit out of the way, check out www.couchsurfing.com or www.globalfreeloaders.com—members around the world offer up free places to stay to promote cultural exchange and in the name of good travel karma.

EASY CRUISING

Always wanted to take a cruise? The all-inclusive aspect can be convenient but costly. It's best to book during "wave season," which runs from January to March, when cruise lines operators offer a variety of promotions and deep discounts.

Discounts on traveling during off-season apply here too, so it's best to travel January through April and September through November. The summer is high season for European and Alaskan cruises, and those that sail to the Caribbean are packed during the holidays, so avoid those. Save money by booking your trip with a nearby port city, so you can drive rather than fly. Popular port cities include Galveston, Texas; New York City; Miami, Florida; Los Angeles; and Seattle, among others.

A hip, and budget-friendly, addition to the cruise industry is the EasyCruise. Working more like a floating hotel than a luxe all-you-can-eat liner, guests pay peanuts for a room (as low as $19 a night depending on the itinerary) but must pay separately for everything else, including food, drinks and maid service. What's unique about EasyCruise is they spend more time at destinations than other liners, usually from noon to 3 a.m., so you can get a better taste of a place. Their most popular cruises include island-hopping the Caribbean and the Greek Isles. Check out easycruise.com for more information.

I've posted my apartment on a rental Web site many times while I was traveling. It's a great way to earn cash to fund my sojourn, and it's a great deal for someone else because they get a cute and conveniently located apartment at a fraction of what a hotel would cost in New York City.

If you have an apartment or home in a desirable location, another lodging possibility is to apartment-swap. Try www.apartmentexchange.com or www.intervac.com to check out what's available.

A smart way to save money on food when traveling is to hit up the grocery store ASAP. Not only will you feel like a local in the neighborhood store, but you'll get to discover cool new brands and enjoy the local cuisine cheaply. Stock up on meats and cheese and enjoy a lunchtime picnic. You can also buy snacks, like nuts and chips, and alcohol, so you can enjoy an aperitif in your room, which saves you money on expensive pre-dinner cocktails. And definitely buy water, as grabbing some from the minibar after a boozy night will cost you.

Grocery stores are also the best places to buy inexpensive souvenirs. I usually bring back local bars of chocolate or jam, and native liquors. I also like loading up on beauty products like soaps and body washes. My favorite French soap is called Le Petit Marseille—it features an adorable illustration on the label. It's always a hit when I give it to someone, and it's only $3!

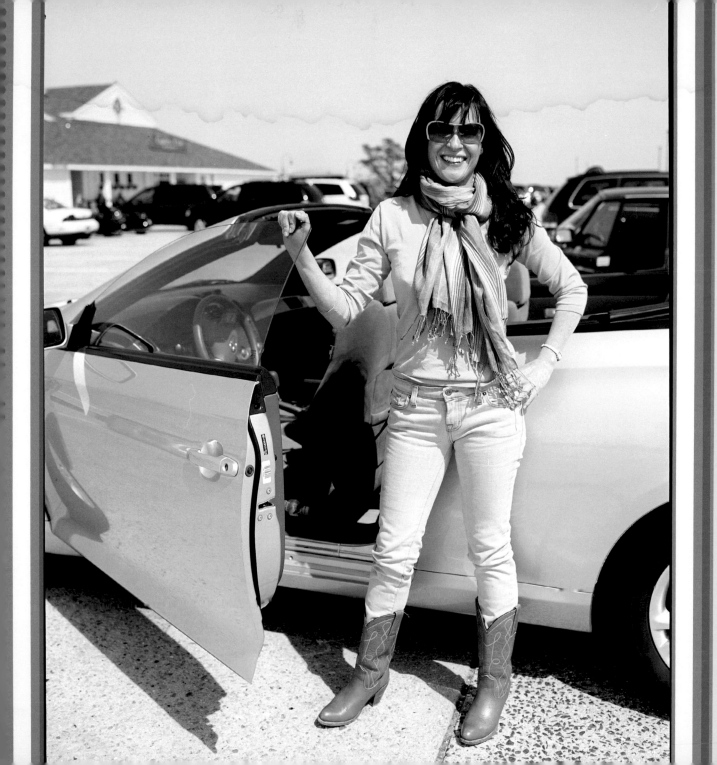

THREE AWESOME TRIPS—THREE COOL ALTERNATIVES

Fake it till you make it!

1. If you can't get to the City of Light (Paris), opt instead for *magnifique* Montreal.

Just north of the Canadian border, Montreal is the second-largest French-speaking city in the world. A combination of Old-World charm and modern sensibility, it's the ideal destination for chicks seeking a cultural escape. Vieux Montréal (Old Montreal) in the heart of the city boasts beautiful views of the St. Lawrence River and Montreal's own Notre Dame Basilica. Popular for both shopping and dining, the hip Le Plateau neighborhood has great boutiques showcasing local designers. After perusing the goods, enjoy a steak frites and glass of wine at L'Express, the perennially chic brasserie. The music scene in Montreal is *très chaud*. Head to Boulevard Saint-Laurent, where indie venues play local favorite Arcade Fire and fashionable cafés dot the street. For centrally located digs, lay your head at Fairmont, the Queen Elizabeth, site of John and Yoko's 1969 "love-in." The adorable Auberge de La Fontaine is a cozy and reasonably priced alternative. Make sure you apply for a tax refund on goods or hotels (see page 200). Check out www.tourismmontreal.com for more information.

2. Instead of visiting vineyards in Bordeaux or Tuscany, stay stateside and head to the rolling hills of the Shenandoah Valley, just outside Charlottesville, Virginia or go west to Oregon's Willamette Valley.

Home to 122 wineries and growing, Virgina has a heralded wine tradition since Thomas Jefferson brought back grapes from France to grow on his property. The area is now known for its Bordeaux-like varietals, especially the Cabernet Franc though. The region's sparkling wine also has a cult following. In addition to winery tours, visitors can tour Jefferson's home, Monticello, an architectural wonder, as well as, Montpelier, home to James Madison. As lush as the English countryside, the area also boasts many riding stables. Keswick Hall, located on acres of verdant farm country, is truly a posh stay. Visit virginia.org for more information.

Located an hour southwest of Portland, lies the heart of America's Pinot Noir country: the Willamette Valley. With over 250 wineries, oenophiles will have a heyday. When you've had your wine fill, visit progressive Portland for its renowned food scene, or if craving a little nature, you're only a 2-hour drive to the Oregon Coast or Mt. Hood, where you can ski, windsurf, or hike depending on the season. Visit traveloregon.com for more information.

3. Always wanted to get lost in Patagonia? Why not head to Big Bend National Park?

Located in the southwest corner of Texas, Big Bend is one of the country's largest national parks with 801,000 acres of land. It's also one of the country's least-visited parks, so it can provide a true sense of the wild. Raft down the Rio Grande or hike the Chisos Mountains to view the massive canyons. Camping grounds are available at Big Bend, or stay at Lajitas, an upscale resort 42 miles east of the park.

Another stellar scene is nearby Fort Davis, Texas. It's one of the darkest spots in North America, which makes it the ideal home for the McDonald Observatory. Open from 9 a.m. to 5 p.m. daily, the observatory is a must-see for fledgling astronomers. Because the area's skies are so unobscured, meteor showers and comets provide awesome galactic fireworks that aren't visible elsewhere. You can even see Andromeda, our closest neighboring galaxy, with the naked eye. An affordable and charming place to stay is at Hotel Limpia in downtown Fort Davis. While you're in the area, take a drive to the town of Marfa and check out installation artist Donald Judd's Chinati Foundation, an art museum that houses permanent large-scale installations on 340 acres of land. For more information about the park, visit www.nps.gov/bibe, for information on the observatory, visit mcdonaldobservatory.com and to get information about the museum, visit chinati.org

BACKYARD TRAVFL

When I was little, my family and I would take yearly road trips to California to visit our relatives. We'd all pile into our family van—usually accompanied by a stowaway cousin and a case of Big Red soda to be offered as a housewarming present—and take off. After slowly making our way up the long, boring stretch out of Texas, then veering west through the haunting desert beauty of New Mexico and Arizona, we'd finally arrive in Los Angeles: home to Disneyland, Hollywood starlets, and my cousins' backyard pool.

Sometimes we stopped at the Grand Canyon, and other times we'd keep driving north to the soft beaches of Santa Barbara. We visited the stunning Sequoia National Park, and I remember being awed—not only by the massive trees, but also by the giant chipmunks I imagined living in them.

These "Mexican Meccas," as my sisters and I jokingly referred to them, sparked the curiosity and wanderlust that define me today. And, best of all, they required no plane tickets or passports.

While I strongly encourage you to see other parts of the world, until you get that lovely combo of both time and money, you can still satisfy your desire to travel by visiting the many stunning sites North America has to offer.

Cross country road trips

Grab a pal and channel Thelma and Louise as you journey across the United States. Traveling by car is as American, and as easy, as apple pie, so pick a route and hit the road.

THE PACIFIC COAST

Cruise from sunny San Diego, California, all the way to the glacier-capped peaks of Olympic National Park in Washington State. The 1,500-mile trip takes you along the water through the distinctive cities of San Francisco and Los Angeles. One of the best parts of the trip is the stunning stretch of the Pacific Coast Highway that runs from north of Santa Barbara and winds through the coastal California towns of Cambria, Big Sur, Monterey, and Santa Cruz—all sandwiched between redwood forests and the sparkling Pacific Ocean.

THE ATLANTIC COAST

The New York City to Key West, Florida 1,450-mile route runs through the quirky coastal towns of Atlantic City, New Jersey; Ocean City, Maryland; and Myrtle Beach, South Carolina, then threads through the languid low country of Charleston, South Carolina, and the gentle southern town of Savannah, Georgia. You'll smell the change in the air when you hit vibrant Daytona Beach and pass West Palm. Stop to take in the Eurotrash glamour of Miami, and end with kitschy Key West.

SEA TO NORTHERN SEA

Probably the most varied and extreme landscapes will be found along this route that travels from Acadia National Park in Maine to Seattle, Washington. Often referred to as "the Great Northern" because of the pioneer railroad that runs along the western half of the road, the route along US-2 is the longest of the cross-country road trips. It's impossible to pick a favorite spot, but highlights include Acadia Park, where you can see Canada beckoning across the water, the haunting Great Plains where Sioux, Cheyenne, and Blackfoot Indians roamed alongside buffalo, followed by Glacier National Park and its natural beauty, keep you riveted for miles to come. It's a testament to the ethereal beauty of the drive that Seattle is but a footnote.

ROUTE 66

You can still get some kicks on Route 66, but some spots on this over-2,000 mile trail have become a little dilapidated. Starting off in the Windy City and ending in the City of Angels isn't so bad, and if you're looking for greasy spoons and campy Americana, you probably can't do much better. Plus, you'll get a good lesson in fortitude by following the path so many took to California after being displaced by the Dust Bowl during the Great Depression. Highlights include eating some hometown barbecue in St. Louis and checking out the original London Bridge, which inexplicably ended up in Lake Havasu, Arizona.

Check out www.roadtripusa.com for detailed routes and recommended stops along the way. This would be an optimal time to get your hands on a hybrid car so you can save some money on gas. But if you get together enough pals, you can split travel costs and maybe splurge for a convertible!

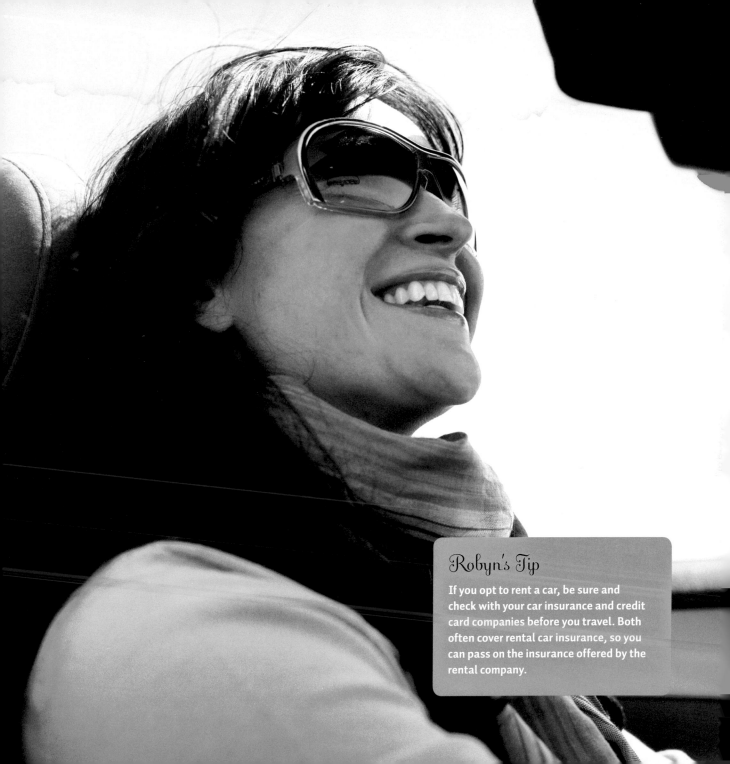

Robyn's Tip

If you opt to rent a car, be sure and check with your car insurance and credit card companies before you travel. Both often cover rental car insurance, so you can pass on the insurance offered by the rental company.

TRAVEL DETAILS

PASSPORTS AND PUERTO RICO

You now need a passport to enter both Mexico and Canada, and this includes cruises where these destinations are on the itinerary. The fee for adults is $97; you can get an application at the post office or your local library. You should receive your passport in about six weeks, but one can be expedited for an extra cost. Check out www.napvs.org for more information.

If you don't have a passport but are still craving a beach getaway, consider a vacation in Puerto Rico. Many airlines fly cheap and direct to the capital city of San Juan, since it's a gateway to the Caribbean. Admire the Spanish Colonial architecture of Old San Juan, one of the oldest towns in the Americas, then take a ferry to the idyllic islands of Vieques and Culebra. With blue-lagoon-like water, these affordable islands are truly paradise found. Visit www.gotopuertorico.com for more information.

WHAT TO PACK

Looking for a golden rule of packing light? Try to only take carry-on bags. Nothing says novice, or overindulged pop star, like loads of luggage. However, going straight to the gate is much more challenging with the new restrictions banning liquids, so you'll have to be clever when packing your cosmetic bag.

SECURING YOUR BEAUTY

According to the new airline laws, all liquids must be less than three ounces and fit in a Ziploc bag. I've found some airports to be stricter than others: I just returned from Miami and made it through security with my entire makeup bag intact! To play it safe, follow the rules and get creative. While most hotels offer normal toiletries like shampoo, conditioner, body wash, and moisturizer (which you should definitely stash extras of for your next trip), you can still take your own travel size: Kiehl's and Aveda offer mini versions. For contact solution, or other beauty must-haves, pack your favorite creams, gels, and balms in small plastic containers you can find cheaply at beauty supply stores. If you're headed to a sunny locale, consider that you'll probably be using more than 3 ounces. Or, if you need to stock up there, avoid hotel sundries stores that charge exorbitant prices for sunblock and hit up a local drugstore or check your bag. If you're bringing back local booze, you'd have to check in anyway.

NOW THAT WE HAVE THAT OUT OF THE WAY, A PEEK INSIDE YOUR SUITCASE SHOULD ALSO REVEAL:

+ A couple of sexy dresses that can work for day or night. Cotton jersey is the *best*—no iron needed.

+ A light sweater, preferably a cardigan, you can put on over a sundress if it gets chilly at night.

+ Hot sunglasses—Stella McCartney is my favorite on the high end, Ray-Ban's on the mortal level, and if you're going ghetto cheap, take two in case one breaks.

+ Kitten-heel sandals that you can dress up or down. Gold and red are great colors and are more neutral than you think. Cute yet comfortable trainers you can explore or hike in. (Always protect your clothing from your shoes by placing them in fabric or plastic shoe bags.)

+ A multiuse accessory like a scarf. Not only will you channel Grace Kelly when you wear it as a head wrap, but it can conveniently transform into a chic belt.

+ A pashmina (faux is fine). You will use it day and night, and it can pull double duty as a beach towel and sarong.

+ A journal—you're a creative chick; who knows when you'll be struck by inspiration?

+ An extra bag to carry your new purchases—a nice, sturdy bag that folds up easily and can also work as an easy-to-get-sand-out-of beach bag is key.

+ An umbrella for rain or shine. I love the sun, but it's a killer, and an umbrella is extra useful when you find yourself on a deserted beach without a cabana boy.

+ Tampons. Simplify things without having to schlep to the sundries counter.

+ Ibuprofen. Works on both hangovers and sunburn.

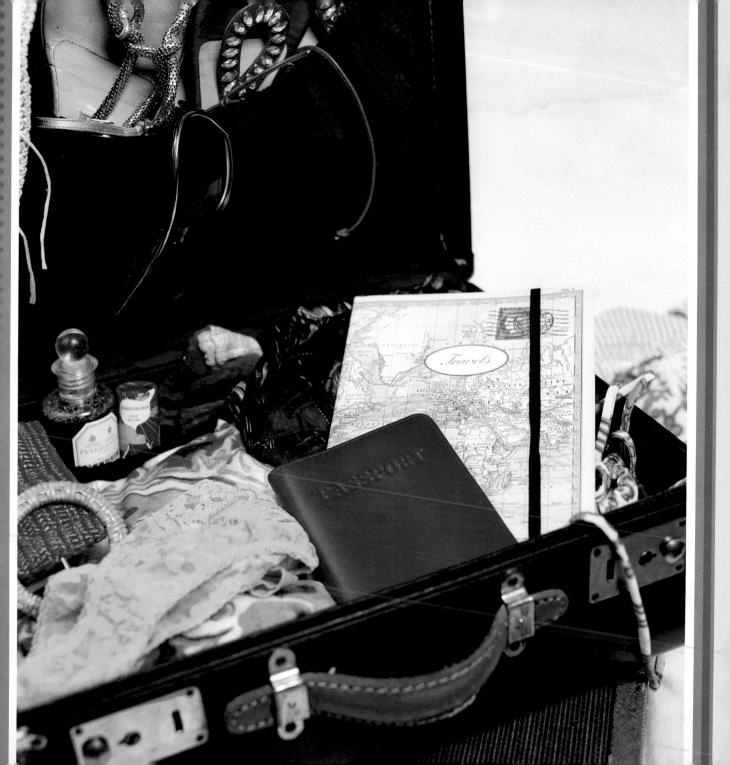

Do Good

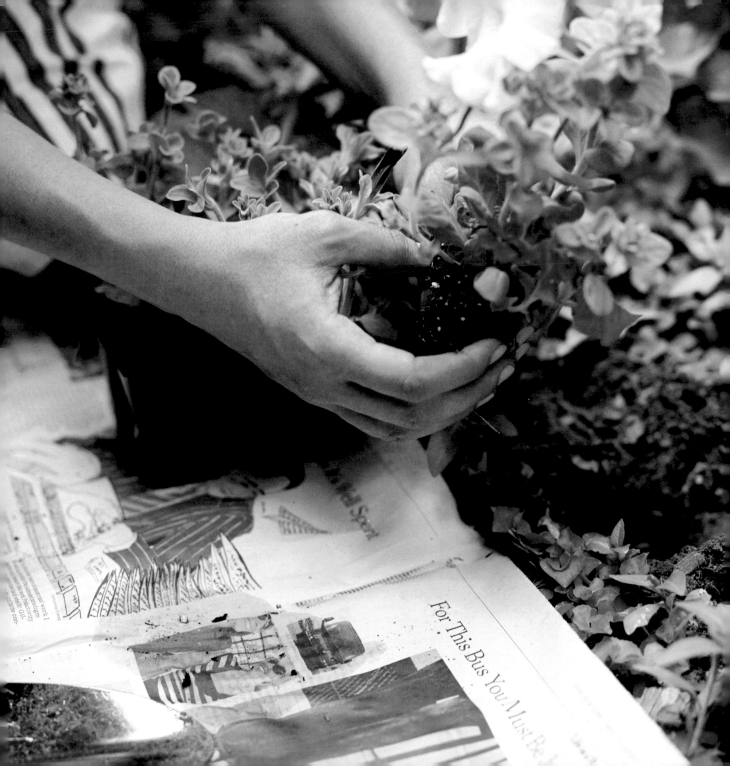

"It is not enough to be compassionate; you must act."

Dalai Lama, Tenzin Gyatso

Whenever I think of practically posh women, images of Oprah, Angelina Jolie, Madonna, and Christiane Amanpour come to mind. These women exude class and confidence, but also a keen awareness. They get life—how to enjoy it and how to enhance it. Throughout this book, we've learned how to create a rich existence with the resources available to you; that's the practically posh way. But now, grasshopper, we have reached our final lesson: a posh life is not just one of pleasure, but also one of purpose.

Did you know there is a fundamental difference between pleasure and happiness? In his book *Authentic Happiness*, psychologist Martin Seligman contends that while enjoyable experiences such as dining at a four star restaurant or buying a bootylicious dress do bring moments of exhilaration, these feelings of elation soon wane and leave us craving more epicurean experiences, and an even sexier outfit. True gratification, argues Seligman, comes via "purposeful" activity, such as volunteering. An added benefit of aiding someone less fortunate is that it highlights the abundance you have in your life. Robert Emmons, author of *Thanks! How the New Science of Gratitude Can Make You Happier*, found that people who recognized the goodness present in their lives were not only 25 percent happier, but also more interested in helping someone else. So practical poshies, now that we're living the lush life, how are we going to pay it forward?

We can take a cue from celebrity do-gooders. (No, we don't have to adopt children from impoverished countries. Not yet, anyway.) But A-listers who are driving around in Prius coupes and touring around in bio-diesel-fueled buses are bringing attention to pressing global issues. While we can't all *be* Bono, we do individually and collectively have the ability to create meaningful change in the world. In fact, there are many practical but significant ways you can help out in your own backyard.

> Be grateful . . . It's the only totally reliable get-rich-quick scheme.
>
> *Ben Stein*
> ACTOR, COMEDIAN, ECONOMIST

Getting started

Ready to lend a hand, but unsure of where to begin? A smart way to choose a volunteering gig is to find an outlet for your passions. For instance:

IF YOU LOVE TO EXERCISE

Volunteer at the YMCA (ymca.net) or Boys & Girls Clubs of America (www.bgca.org) where you can teach a child to play a sport like soccer or tennis, or just help them get fit. Thirty years ago, only one in twenty-five children was obese; now one in five fit that category.

My fitness trainer friend Francesca helps teach underprivileged city kids good nutrition and exercise habits via an organization called Concrete Safaris. At first she was shocked over how unathletic these children were, but she quickly whipped her group into shape. She now reports that the kids are supermotivated to get healthy and eat better. They're even starting their own garden! Check out concretesafaris.com.

If you prefer to work with adults, you can volunteer to be a running guide for a blind person during a race, or you can partner with them on a tandem bike, so they experience firsthand the simple joy of a bike ride (United States Association of Blind Athletes, www.usaba.org).

IF YOU LOVE THE OUTDOORS

Volunteer to clean up a local beach or lead a nature tour for inner-city children with the Sierra Club (sierraclub.org). If you're an astronomy buff, you can show off your skills as a stargazing guide for the National Park Service's Volunteers-In-Parks (VIP) program (nps.gov/volunteer).

IF YOU LOVE THE ARTS

Volunteer to take tickets or usher at your local playhouse. My cousin Jenny runs a small nonprofit theater company and she's always looking for extra help. She wanted me to pass on that the success of small theater groups across the country depends on the kindness of strangers like you. If you desire a more hands-on approach, teach a drawing, painting, or even a jewelry-making class at your local cancer center to help patients de-stress and heal. If you're a total ham, you could try your hand at offbeat acting by playing a victim (decked out in fake blood and bandages) for your local paramedics-in-training.

IF YOU LOVE TO WRITE

Volunteer to help create press releases for your favorite charity. Most nonprofits rely heavily on the media to get the word out on their organization and events. You could also write letters to soldiers via adoptaplatoon.org or even help high school seniors edit their college admissions essays. (As the only writer-in-residence in my family, I still help my sisters and mom draft letters to bosses, teachers, disappointing airlines, etc. I keep telling myself it's charity. . . .)

IF YOU LOVE ANIMALS

Volunteer to provide a foster home for stray animals, or if you can't take in a pet, spend time playing with, training, or walking animals at a local shelter. Pets that are friendly and socialized have a much better chance of getting adopted, according to the ASPCA (aspca.org). If you own a pet, take him to area hospitals and nursing homes to help cheer up patients through the Delta Society's Pet Partners program (deltasociety.org).

IF YOU LOVE TECHNOLOGY

Don't worry if you sound like Kip from *Napoleon Dynamite*, Web skills are in much demand. Volunteer to design or update a Web site for a not-for-profit group via the United Way (unitedway.org).

IF YOU LOVE CHILDREN

Volunteer to become a mentor with Big Brothers Big Sisters (bbbs.org). Your attention (and nagging) has profound effects. A study showed that kids with a mentor were 52 percent less likely to skip school, and minority children with a mentor were 70 percent less likely to begin using illegal drugs.

IF YOU LOVE TO SPEND TIME WITH FRIENDS

Volunteer with them. Get together with your ladies, research a local charity of your choice, and make a commitment to spend once a month helping out and/or donating or raising money. It's a great way to get involved in your community and a proactive way to spend time with your buddies. For ideas on how to organize your pals, visit givingforum.org.

IF YOU LOVE TO THROW PARTIES

Volunteer to help plan a fund-raising event for a charity close to your heart. Growing up in Texas, I had a big backyard and easy access to rivers, lakes, and miles of open space. Because the only access many kids have to green space in New York City is parks, I really wanted to help maintain them.

So I joined an organization called New Yorkers for Parks—NY4P.org. Besides planting daffodils in the park, I also co-chaired a tequila-tasting charity event and a holiday shopping fund-raiser at a local boutique. This was really the perfect volunteering experience for me, because I had to dedicate about a month every season and had a great time. To help polish your socialite skills, check out give.org for an index of national charities you can help.

IF YOU LOVE TO KNIT

Volunteer to make blankets for sick or underprivileged children with Project Linus (projectlinus.org).

IF YOU LOVE TO READ

Volunteer to read to terminal patients via the Hospice Foundation of America—hospicefoundation.org. Reading to an ailing person, and just providing company, helps alleviate stress, anxiety, and pain. You can also read to the elderly and children at your local hospital.

DID YOU KNOW?

In 2006, 61 million Americans dedicated 8.1 billion hours to volunteering.

Robyn's Tip

Because my father died of cancer when I was young. I've always wanted to volunteer in a cancer ward helping patients and grieving families but I never seemed to have the time or opportunity. Finally, I decided that the best way to honor his memory was to start a scholarship in his name. As a former teacher, education was paramount to him. So I reached out to family members and we started our own giving circle, creating a college fund in conjunction with the Lions Club, a community group he was active with. The recipient is a college-bound senior from my dad's high school alma mater, which is located in a low-income neighborhood. We kept the scholarship amount small, only $1500, because we wanted an amount that we all felt we could realistically contribute every year. An added plus is that it allows me to stay in touch with relatives I haven't spoken to in years.

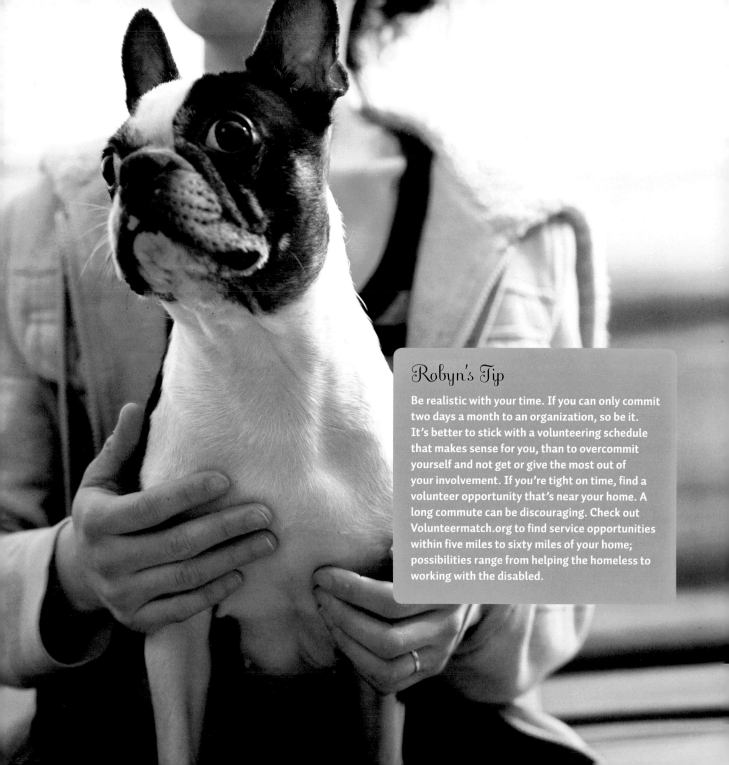

Robyn's Tip

Be realistic with your time. If you can only commit two days a month to an organization, so be it. It's better to stick with a volunteering schedule that makes sense for you, than to overcommit yourself and not get or give the most out of your involvement. If you're tight on time, find a volunteer opportunity that's near your home. A long commute can be discouraging. Check out Volunteermatch.org to find service opportunities within five miles to sixty miles of your home; possibilities range from helping the homeless to working with the disabled.

Volunteer vacations

Want to make your next getaway a meaningful one?
Consider these adventurous—and altruistic—expeditions.

HABITAT FOR HUMANITY

Founded in 1976 and made famous by former President Jimmy Carter, Habitat for Humanity International builds shelter for the poor and displaced around the world. Volunteer home-building trips range from sojourns to the still-recovering Gulf Coast to constructing adobe homes in New Mexico. They also have international building trips to destinations as varied as Ghana, India, and New Zealand. Volunteers pay for their own airfare or transport—at home or abroad—as well as a flat fee (on average, $1,200 domestic, $1,800 international) that includes lodging, meals, local transportation, and insurance. Although these trips can seem pricey, they are tax-deductible and offer once-in-a-lifetime experiences, such as working with the indigenous Maori tribe in New Zealand and in farming villages of Malawi. And like Habitat for Humanity says, Global Village trips are more about having a "day on" than a "day off." For more information, visit habitat.org

PASSPORT IN TIME

Passport in Time (PIT) is the preservation arm of the USDA Forest Service. Volunteers work with professional forest service archaeologists and historians throughout the country on projects like archaeological excavation, historic structure restoration and the gathering of oral history.

Assignments range in length from two days to two weeks. There is no fee, but you have to take care of your own transport, food, and lodging. Training is provided by PIT team leaders, so the groups remain small. Trips include excavating a 10,000-year-old bison site in Nebraska, preserving ancient cliff dwellings in New Mexico, and conducting archaeological surveys in the Salmon Fork of Montana, with a side trip of world-class fly fishing. For a list of upcoming trips, visit passportintime.com

SIERRA CLUB

Founded in 1892, this environmental organization's philosophy of protecting the earth has always emphasized enjoying and exploring nature. "If people in general could get into the woods even once to hear the trees speak for themselves, all difficulties in the way of forest preservation would vanish," said founder and naturalist John Muir.

The Sierra Club runs about 90 service trips annually. Destinations include observing humpback whales and repairing archaeological sites in Maui, restoring trails through the Redwoods in Big Sur, California, and rebuilding a seashore trail in Cape Cod. Prices vary from $500 to $1900, depending on location, and include food and lodging. Training is provided. Visit sierrclub.org for more info.

IF YOU WANT TO SPLURGE, THESE GROUPS OFFER UNFORGETTABLE SERVICE TRIPS

EARTHWATCH INSTITUTE

Founded in 1971, Earthwatch supports the protection of the planet through education and research. Volunteers on the hundreds of global "Earthwatch Expeditions" work alongside research scientists to collect field data on everything from the rain forests to climate change. Diverse trips include a visit to the Bering Glacier in Alaska, the largest alpine glacier in North America, to measure how fast it is shrinking due to global warming; travel to the Andes to help excavate the ancient settlement of Peru's Wari Empire; or work on a cheetah conservation farm in Namibia to help preserve the earth's fastest mammal, half of which have gone extinct since the 1980s. Trips are about two weeks long and among the most expensive of volunteer vacations, averaging about $2,200, plus airfare. However, they are tax deductible and spectacularly cool. For more information, visit earthwatch.org.

LA SABRANENQUE

Based outside the fortified city of Avignon in Provence, La Sabranenque is a nonprofit preservation group that helps to restore the decaying, medieval villages throughout the Mediterranean. Volunteers work in idyllic hilltop towns reconstructing churches and homes using stone masonry and other traditional techniques that are becoming extinct. The rebuilding requires no special construction or engineering skills and the stone-laying is easily taught at the start of each session. Prices range from $400 to $1300 for one to three week sessions, plus airfare, and include food, lodging, and activities. Trips are available April 1 through October. For more detailed information visit sabranenque.com.

Robyn's Tip

We'd all love to fly around the world like Angelina Jolie aiding those in need, but volunteering abroad is an expensive endeavor. Alleviate the costs by fundraising for your trip: run a race, have people donate items and hold a garage or stoop sale, throw a "I'm going to save the world" superhero costume party and have guests donate at the door, or find out if your company is interested in sponsorship.

Save The Planet

Okay, so now we know the "inconvenient truth": our little planet is taking a big beating from global warming. But luckily for us there are many easy ways to do our part to heal the environment.

Temperatures on earth have steadily increased since the industrial revolution, but have risen exponentially over the past two decades because of the dramatic greenhouse gas (carbon dioxide, methane, and nitrous oxide) buildup caused by human activity, like CO_2 emissions from driving SUV's.

If we do nothing to counter the effect of global warming, scientists predict that the steady increase in global temperatures will cause sea levels to rise and climate conditions to change, affecting the earth's landscapes as we know them. It sounds apocalyptic, but as the Buddha said, "Change can happen at any moment." So we must act now.

KNOW YOUR CARBON FOOTPRINT

Because global warming is driven by the release of greenhouse gases into the environment, our personal addition to the climate-change problem is mostly determined by how often we travel (via car or plane) and how much electricity we use. Calculate your footprint at www.safeclimate.net/calculator to see for yourself how much you're contributing and what you can do differently.

EASY WAYS TO SAVE ENERGY AROUND THE HOUSE

Shop smart. When shopping for new appliances or household items be sure and look for the Energy Star symbol, which means it's been approved by the U.S. Environmental Protection Agency and the Department of Energy as energy saving and good for the environment. Energy Star–approved products run the gamut from big-ticket items such as refrigerators to more frequent purchases like lightbulbs.

An Energy Star compact lightbulb uses 75 percent less energy than normal lightbulbs and lasts up to 10 times longer. It's also good to remember that even though these eco-friendly products may cost a bit more, you'll eventually save money on your electricity bill.

Bar water bottles. Recycling is integral to our quest for a healthy planet because it saves energy and conserves natural resources. Instead of buying cases of bottled water, either install a water filter on your sink or pull out your old Brita pitcher and put it to use. Not only will you save money on bottled water, but those little plastic water bottles are a big recycling waste. In addition to the high transport costs of water from France and Fiji, 86 percent of beverage bottles are not recycled! Not to mention local tap water is good stuff. America's public water supply is more toughly regulated by the EPA than bottled water is by the U.S. Food and Drug Administration.

Born again. Besides paper, plastic, and glass, there are other items in your home that are recyclable, so get creative. Don't throw out old floor tiles; instead, turn them into coasters or trivets. (Don't worry if they're not perfectly matched. Their asymmetrical quality makes them more authentic.) Convert old ice trays into all-in-one storage for nails and screws. I use old toothbrush holders as vases for individual flowers. Rethinking what you have, instead of running out and buying more household items, will help save the planet and save *you* money.

Be an H2O hoarder

The biggest use of energy in most cities is the water used when we clean our dishes, laundry, and even ourselves. So, turn off those faucets by:

TAKING SHORTER, COOLER SHOWERS.

Water heaters account for nearly a fourth of your home's energy use, so try to limit your hot showers. Brisk showers tend to be more energizing, and won't dry out your skin.

CHOOSE THE COLD CYCLE.

Ninety percent of the energy you use to wash clothes goes to heating the water. Cold water is great for color-fast clothing, and works brilliantly on stains like blood and chocolate. Many detergent companies are heeding the cold-water trend and are creating cold-water-compatible detergents. So the next time you do a load of laundry, go cold!

BE AN ECO-CONSCIOUS TRAVELER.

I know that driving is an easy and necessary way of transport, especially if you work far from your home, have children, or don't live near reliable public transportation. But, if you can, breaking your drive-everywhere habit will save you on gas and is more doable than you think.

GET BUSSED.

Try to pledge to take the bus to work just *one* day a week. Most cities in America have an efficient public transportation system and one busload of people can equal 40 cars off the road. Who knows, maybe you'll finally get a chance to finish that book or better yet, sit next to a hot eco-conscious dude.

TRAVEL BY TRAIN.

Rail travel emits about half the carbon dioxide per person per mile as a car or a plane and is a great way to see the country, if you've got the time. You might even be inspired to write a cheesy mystery novel by riding the rails.

FOUR WHEELS BAD, TWO WHEELS GOOD.

Americans ride bikes almost less than anyone else in the world, and we use the most gas. Coincidence, I think not. About 70 percent of personal errands are within five miles of your home, so grab your bike, enjoy blowing through traffic, and stay fit.

TAKE A WALK.

Walking a mile is projected to add 20 minutes to your life, and burns about 100 calories. So, put away your keys and pull out your kicks.

SHARE A RIDE.

Carpooling is not a new idea, but it is still an effective way to lower pollution, and a smart way to save dough. A commuter with a 60-mile daily commute saves $1,125 annually in a two-person carpool, according to ridefinders.org. Plus, who doesn't love to zip by the other cars when driving in the carpool lane?

DRIVE SMART.

With the price of gas so inflated, buying a hybrid or PZEV car is as good for your wallet as it is for the environment. Hybrids have gasoline engines and electric motors, a combo that greatly reduces emissions and saves gas. And while hybrids can still be relatively expensive, the federal government, and many states, are offering tax credits for owners. If hybrids are simply out of your price range, consider a PZEV (Partial Zero Emissions Vehicle) like the Ford Focus, which is a fuel-efficient vehicle that meets the same emissions standards as the best hybrids, and is much more affordable.

OFFSET YOUR EMISSIONS.

The next time you board an airplane, you can neutralize the impact of emissions from your flight by contributing to a project that's helping decrease carbon emissions somewhere in the world. So whether you give $10 or $50, you can fly easy knowing that a tree is being planted or your *dinero* is helping to build a solar-energy windmill. Check out carbonfund.org

DID YOU KNOW?

By driving two days less per week, the average person can save about 143 gallons of gasoline and keep about 2,778 pounds of CO_2 out of the atmosphere in a year.

(Source: Greenmatters.com)

Simple ways being green can save you some green

Eco-expert Danny Seo, TV host of *Simply Green* on Lime Network, recommends breaking some bad habits to save you money.

1. GET UNPLUGGED. Whether it's phone chargers, coffee makers, or DVD players, any appliance that is plugged into the wall even when not in use wastes energy and raises your utility bill. Instead of running around every morning pulling the plug on your electronics, connect them to one surge protector. Then with one flip of a switch, everything is off. This one act can save you up to $200 a year!

2. CHANGE YOUR CAR HABITS. To preserve fuel and green in your wallet, make sure your tires are properly inflated to get the best gas mileage. Whenever possible, always get a full tank of gas, since those back-and-forth trips will accumulate to wasted gas and money. Make sure your gas chamber is closed extra tight to prevent evaporation—turn the cap closed until your hear three clicks. In the summer, save money on air conditioning by parking your car in the shade.

3. CHECK OUT FREECYCLE.ORG. Known to many as "FreeBay," this site is a huge resource for discarded items. Just type in your zip code to post an item you're trashing or to look for something you need. I've tossed perfectly good couches and mattresses because they didn't fit in my new place and scored a great couch for free because it didn't fit into someone else's. There is a feel-good quality to not throwing something away, and a feel-great quality to getting something for free!

4. GO FOR NATURAL CLEANING PRODUCTS. Who wants to put our yummy organic tomatoes on the counter on which we just sprayed bleach? Yuck! From all-natural cleaning sprays to microfiber towels to phosphate-free detergent, these little choices will make a big difference in our lives. To learn more about the products in your home and how safe they are, check out the National Institute of Health's Household Product Database at Householdproducts.nlm.nih.gov.

If you're tight on cash, go old-school—make your own. Good-for-the-environment household products like the ones Granny whipped up, such as old-fashioned baking soda, vinegar, salt, and lemons, are cheap, easy, and guaranteed to work. Use baking soda and warm water to clean your coffee pot or scrub the tub. Mix one part water to one part distilled vinegar in a spray bottle for an all-purpose disinfectant and deodorizer. Half a lemon dipped in salt will clean and shine your brass and copper.

5. MAKE SURE YOUR FIREPLACE IS CLOSED. In winter or summer, an open fireplace is an energy hog. To know if your flue is open, take a tissue and stick it in the fireplace. If it's blowing, you'll have your answer.

. .

DID YOU KNOW?

The average American today creates 65 percent more garbage than they did in 1960.

(Source: greenmatters.com)

. .

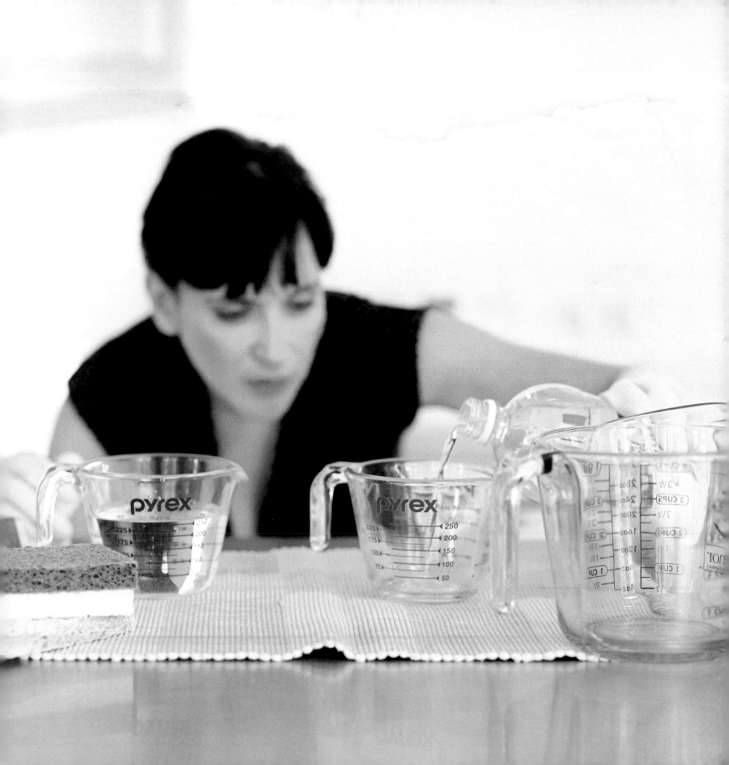

Buying power

This is undoubtedly the easiest way for us to make a difference in the environment and the lives of people around the globe. Because we already shop for clothing, coffee, and other daily essentials, just being *aware* of our daily purchases will have almost effortless yet profound consequences.

Fair trade

The next time you go to the grocery store, look for the Fair Trade Certified symbol that is currently available in the United States on coffee, tea, herbs, sugar, cocoa, chocolate, vanilla, rice, fresh fruit, and flowers. Buying fair trade products means that the farmers who made these staples, usually from developing countries in Latin America, Africa, and Southeast Asia, were paid competitive wages and labored in good working conditions. Plus, part of your money is guaranteed to be reinvested into their communities on social and environmental projects, like building schools and hospitals, and converting their farms into organic systems.

Have an eco-chic home

Going green doesn't always have to be snoozingly practical. Posh out your home with the huge array of earth-friendly accessories.

Organic cotton sheets. Wrap yourself up in goodness with all-natural cotton sheets. Plus, they're reasonably priced and supercomfortable. Check out Bed, Bath & Beyond, Target, and Wal-Mart.

Recycled glass tableware and vases. Liven up your pad with cool-colored vases and add instant sparkle to a dinner party with recycled glass dishes and wineglasses. Visit fireandlight.com.

Eco-friendly paint. Next time you freshen up a wall, use these low-odor and low-chemical paints and you'll breathe easy as you gush over your handiwork. Visit benjaminmoore.com and ecospaints.com.

Bamboo you. Found in flooring, furniture, and home accessories because of its lovely natural design, this multitasking grass is a more sustainable material than wood. If you're more of an oak or teak kind of gal, look for retailers like Pier 1 Imports, who craft their furniture from Forest Stewardship Council–approved wood. This means that the wood they use comes from well-managed forests. Check out pier1.com and WestElm.com.

Robyn's Tip

Check out ecomall.com, which provides links to green products in over 60 categories from organic bedding to nontoxic paint.

Get involved

Although it's easy to forget how much power for change each individual possesses, there is a lot little-old-you can do to help stop suffering and injustice in the world. Start by reading the paper and just opening your eyes. Become familiar not only with what's happening in Darfur, but also in your own city.

While you're at work, instead of perusing Perezhilton.com for celeb gossip, visit the National Organization for Women's Web site (now.org) for a briefing on issues affecting women. Check out the UNICEF Web site (unicef.org) to learn about the plight of children around the world. Adopt a campaign you and your practically posh peers can champion.

Robyn's Tip

A fun way to get involved in an election campaign is to throw your own fund-raising party. Try to get similarly politically minded companies to sponsor food and drinks. Send out an e-mail blast and let everyone know what's up. In lieu of handling money yourself, set up a computer at the entrance set to your political candidate's Web site and have people donate directly to the campaign online, so you are free to work the room like Jackie Kennedy.

Vote

It's quite empowering when we remember that politicians *need* us to get and keep their jobs. Get familiar with your politicians on the local and national level and their views on issues. You can find their voting records at www.vote-smart.org.

Hopefully, you'll be inspired enough to get behind a candidate. The last presidential election, I adopted a neighboring state to get the vote out. Months prior to the election, my friends, cousin, sister, and I spent weekends knocking on doors, registering people to vote, and trying to explain why their vote did matter. We told them that it's futile to complain about minimum wage, gun control, universal health care, and expensive wars if they don't speak up when they have the chance at the ballot box. Show up on Election Day and exercise your democratic right, and while you're at it bring you friends, neighbors, granny, and grouchy aunt. Go out for lunch after and bask in the glow that you performed your civic duty.

Be nice. Take a deep breath. Meditate.

How often has some mean person ruined your day, whether it was an evil boss, or some grump on the street? God knows I have had times when I was nasty to a checkout girl because she was moving a little too slow for my liking. But it doesn't have to be that way, or rather I don't have to react like that. I realized this one day after shoving an old woman out of the way as I was rushing up the subway stairs to work.

After plowing over her like a linebacker, I cast a guilty glance over my shoulder and the little old biddy shot me an evil look. Disturbed by my brazen action, I was confused and depressed all day. There was nothing practical, posh, or nice about disregarding someone, especially someone's poor grandma. I made a vow to change my frenetic ways and to slow down, so I wouldn't be poised to assault at 8:30 in the morning. I started waking up earlier and easing into a few yoga moves in the morning to de-stress before I commenced my crazy day. I found myself in a much better mood all day, more capable of forgiving annoying transgressions that probably had nothing to do with me

anyway. Taking a deep breath instead of tensing your body when someone is bothering you works wonders to squelch negative outbursts and keep bad energy at bay. Now repeat after me: "I am one with my poshness."

And to be a little revolutionary here, how about we make an effort to be kind daily? Indulge your annoying coworker and listen to her drone on about her upcoming wedding. Don't flick off the painfully slow driver in front of you—maybe they're lost. Kind gestures are grace in motion, and like the homeless dude on my morning train always says: Smile, it doesn't cost you anything.

Acknowledgments

What's lovely about writing an acknowledgment page is that because it's at the end of the book-writing process, I get to take a breather, and reflect on the outpouring of generosity I have received along the way.

First, I'd like to thank Raymond Garcia and Rene Alegria for approaching me about this book and seeing the hints of poshness that was to unfold.

Thanks to my brilliant editor, Melinda Moore, for spot-on edits, fun brainstorming sessions, and lush support.

An overwhelming thanks to my agent, Joy Tutela, for advice and support in every aspect of this book, from inking the deal to deciding on the cover. I am very lucky.

Huge thanks and gratitude to my prodigious photographers, Jessie and James Owens, who got me naked on our first shoot, and patiently guided me through this process.

To my wonderfully talented friend Pepa Pedraza for inspiration and helping me style the gorgeous shoots. Besitos

Thanks to Irasema Rivera—the coolest Jackelope in town—who defined generosity by lending me her tim, talent, house, and dog.

Thanks to David Stéphan for his ongoing encouragement of this project, and thanks to Laura, Ottavio, and Olivier for inviting me to your beach house to write my proposal.

Thanks to the lovely men and ladies who shared their singular knowledge with me: Grace Bonney, Angela Matusik, Debra Condren, Meredith Haberfeld, Robin Hollis, Wendy Gonzalez, Sofia Crokos, David Tutera, Danny Seo, Lisa Hunter, June Saruwatari, Dr. Doris Day, Barbara K., Leatrice Eiseman of the Pantone Institute, Andy Maier, Devon Manges, Carmen Wong Ulrich, Lauren Purcell, Francesca Meccariello, Stephanie Elizondo Griest, Heather Lord, Beth Schoenfeldt, Victoria Colligan, Steve Boorstein, Carolina Buia, and Isabel Gonzalez.

Mil gracias to my cousins Javier and Debra for food inspiration and letting me shoot beautiful pictures in your restaurant.

Thanks to Jennifer "Honey" McCulloch for letting me shoot in her gorgeous store and for being a great friend.

Thanks to Jason Blum, Victor Gallo, and Ricardo Medina, for recipes and location help, and to Jon Tierney for last-minute recipe edits.

Thanks to Erica Recto, Greg Morris, Andrew Park, Gerald De Cock, Catriona Macrae, Paul Bolinger, Abraham Zepeda, Olivier Pasquini, Anne Fritz, and Giovanna Galeotafiore for agreeing to let me ply you with tequila and take your photos.

Thanks to my cousin Michael Ortega for letting me shoot vivid pics in such a fun place.

Thanks to Angélina Stéphan, Catherine Cutier, Lena Kwon, Jorge Gallegos, and Aparecida Teixeira for translation help.

Thanks to my board of advisors who helped immeasurably with advice and edits: Ivette Manners, Anne Fritz, Michelle Mulligan, Giovanna Galeotafiore, Lisa Martin Louro, Holly Corbett, Shirley Velásquez, Kristen Wolfe Bieler, Genevieve Roth, Catherine Miles, Anne Sofie Hansson, Cathy Maguire, Stephanie Steele, and Sarah Stebbins.

Thanks to Sandra Mardenfeld and Meredith Ritchie for diligent copyediting, and quick turnarounds. And huge hugs to Helen Song for much-appreciated patience and hard work.

Thanks to Jenny Bohatch for thorough research help.

Special thanks to Ivette Manners for being my sounding board, late-night editor, and wonderful friend.

Thanks to Yvette Moreno for name and photo suggestions, beauty and finance tips, help with fundraising, and for being such a good listener.

Thanks to Nevia Moreno for cleaning tips, photo suggestions, and for being a posh and protective big sister.

Thanks to Bianca Moreno for ideas, suggestions, listening, recipe testing, manuscript help, fashion advice, monetary and clothing loans, and for weathering my outbursts while I wrote this book in my crib by the highway.

Thanks, Mom—your beauty, class, resourcefulness, and enduring hope was the inspiration for this book. Té amo mucho.

And finally, to El Rey, my father, Rudy Moreno, for everything I do is in your honor.